Digital Photography

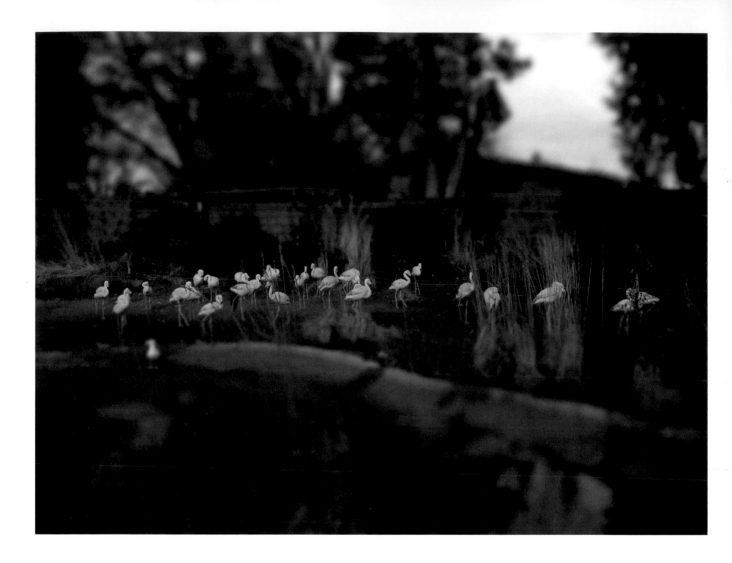

Ann Pallesen, "Flamingos," Woodland Park Zoo, Seattle, Washington
Pallesen uses her camera to "escape our busy world by focusing on landscapes in unfamiliar territory and subjects in stolen quiet moments." Her approach is decidedly low tech, influenced heavily by photographs from the early 1900s, including scrapbooks from that period, to suggest "nostalgia and a time gone by."

Photographers need a good eye more than they need a good camera, and Pallesen is able to work unencumbered when she uses a compact point-and-shoot model (pages 12, 26–27). It frees her to concentrate on her subjects, rather than technical matters. *www.annpallesen.com*

Digital Photography

A Basic Manual

Henry Horenstein
Rhode Island School of Design

with Allison Carroll
Saint Sebastian's School

LITTLE, BROWN AND COMPANY
NEW YORK BOSTON LONDON

Little, Brown and Company
Hachette Book Group
237 Park Avenue, New York, NY 10017
www.hachettebookgroup.com

First Edition: November 2011

Little, Brown and Company is a division of Hachette Book Group, Inc.
The Little, Brown name and logo are trademarks of Hachette Book Group, Inc.

The publisher is not responsible for websites (or their content) that are not owned
by the publisher.

Library of Congress Cataloging-in-Publication Data

Horenstein, Henry.
 Digital photography : a basic manual / Henry Horenstein with Allison Carroll. — 1st ed.
 p. cm.
 Includes index.
 ISBN 978-0-316-02074-9 (pbk.)
 1. Photography — Digital techniques. I. Title.
 TR267.H67 2011
 770 — dc23 2011018758

10 9 8 7 6 5 4 3 2 1

Book design by Kiki Bauer
Illustrations by Mine Suda / em.es.
Copyediting by Anne McPeak

Printed in China

To Tom.
AMC

To Allison.
HH

Contents

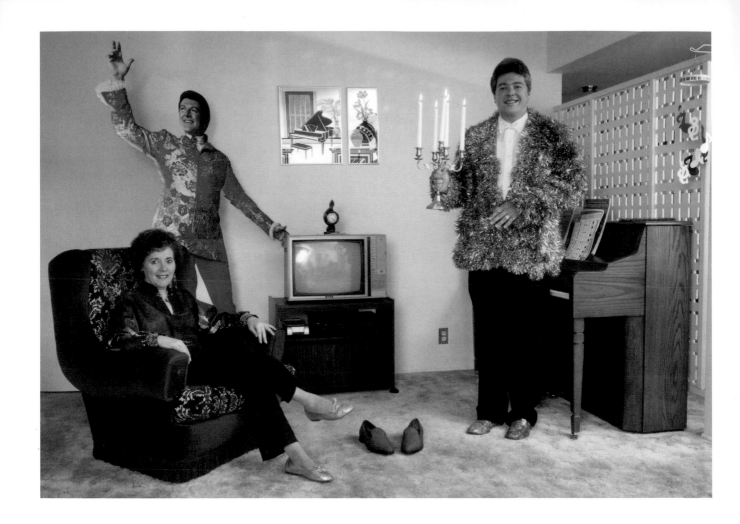

**David Graham "Paula LaChance and Gregory Mikeska with Liberace's Shoes,"
Las Vegas, Nevada**
Some photographers think that a good picture must have a serious and "deep" message. But there's nothing wrong with humor as a subject, and Graham's amusing pictures of American landscapes and people prove it. We are a unique and quirky culture, he seems to be saying. And he takes great delight in showing it off, whether he's photographing circus trainers, farmers, fishermen, or just folks on vacation. This portrait of Liberace impersonator Mikeska from Graham's celebrated book *Land of the Free: What Makes Americans Different*, is a case in point. *www.davidgrahamphotography.com*

Foreword

Digital photography is so popular right now that it's easy to forget the many other monumental changes in photography over time. In the 1870s, dry plates were introduced, lowering the cost of making pictures and freeing photographers from having to travel with their darkrooms. The end of the nineteenth century brought roll films, which democratized photography. Expensive equipment and training were no longer needed. Now anyone could take a picture. And they did. The invention of practical systems of color photography in the 1930s was also huge, as was Polaroid's contribution in the late 1940s—instant photography.

In some ways, digital photography encompasses all these past developments and promises so much more. It is freeing, affordable, and easy to use. It also produces pictures in color—instantly. The improvements and changes are dizzying, and they seem unstoppable.

All that has made writing a digital instruction book a daunting task. What can be said that won't be subject to change in short order? While change is inevitable, many of the tenets of photography have remained the same for many years—even the computer-based editing and adjustments so fundamental to digital photography are now pretty well established.

Most importantly, photographs are still made by humans, not machines. Reviewing the many wonderful photographs in this book reminds me of that. When collecting these pictures, attention was paid first and foremost to visual considerations—regardless of whether the images were shot with a digital camera or not. After all, nowadays virtually every picture becomes digitized along the way—whether at the time it's taken or later when it's prepared for print in a book or magazine.

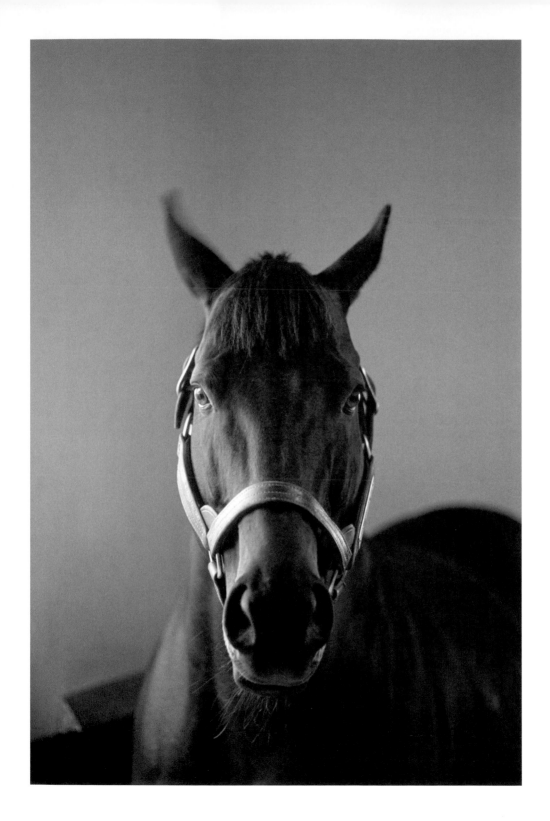

Introduction
Getting Started

This manual is a basic guide to photography, emphasizing a digital **workflow** (a progression of steps) and covering all the points typically taught in an introductory class. The book starts at the beginning, assuming you know little or nothing about photography, and guides you through the practical details of **digital capture** (taking pictures) and **postproduction** (image editing, printing, and so forth). The book also covers a variety of other subjects, such as scanning film and prints and saving and **archiving** (storing and preserving) your photographs for future use.

→ *image editing, pages 168–203*

While practical details are essential, your most important goal should be getting the best possible pictures—hopefully, ones that look great, capture a moment, tell a story, or generally accomplish whatever you're trying to achieve visually. To that end, this book also includes photographs by working photographers, accompanied by captions discussing composition, framing, color, light, and other factors to consider in making more effective pictures. It also suggests ways to present your work, whether on a home or gallery wall.

There is a lot to learn, but it's not all that difficult with today's cameras and imaging tools. Modern cameras can seem overwhelming, but they are quite intuitive, and you can get excellent results even when photographing in an automatic mode. Furthermore, when using a computer, there is much software readily available for editing, printing, and putting your work out for others to see. And, as you advance, there are any number of choices for more controlled and refined picture taking, image editing, printing, and so forth.

However, taking pictures on automatic is not foolproof. A camera can't know what a subject looks like, or how best to compose and capture it. And a lot can go wrong technically, even in the most automated cameras, such as autofocus that misses the mark or tricky lighting that leads to inaccurate exposure or odd color. Working with computers can pose another challenge because the technology changes so rapidly. There are many day-to-day issues, such as big images slowing down your

Henry Horenstein, "Seattle Slew," Three Chimneys Farm, Midway, Kentucky
A good rule-of-thumb is: good subject, good picture. Much more than a good subject goes into making a good photograph. But a compelling subject really helps to draw a viewer's attention, which may explain why photographs of celebrities and animals are so popular. Here, the picture of celebrity horse Seattle Slew (who won the Triple Crown of racing) is simply composed, with the subject in the middle filling the frame and set against a plain green background. There are no distracting elements to speak of—just Slew and his direct gaze engaging the viewer.
www.horenstein.com

machine, running out of space on your hard drive, and system crashes—not to mention the ever-present possibility of user error.

The more you understand how everything works, the fewer problems you'll encounter along the way. You'll have more control over the process, allowing you to make the pictures you want, even when working in automatic mode.

People make good pictures, not cameras. So don't worry if you don't have a top-of-the-line model. Inexpensive, compact **point-and-shoot** models are mostly made to work on automatic and are simple to use, but they also are capable of taking excellent pictures, as long as you don't plan to make very large prints. More sophisticated cameras generally offer more choices, control, and quality (especially at large print sizes). To get the most out of this book, consider using a **digital single-lens reflex (DSLR)** model, which will offer the best overall image quality, and also the simplest access to manual settings, the ability to use a variety of lenses, and so forth. There are also hybrid models that fall somewhere between the point-and-shoot and DSLR in terms of size, price, image quality, and other useful features.

To make the best use of the chapters on postproduction, you'll need access to a fast, fairly new computer, software, printer, and possibly other devices, such as an external hard drive and a scanner. As you read this book, refer to the relevant instruction manuals and/or websites and blogs or be prepared to check a manufacturer's FAQs. Tools for digital photography vary widely in design and use, and the manufacturer's information is often critical when looking for specific information or troubleshooting. Moreover, change is constant in the digital environment. It's important to keep as up-to-date as you can.

→ *point-and-shoot, pages 26–27*

→ *DSLR, pages 22–25*

→ *hybrid, pages 27, 29*

→ *scanner, pages 154–157*

Point-and-shoot (1). Simple, compact camera, mostly intended for automatic operation, but capable of good results.

Digital Single-Lens Reflex (DSLR) (2). The preferred camera for best pictures with maximum control.

Eric Roth, " Turkish Bath Interior, Istanbul"
Roth was invited by the Turkish government to photograph their ancient baths for a book project. Fortunately the baths were open air, allowing plenty of beautiful natural light to enter from the side and through small windows in the ceiling. Capturing the scene in RAW file format, Roth was able to make adjustments in postproduction to produce even and balanced light throughout. *www.ericrothphoto.com*

1 2

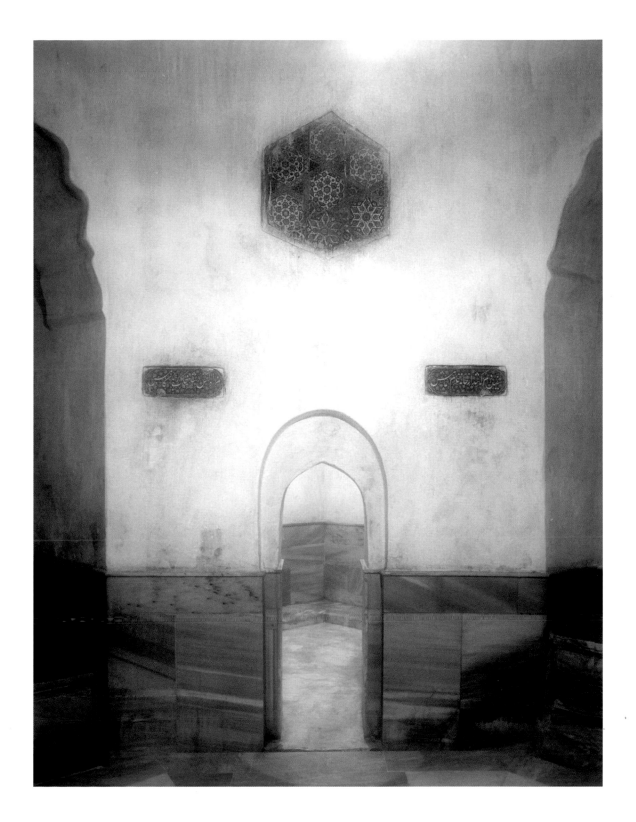

→ *memory cards, pages 42–44*

→ *formatting, page 43*

→ *file format, pages 35–37*
→ *image file, page 21*

→ *JPEG/RAW, pages 35–36*

→ *file quality, page 37*

A Quick-Start

Here are some very general instructions and tips on getting started with your camera. Despite many differences, almost all models can be operated by following these guidelines.

1. **Charge the battery.** Use the battery charger that comes with the camera, and always charge it fully before you use it for the very first time to get the maximum usage possible. Charging time varies from one battery to another, but figure in at least a few hours for a full charge.

2. **Insert the battery.** It should slide easily into a slot on the camera. Don't force it.

3. **Insert a memory card.** These cards contain silicon chips to record and store your pictures as well as manage the image data. Most cameras take either an **SD** (secure digital) or the larger **CF** (compact flash) card; a few take both. Make sure you have the type of card that works with your camera. Again, it should slide in easily, so don't force it.

Note that memory cards are rated by capacity (how much data they store) and speed (how fast they record the data). For instance, there is an SDHC model that offers higher capacities than a simple SD card. Whatever the version, all SD cards should be cross-compatible—and the same goes for CF cards.

4. **Turn on the camera.** Once the memory card is in place, turn on the camera. If it's a new memory card, you will have to **format** the card so it will work with your camera. You do this by going into the camera menu and choosing the format option.

5. **Set the file format.** The **file format** is a primary factor in determining image quality. It refers to how data in an **image file** (your digital photograph) is **compressed** (reduced to a workable form) and stored—and also how big the file sizes will be. Go into the camera menu and choose a file format. The menu may refer to this as "recording mode," "image-quality," or "image size."

With most cameras, you have a choice of creating **JPEG** or **RAW** files. JPEGs are the most commonly used and the easiest to work with because they are highly compressed. RAW files are larger and preserve all the original image information, thus providing more flexibility during postproduction, and allowing you to produce higher quality results.

Most of the time you'll probably want to shoot in RAW, since these are higher-quality files, but many cameras will allow the option to shoot in RAW and JPEG at the same time. If you choose this option, you can also choose what size the JPEG files will be, from large to small options.

SOME TERMS DEFINED

There are several terms that you'll encounter as you read this book and continue in digital photography. All of these will be discussed later, but here are a few that you'll encounter repeatedly.

Color space – how color is represented in an image file— typically RGB, CMYK, or grayscale (page 173)

Compression – reducing the size of an image file for more efficient storage and use (pages 35–37)

Image editing – adjusting and fine-tuning an image file (chapter 7)

Image file – digital form of a photograph (page 21)

Image sensor – light-sensitive chip inside a digital camera that reads the light coming into the camera

(pages 21, 29, and 31–33)

Megapixel (MP) – one million pixels (pages 29 and 31)

Pixels – individual colored picture elements that make up a digital image file (pages 29 and 31)

Resolution – pixel count of an image file, described as pixels per inch (ppi) (pages 33, 162, and 198)

→ *exposure, pages 94–123*

→ *lens aperture, page 54*
→ *shutter speed, pages 81–85*
→ *ISO, pages 98, 100–101*

There are several ways to set the exposure mode, depending on the camera you use. Here are three typical methods: dial, control wheel, and menu.

6. Set the camera's exposure mode to automatic (AUTO or A) or program (P). Choosing one of these fully automatic settings is the easiest way to start making pictures. Depending on your camera, you do this by turning a dial, spinning a control wheel, or making a menu selection. Your camera offers several other exposure-mode options, and you should explore these once you get used to shooting in full automatic (**AUTO**) or program (**P**). For example, you can work in **manual (M)**, **aperture-priority (A or Av)**, or **shutter-priority** mode (**S, T, or Tv**). All these allow you more control of exposure by allowing you to set a particular lens **aperture** (the opening that lets light through to the image sensor) and/or **shutter speed** (the time of exposure). Much more on this later.

Another way to control exposure is by adjusting your **ISO**—a numeric rating of the image sensor's sensitivity to light. Working on fully automatic, the camera will probably set the ISO for you. By using a dial or button on the camera body, or with a setting in the camera menu, you can choose a higher ISO (such as 800) for photographing in low light or a lower ISO (such as 200) for bright light—or you can set **Auto ISO** and let the camera choose for you.

Dial on top of camera

Spinning a control wheel

In camera menu

Selecting ISO in the camera menu

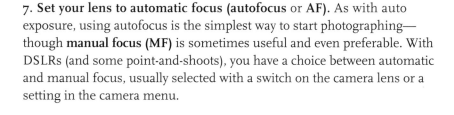

→ *autofocus, pages 50–53*

→ *manual focus, page 53*

7. Set your lens to automatic focus (autofocus or AF). As with auto exposure, using autofocus is the simplest way to start photographing—though **manual focus (MF)** is sometimes useful and even preferable. With DSLRs (and some point-and-shoots), you have a choice between automatic and manual focus, usually selected with a switch on the camera lens or a setting in the camera menu.

Switch on lens for autofocus (AF) or manual focus (MF).

Camera with two types of viewing—optical viewfinder and LCD screen with live view.

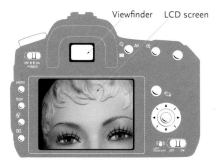

Viewfinder LCD screen

8. Compose your subject. There are two ways to compose your subject: by looking through an optical **viewfinder** on top of the camera or by viewing it on an **LCD screen** on the back. All digital cameras have an LCD, but not all have a viewfinder. Note that older DSLRs may not allow you to compose on the LCD screen.

9. Focus your subject. In autofocus mode, press the shutter button halfway down to focus. Depending on your camera, you'll see the image come into focus and/or there will be some sort of status indicator in the viewfinder or on the LCD screen when focus "catches"—for example, a dot that blinks, then stops when focus is achieved.

Push shutter button halfway down to focus.

On most cameras, a dot lights up when focus is achieved.

TIP: GET CLOSER

Compose your subjects with care. It's possible to take a picture and change the framing to a degree in postproduction. But it's always easiest and fastest to get it the way you want it at the time you take the picture.

One of the most common problems when composing is not getting close enough to your subject. Before taking the picture, look critically at the framing on your LCD or through the viewfinder and consider whether getting in a little closer will improve your results.

10. Steady the camera. If your camera moves even a little when you take a picture, you may get a blurred image. So, take extra care to steady the camera from the time you prepare to take the picture until just after, to make sure you don't move it accidentally during the exposure. A tripod or some other steadying device also can help, especially when photographing in low light or with a bulky lens.

11. Take your picture. Push the shutter button all the way down to take the picture.

Review button symbol for playing back images

12. Review the results. Your captured picture will be displayed on the LCD screen for a few seconds, right after it's taken. To review the picture or other pictures on your memory card, press the camera's playback button and skim through them using a control wheel, toggle, or whatever method your camera allows.

Delete button symbol on the back of camera

13. Delete pictures with caution. When you see a picture you don't like for whatever reason, you can delete it on the spot using the delete button on the back of your camera. This goes for pictures just taken, as well as any picture stored on your memory card. Don't delete rashly, however, as you may regret your decision later on. Memory card space is fairly cheap, so when in doubt, don't delete.

→ *memory card reader, page 43*

14. Copy your images to a computer. There are two commonly used methods for transferring pictures from the camera to your computer's hard drive. You can attach your camera to the computer with a cable, or you can remove your memory card from the camera and put it in a **memory card reader** to copy pictures from the card to the computer. Some computers have a built-in slot for reading memory cards. Otherwise, you'll need an external reader.

15. Work on your images in postproduction. Once your pictures are loaded on the computer, you can use software to edit (adjust) the image files. Image editing allows you to perform a wide variety of tasks, including making them lighter or darker, resizing, fine-tuning color, cropping, as well as many others. You then have many options for **output**—how the image is displayed or viewed—such as printing, e-mailing, uploading to the web, and so forth.

→ *back up, page 203*

16. Back up. Your pictures are valuable, even priceless, so back up right away to an external hard drive or other media. Better yet, make multiple backups and store them in different locations for even greater security.

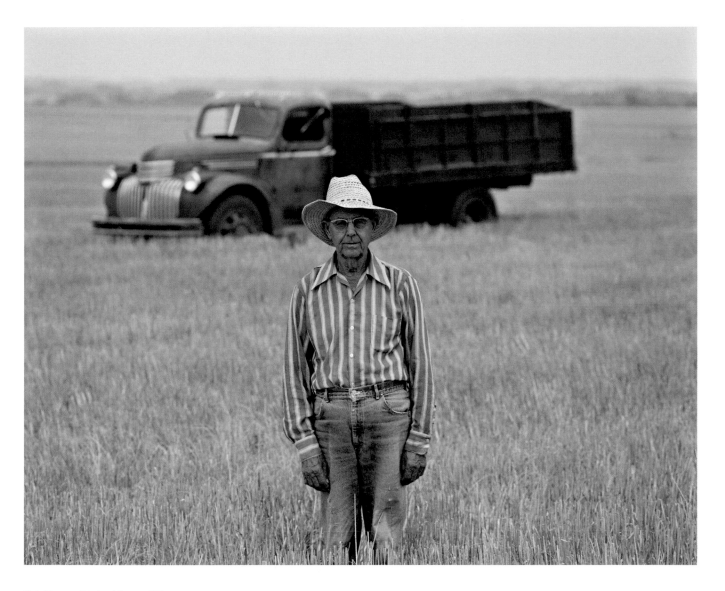

Bob Hower, "Retired Farmer," Pretty Prairie, Kansas

Whenever possible, Hower takes a road trip to make personal photographs and indulge his interest in smokestack industries, lonely byways, and vintage vehicles. "I spotted this beautiful old GMC truck in a freshly cut wheat field. I set my camera on a tall tripod, climbed a stepladder, and tried to do justice to the truck. The grandfather stood by and I asked if I could photograph him. His pose and expression seemed so natural that I gave him no direction whatsoever."
www.qphoto.com

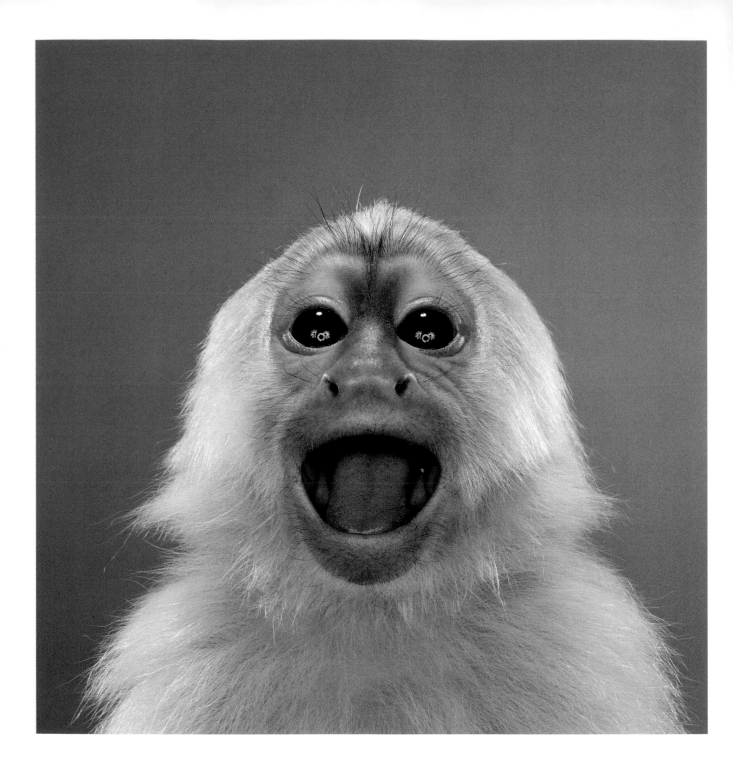

Chapter 1
Digital Capture

→ *image sensor, pages 29, 31–33*

Taking pictures with a digital camera is called **digital capture**. As light enters the camera through the lens, it strikes an **image sensor**, a light-sensitive chip that converts the image seen by the camera lens into digital information. The captured information is then processed in-camera to create an **image file**. The image file is stored on a memory card. You then download the file to a computer so you can **edit** it the way you want it—adjust brightness, contrast, color, and other characteristics. You can also prepare the file for various types of output, such as making prints, e-mailing, or posting online.

A digital camera is basically a light-tight box that incorporates an image sensor, lens, shutter, light meter, memory card, and other picture-taking tools. In this chapter, you will learn how a digital camera works and how to use it. The process can be complicated, but it will be explained in greater detail as you read on.

Jill Greenberg, "The Hatchling"
Greenberg made her "Monkey Portraits" in studios, using a medium-format digital camera, which produced large image files for maximum sharpness and detail. This allowed her to make huge prints, as big as 50"x 43" or even larger. Here, the monkey's gaze and expression are riveting, and the simple color scheme helps focus our attention. The gray/blue background works with the pink face to offset the white fur.

Greenberg's monkeys are good examples of two basic qualities that are fundamental to good human portraits—gesture and emotion. The combination helps make her monkeys variously scary and sweet, haughty and humorous, strong and vulnerable. *www.manipulator.com*

Camera Types
There are so many digital cameras available that choosing the right one for your needs can be daunting. As a general rule, newer models incorporate the most up-to-date technology, and will likely perform better—both in terms of features and image quality. Pricier professional models almost certainly perform best and are more durable. But for most users, the more affordable cameras can provide excellent pictures. Even simple snapshot-type cameras, including cell phone models, can work perfectly well in certain situations. Following are some details about popular digital camera types.

Digital single-lens reflex (DSLR)

A DSLR is a sophisticated camera type that allows you to view, compose, and focus the subject "through the lens." This means you see the subject as the lens sees it, which makes your composition and focus very accurate. DSLRs offer many other advantages, such as **interchangeable lenses**. You can use the lens that you have on the camera or exchange it for a **macro lens** to focus very close to your subject, or a **prime lens** to photograph in low light without a flash. Because of the range of lenses you can use with a DSLR, you have more control of the range of sharpness in a picture. For example, you can more easily blur the background while keeping the subject sharply focused.

A DSLR can be used on full automatic, but it also offers many manual ways to fine-tune the picture-taking process. For example, focus, exposure, flash, and many other settings can be easily adjusted in a DSLR so you'll be better able to get the results you want. Some other camera types allow for similar controls, but many are designed for fully automatic use, making the process of choosing settings manually more unwieldy.

Quality is another good reason to choose a DSLR. They are generally better designed and more rugged than most other camera types. DSLRs also respond pretty much instantaneously. Automatic focus is very quick,

→ *macro lens, page 73*
→ *prime lens, pages 58, 62*

1

2

3

and so is the capture. When you press the shutter button, the picture will be taken without delay.

DSLRs almost always produce the best-quality pictures. There are many reasons for this, including higher-quality lenses, and most importantly, bigger image sensors and better image processors. These help in many ways, including reducing the appearance of **digital artifacts** in your pictures, something that will be discussed later on.

→ *image processor, page 33*
→ *digital artifacts, page 34*

There are many types of DSLRs at widely varying prices. You can get excellent results from entry-level models, but you should naturally expect more from cameras that cost more—certainly better image quality and more ruggedness. Some of the features of more expensive cameras may or may not be important to you. Sports photographers or photojournalists, for example, may appreciate features such as the ability to shoot at higher **burst rates**, thus capturing more **frames** (pictures) in a short period of time, generally measured as **fps** (frames per second).

DSLRs are a good choice for high-quality photography, but they do have drawbacks. They are relatively expensive, a little bulky to carry around—and somewhat complex, so they may require a long learning curve. This is especially true if you want to fine-tune their settings, rather than always using them on full automatic.

4

DIGITAL CAMERA TYPES

There are several types of digital cameras, but almost all can be categorized as follows: **(1)** A digital single-lens reflex (DSLR) is the camera of choice for best results in terms of image control and quality—at a relatively affordable price. **(2)** A point-and-shoot camera is ideal for casual shooting because of its compact size and low price. These cameras are usually designed for full automatic use, but most models offer some manual settings as well. **(3)** A hybrid camera covers the ground between DSLRs and point-and-shoots. Most have interchangeable lenses and may require an additional accessory viewfinder if you don't want to compose through the LCD. **(4)** A medium-format camera produces extra-high-quality results at an extra-high price.

It's widely assumed that any mistake you make in digital capture can be fixed later in postproduction. This is sometimes true, but not always. You'll guarantee best results if you take the picture the way you want it in-camera, then fine-tune it later in post as needed. This goes for technical matters, such as choosing the right settings and photographing in good light, as well as creative choices, such as framing your subject the way you want it.

DSLRs generally have a viewfinder at the top of the camera for composing your subject. The viewfinder is basically a rectangular window that shows you what the lens sees. In order to accomplish through-the-lens viewing, DSLRs use a series of complex mechanisms, described in the box below.

On the back of a DSLR there is an LCD screen used to review the picture once it has been captured. With most DSLRs, you also can view and compose your subject on the screen prior to capture, an option called **live view**, also found on other types of cameras. It's a matter of personal choice whether you compose through the viewfinder or on the LCD.

One good reason to use live view is when you need to hold the camera away from you to take a picture—for example, when lifting it up

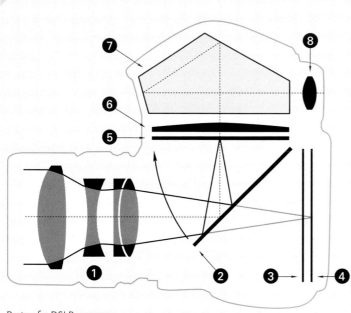

Parts of a DSLR camera
1. Lens
2. Reflex mirror (down position)
3. Focal-plane shutter
4. Image sensor
5. Reflex mirror (up position)
6. Frosted-glass focusing screen
7. Pentaprism
8. Optical viewfinder

DSLR VIEWING

Through-the-lens viewing is one of the key features of a DSLR, because it allows for precise composing and focusing of your subject. The mechanics of DSLR viewing are a little complicated. You can't look directly through the lens, because this would mean looking through the image sensor, which sits right behind the lens in position to capture the image. Through-the-lens viewing is accomplished using a mechanical mirror system to direct light from the lens to an optical viewfinder on the back of the camera, as the accompanying illustration shows.

Light bouncing off the subject travels through the lens and strikes a mirror, positioned at a 45° angle in front of the image sensor. The mirror directs the light upward to a frosted-glass screen. When you look through the camera's viewfinder, you see a reflected image from that screen, with the aid of a pentaprism, a five-sided prism. Ordinarily, a lens turns what it "sees" upside-down and laterally reversed. This mirror-and-prism system turns the subject right side up and orients it correctly for viewing and focusing.

Because you see what the lens sees, DSLR viewing is fairly accurate. However, many DSLR viewfinders crop the edges of the image very slightly. Some professional models will show 100% of what the lens sees, but most models will only show 95% or so.

TIP: TRY USING THE VIEWFINDER

In most DSLRs, you can choose to compose your subject using either the LCD screen (if it has a live-view option) or the viewfinder. If you compose by looking at the screen, you'll have to hold the camera away from you, which can make it unstable and prone to movement during exposure—leading to blurred or unsharp pictures. Try composing through the viewfinder instead, because this allows you to brace the camera against your forehead to steady it.

Put your viewing eye right up against the viewfinder for precise composition. You can't do this if you wear eyeglasses, so try to compose and focus without them, if possible. Most DLSRs have a **diopter** that you can adjust to match the viewfinder to your eyeglasses prescription. The diopter adjustment is usually a dial or slider mechanism located next to the viewfinder. Look through the viewfinder at a focused subject, turn the dial until the scene looks sharpest, and keep that setting locked in whenever you photograph.

to photograph over a crowd. Live view is a drain on the battery, however, so if you're not using it, go to the camera menu and turn it off. Note that autofocus is also slower on most cameras when live view is on than when it is off.

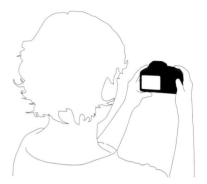

Viewing with the viewfinder Viewing with the LCD

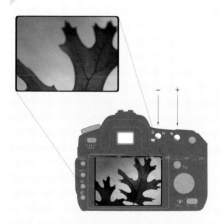

It can be hard to see and evaluate a captured image on an LCD screen. To determine image sharpness, zoom in to the displayed picture. Here, the unzoomed image looks sharp enough, but when you zoom you can see some edge softness.

LOOKING AT THE LCD

When most people take a picture, they immediately look at the camera's LCD screen to review the results. The screen can tell you a lot, for example if you like your subject's expression or if the composition is pleasing. It also may give you a pretty good idea about the exposure—whether the picture is too light or too dark. However, there are better ways to judge exposure, which will be covered later.

The LCD screen has its limitations. First, consider its size. It can be hard to assess technical details even on the largest screens, especially if there is a lot going on in the scene. Sharpness is another matter. It's difficult to tell how well focused an image is from viewing a relatively small display. You can zoom in on the LCD screen to see a portion of the image, allowing you to check for good focus and detail. This can be useful in some cases, but because the screen is small, the results may still be unclear. Besides, zooming in takes time, and can distract you from the task at hand—making good pictures.

The viewing conditions also are an important factor. For example, bright sunlight may make the screen difficult or even impossible to see. Viewing the screen under less direct light, such as in the shade or indoors, should help. In sunlight, you can also block the screen with something, such as your hand or jacket, or move into the shade to examine it; however, it may not always be practical to do so. There also are **viewing hoods** available to block extraneous light from hitting the LCD. They allow for better viewing, but can be cumbersome to use.

Point-and-shoot cameras

Point-and-shoot models are compact in size and designed for simple, automatic use—literally to point at the subject and to shoot the picture. Although capable of very good results, their main advantages are their compact size, simplicity, and affordability. Point-and-shoots are widely used for snapshot pictures, such as celebrations, travel, and other events—and they are handy for taking pictures to post on a web page.

→ *zoom lens, pages 64, 66–68*

Almost all point-and-shoot cameras have a **zoom lens**, allowing you to get a closer or wider view of the subject without physically moving forward or backward. This lens is not interchangeable—it's permanently attached to the camera body.

Most point-and-shoot cameras offer a variety of features that allow them to be modified and customized for greater image control—for example, you can adjust the exposure or turn off the flash. There are even a few point-and-shoots that offer very sophisticated features, such as easier manual controls, higher-quality lenses, better image processors, and larger image sensors. These models are relatively compact and unobtrusive, and professionals and serious hobbyists sometimes use them when they want a quality camera that won't draw attention.

→ *flash off, pages 133–134*

Most point-and-shoots have no viewfinder; they offer LCD viewing only. This can be a plus, because the display shows what the lens will actually capture when the picture is taken.

One often-noted problem with inexpensive point-and-shoot cameras is **shutter lag**—the delay between pressing the shutter button and capturing the image. This delay is brief, but it may cause you to miss the exact moment you had hoped to capture, especially with action or candid photos. Pre-focusing can help reduce or eliminate the lag time. Press the shutter button halfway down to focus on your subject, and hold that position until you see the picture you want to capture. Then, press the button all the way down to take the picture.

Perhaps the most common point-and-shoot is a **cell phone camera**. It provides relatively low picture quality, but it's portable and almost always available. This makes it perfect for photographing at parties, on vacation, and so forth. A cell phone camera also can be a good tool for documentation, for example to show damage if your car is in an accident or to record a newsworthy incident when no journalist is around. And some photographers even use their cell phones to produce their artwork, using the low-quality results as a visual element.

There are many advantages to using a cell phone camera, including the ability to quickly e-mail or text an image. But be careful not to trade convenience for quality. If the picture is important to you, you may

want to use a DSLR, or at least a good hybrid or point-and-shoot camera. Otherwise you may end up with a terrific picture, but disappointing quality—usually a poor trade-off.

Your cell phone is always available for simple snapshots, such as this portrait. There are also many camera apps that allow you more control over your cell phone pictures. This photo was taken on an app that is meant to simulate a Holga, a popular plastic film camera that shoots squares instead of rectangles.
© Allison Carroll

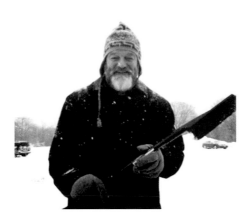

Hybrid cameras

This category covers a few different types—cameras that fall somewhere between DSLRs and point-and-shoots in size, features, price, and quality. Like DSLRs, most hybrids have interchangeable lenses, fairly easy-to-operate manual controls, and no shutter lag. Because of the extra dials and switches on the camera body, you don't have to go into the camera menu as often to change settings the way you do with most point-and-shoots.

Hybrids don't have a reflex mirror or a prism, so you compose your subject on the LCD or in some models by looking through an **electronic viewfinder (EVF)**, usually sold separately, which shows you what the lens sees, but electronically, without mirrors and prisms.

Hybrids are sometimes referred to broadly as **ILCs** (interchangeable lens compacts) or **mirrorless interchangeable lens** cameras. One popular type is the **micro-four-thirds** model. The name comes from the 4:3 **aspect ratio** of the image sensor, which is larger than a point-and-shoot, but smaller than a DSLR. These cameras are compact, relatively affordable, and deliver good-quality results. But the smaller image sensor means these cameras usually produce pictures of somewhat lower quality than DSLRs, particularly in low light.

Aspect ratio expresses the image proportions—the relationship between the width and height (or height and width). Most DSLRs have a rectangular 3:2 aspect ratio, which means that one dimension is one-

REVIEW AND DELETE

A digital camera can record and save every picture you take, using a removable memory card. And one of the key features of digital capture is **autoreview** or **playback**—the ability to look at your picture immediately after you take it, and then choose to save or delete it if you don't like the exposure or your subject's expression or for any reason at all.

Autoreview is usually a default setting, but you can choose to turn it on or off from the camera menu. You also can choose how long you want the reviewed image to stay displayed.

It's common practice to check each picture right after you take it. This provides comfort that you've captured your subject the way you want it. If you don't like the results, you can always reshoot.

Autoreview has some drawbacks—for example, it drains the battery. The longer the display time, the greater the drain. Moreover, autoreview can slow down the picture-taking process, especially if you take the time to delete on the spot. If you continue to photograph without reviewing and deleting, you can work more quickly and more naturally. Consider reviewing only the first few pictures you take to make sure all the settings are properly selected—and that you're generally happy with the composition, exposure, lighting, and so forth. Then freely shoot away, deleting unwanted pictures later.

The ability to delete pictures can be a big advantage of digital capture. By deleting, you save storage space and editing time at the computer later on. However, you may have regrets if you are too quick to delete pictures on the spot. LCD screens are often hard to read, which makes pictures hard to evaluate on-camera, especially in bright light. You may be better off deleting after you've downloaded the pictures to a computer, which has a large monitor and better viewing conditions.

Another reason not to delete too freely is that the content and impact of photographs have a way of changing over time. That "deleted" stranger sitting with your sister may become a friend or brother-in-law years later. That local band you photographed and deleted may become world-famous someday. Or, decades from now, it might be fun to see what your roommate's 2011 Toyota looked like. Storage memory is relatively inexpensive, so consider deleting less often and saving even the marginal pictures.

After you take a picture, the results will show up automatically on the camera's LCD screen. To review other pictures on the memory card, simply push the review button and scroll through, using a control wheel, toggle switch, or whatever method your camera offers.

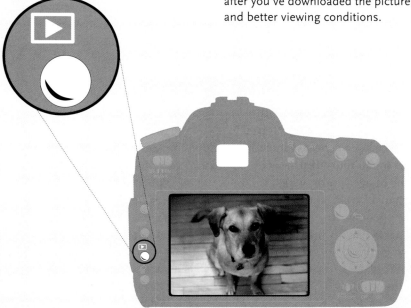

and-one-half times longer than the other. Micro-four-third models have a squarer 4:3 aspect ratio. Your camera may offer a choice, usually 3:2, 4:3, or the wider, HDTV-ready 16:9.

Common aspect ratios include 3:2 (1), 4:3 (2), and 16:9 (3).

1 2 3

Medium-format cameras

These cameras can produce superior quality pictures, mainly because they have the largest image sensors of any camera. Medium-format image sensors are about 50% larger than full-frame DSLRs. The sensor comes built into most medium-format models, or as an accessory called a **digital back** that attaches to the back of the camera.

For the average photographer, the advantages of a medium-format camera are far outweighed by the disadvantages—relatively bulky equipment that is a little slow to operate with a very high price tag. Medium-format cameras can cost about the same as a new car, limiting their use to professional photographers and very well-heeled hobbyists.

Image Sensor

An image sensor is basically a silicon chip positioned inside the camera, behind the lens, that captures light bouncing off a subject and converts that light into digital information. There are many different designs, but the most important factors to consider are the image sensor's pixel count and physical size.

Pixel count

The widely cited benchmark of a digital camera is its image sensor's pixel count, described in **megapixels (MP)**. One megapixel is equal to

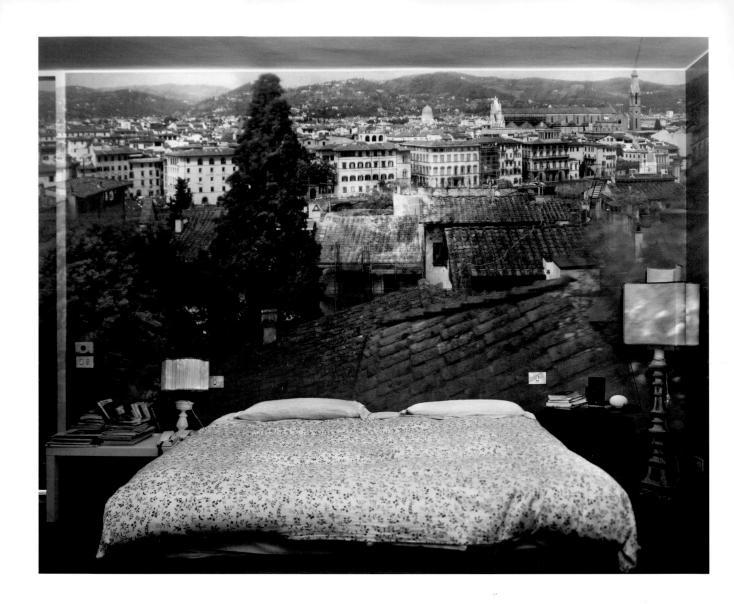

A digital photograph is made up of millions of pixels. © Allison Carroll

HOW IMAGE SENSORS CAPTURE LIGHT

As you might imagine, the way an image sensor captures light is quite complex. And different designs accomplish this in somewhat different ways. But in general terms, here's what commonly happens.

The sensor contains a grid consisting of millions of **photosites**, microscopic sensors arranged by rows and columns. When you take a picture, light traveling through the lens strikes these tiny sensors, which in turn collect and store the light as electronic signals. The individual sensors convert these signals into a number, a digital representation of the intensity and color of the light.

Each photosite produces a single picture element, called a **pixel**. Since the pixels are so tiny—millions of them make up each photograph—they appear to produce a single, continuous image. Enlarging a picture too much can make the individual pixels visible, making a picture look **pixelated**.

An image sensor records light as information. Since highlight (bright) areas reflect more light from the subject, more information is gathered on these areas of the sensor. Shadow (dark) areas of the subject reflect proportionally less light, so less information is gathered on these areas.

Once the subject is captured, the camera's **image processor** turns the digital information into a picture in the form of an **image file**. This happens almost immediately. While the image is processing, the camera also incorporates the settings that you've designated in the camera menu—or the settings your camera has selected for you. This information is noted in what's called **metadata** and includes file format, exposure adjustments, color balance, and so forth—all of which will be explained later. Metadata is embedded in your image files, so you can refer to it anytime you want from when you take the picture to postproduction on the computer and afterwards.

⌐→ *metadata, page 33*

Abelardo Morell, "Camera Obscura: View of Florence Looking Northwest Inside Bedroom, Italy"
Morell's camera obscura images combine Renaissance and modern techniques. He turns a room into a "camera" by darkening it, and then covers the windows with black plastic, leaving a 3/8" (or so) hole in one window. The hole acts as the camera's lens and projects what it sees from outside the room onto the opposite wall. Morell then photographs the projected image with a large-format camera for a high degree of sharpness and image quality. His early photographs were made in black and white on film. Now he often shoots in color with a digital back on his large camera.
www.abelardomorell.net

one million pixels, which means a 21-MP image sensor can capture and process up to 21 million pixels. This capacity can also be described as the amount of pixels that run across the horizontal dimension of an image multiplied by the vertical dimension. For example, a 21-MP sensor can produce images as large as 5616 x 3744 pixels (5616 x 3744 = 21 MP, approximately).

In general, you can assume that more megapixels means a better quality image file because the image sensor can capture more information and detail. Using this logic, a camera with a 21-MP image sensor should produce better results than one with a 10-MP image sensor, but sometimes it does not. Good picture quality depends on factors other than megapixels, including the quality of the pixels and the image processing that happens just after image capture. Probably the most important factor, however, is the physical size of the image sensor.

Dirt and grime on the image sensor show up as marks and spots in the picture. You can eliminate these in postproduction, but it's a lot less work to start with a clean image sensor and clean image files.
© Tom Gearty

CLEANING THE IMAGE SENSOR

Image sensors easily attract dust, hair, dirt, and other unwanted substances that can show up as dark spots on your pictures. These imperfections can be retouched later when editing in postproduction. However, you'll save time and effort by making sure your image sensor is clean before you take your pictures.

You have to be most careful with cameras that have interchangeable lenses, such as DSLRs and hybrid models. Removing and replacing a lens makes the image sensor more vulnerable to outside elements. Some environments are more hazardous than others—for example, the beach. Sand can easily get into your camera and dirty or even scratch the image sensor. Use a plastic bag to protect your camera at the beach or other dodgy environments—keeping the camera bagged, and removing it only when you're actually taking a picture.

Most digital cameras have self-cleaning features. Such automatic cleaning is very useful, but it does not guarantee a spotless image sensor. It may have to be cleaned manually, which you can do (very carefully) if your camera takes interchangeable lenses. Remove the lens and select "clean" from the menu. This will reveal the image sensor so you can go to work on it.

Note that exposing the image sensor makes it very vulnerable to damage, so take extreme care when using any of the do-it-yourself cleaning accessories available. Blowers that put out a mild puff of air are most recommended. And never use **canned air** (compressed air) as the pressure is too strong for the image sensor's fragile surface.

The image sensor attracts dust when it's on, so turn the camera off when switching lenses. And clean with the camera held vertically or with the sensor facedown to reduce the chances of attracting dust.

Cleaning the image sensor yourself is convenient. However, your best bet is professional cleaning, especially when a quick puff of air won't do the job. Many good camera stores and repair shops will do it for you on the spot—at a cost.

TIP: CHECKING FOR DUST

One easy way to see if your image sensor is clean is to take a picture of a light, blank subject—say, a clean, white board or an even blue sky (no clouds)—and check it for unwanted markings. You can check it in dim light from the back of your camera's LCD, but a better method is to upload the image to your computer so you can inspect it on a larger screen to see if it's squeaky clean.

Physical size

Larger image sensors should produce the best results, given equal megapixels and other factors. This is partly because they allow more space for pixels to gather light efficiently. Cramming too many pixels on a small sensor can result in more image noise. If you have 12 MP in a small image sensor, it may not gather light as efficiently as 12 MP in a larger sensor, and the result will be diminished image quality—especially in low-light situations, where an image sensor's ability to capture light is most tested.

The physical size of image sensors varies widely from one camera to another—even among models made by the same manufacturer. Most entry-level and midrange DSLRs have an **APS-C** (also called **DX**) image sensor, which measures about 5/8 x 1 inches. More advanced models

The size of an image sensor varies widely depending on the camera, from full-frame DSLRs to tiny point-and-shoots. Medium-format image sensors are even larger. Here are some approximate image sensor sizes. They will vary from one manufacturer to another:

1. Full-frame 3. Micro-four-thirds

2. APS-C 4. Point-and-shoot

have a larger **full-frame** (also called **FX**) sensor, measuring about 1 x 1 1/2 inches—the same size as a "full frame" 35 mm film image. Point-and-shoots have much smaller image sensors—and they vary quite a bit, depending on the model. For instance, many are about 1/4 x 1/3 inches. The size of the image sensor in most hybrids is in-between a DSLR and point-and-shoot, usually closer to the APS-C size. And medium- and large-format cameras have the largest sensors, as reflected by their high price.

Image Processor

Once you've taken your picture, the information captured by the image sensor must be handled by an **image processor**—a dedicated chip inside the camera linked to the sensor. The image processor has a wide variety of functions. Its most important function is to convert information from the sensor into an image file, which you can see and work with. The most sophisticated image processors produce the best-quality image files—and they do so quickly and with the least amount of digital artifacts.

The image processor not only controls what pictures look like, but it also influences some of your camera's operations. For example, the speed of the image processor affects the rate at which you can take pictures in succession (the **burst rate**) and the time it takes for the camera to pass the image to a memory card.

In addition, the image processor records the metadata of the image. Different camera models record different types of metadata, but most include the following information: date and time the picture was taken, its size, **resolution** (amount of pixels), and exposure settings, and various equipment matters, such as camera model and lens used. Metadata remains embedded in the image file, so you can view it in the camera or on the computer at any time. Keep in mind that the correct time and date must be set in your camera or else that information will be wrong in your image files.

Image noise is probably the most common digital artifact, and appears as random grainlike and textured color specks.

IMAGE NOISE AND OTHER DIGITAL ARTIFACTS

A **digital artifact** is a defect or other unwanted element in a picture that occurs during digital capture or in postproduction. **Image noise** is the most common type and appears as random, grainlike, and textured color specks. You should almost always attempt to avoid image noise and other digital artifacts, though occasionally a grainy look may add to the style or mood of a picture.

Some camera models do a better job of minimizing image noise than others. In particular, cameras with large image sensors are inherently less "noisy" than cameras with small sensors. Therefore, for best results, use a DSLR or hybrid camera rather than a point-and-shoot. Moreover, a full-frame DSLR will produce pictures with even less noise than a DSLR with an APS-C-size image sensor.

There are other factors that affect the amount of noise in your pictures. These will be covered in great detail in future chapters. Briefly, noise is most likely to occur when shooting in low light with a high ISO setting. So, you can minimize noise by shooting in light that's bright enough to allow for a low ISO.

Also, any underexposure, whether in low light or bright light, may produce image noise. Long exposure times may also contribute to increased image noise, though some cameras have settings to reduce noise when making long exposures.

Other types of digital artifacts include pixelation, when individual pixels are overly sharp and visible, **jagged edges** (or **jaggies**), when lines or edges of objects appear serrated, and **posterization**, when gradations of tones or colors appear banded and noncontinuous. These digital artifacts are more likely to occur in postproduction than when taking a picture. More on this in chapter 7.

Setting Up the Camera

Before you begin to photograph, you must be sure your camera is set up to provide the results you want. The manufacturer's default settings should provide good results most of the time. But sometimes they don't. At other times, their "good results" aren't necessarily what you want for your pictures.

Start photographing using the defaults, but adjust the settings as you begin to understand your camera better—and as you figure out what works best for you. There are dozens of options, and they will take a while to learn. You'll find that some of the settings are redundant or simply not that helpful. In practice, many photographers eventually set up their own customized settings for the controls they find most useful.

With less sophisticated models, such as most point-and-shoots, you have to change most of the settings in the camera menu. This is not very convenient, because it usually requires several steps to make your selections. With more sophisticated models, such as DSLRs and most hybrids, many of the important settings are made by pushing a button, toggling a switch, or turning a control wheel conveniently located on the camera body.

To change settings, you'll have to learn the basic **navigation system** of your camera—what buttons or wheels to turn in order to select the options you want. The accompanying illustrations show typical navigation systems, but you should refer to your camera's instruction manual for details.

Of the many possible settings, some of the most important are file format, image size, and white balance. Below is a discussion of these and some other common settings.

To navigate your menu settings, most cameras have a menu button on the back or top of the camera. Push the button to activate the menu and see the available options. Scroll through the options with a control wheel, toggle switch, or arrow buttons, depending on the camera model. Make your selections, and then push the "select" (or "set" or "ok") button to activate the setting.

Some options are not located in the menu, but rather on the camera body for easier navigation. For example, setting the ISO may be done in the menu on most point-and-shoots. But in most DSLRs, you simply push a dedicated button on the camera body to activate the setting, then turn a control wheel to make your choice.

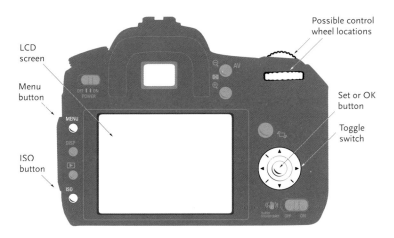

LCD screen

Menu button

ISO button

Possible control wheel locations

Set or OK button

Toggle switch

File format

The file format refers to how data in a digital file is compressed and saved. This tells the computer how to work with that data. There are several file formats available when working with pictures digitally. However, only two are routinely used for digital capture: JPEG and RAW. Most cameras will give you a choice of either format, but simple point-and-shoots may only offer JPEG.

JPEG (Joint Photographic Experts Group) is the most widely used image-file format. With JPEGs, the camera's image processor makes color, contrast, and other basic decisions about the captured picture, and then compresses it to make it smaller, eliminating any unnecessary data based on those decisions.

JPEGs have many advantages. If the picture is well exposed, JPEGs should deliver a good, useable image file most of the time. Furthermore, reduced file size makes for quicker transmission and editing, and also more efficient storage. JPEGs are great for simple uses, such as e-mailing and putting pictures on the web. And they also may make very good prints—but not always.

TIP: COLOR SPACE
In most camera menus, you can choose a **color space**, which is one way to describe how color is represented. The menu choice is generally between Adobe RGB and sRGB. Adobe RGB produces a wider range of colors, and is your best bet if you're planning to make high-quality prints. However, on most cameras sRGB is the default color space, and is generally preferable if you're planning to use your pictures for small, snapshot prints or for posting on the web.

Shooting RAW allows you to put off this and other important decisions until later. This is because RAW files retain all critical image information, so you can adjust them when working on the computer. If you're shooting JPEGs, however, you must set the color space in your camera menu before photographing. More on color space on page 173.

→ *image editing, pages 168–203*

TIP: DOUBLE-CHECK YOUR SETTINGS
Digital cameras offer an incredibly wide range of settings for controlling what your pictures will look like. But it's easy to change settings for a few pictures, and forget to change them back—or, to make changes in your settings by accident.

To avoid this, double-check your settings every time you get ready to photograph. This is a good strategy whether you haven't used your camera for weeks or you've just put it down for a half hour between shots.

The main downside of JPEGs is that information lost during compression can't be recovered. This means you have less information to work with, therefore less flexibility in postproduction—which could be a concern when trying to make prints of the highest quality and size with the greatest amount of control. Note that saved JPEGs are assigned the file extension (suffix) **.jpg**—as in, allisonparty.jpg.

RAW is an information-rich file format which uses **lossless** compression. This means that the "raw" picture data captured by the sensor is kept intact—not lost—even if it's somewhat compressed. Unlike JPEGs, where the image processor locks in color, contrast, and other characteristic adjustments, with RAW, you make these choices yourself in postproduction.

RAW is the purest form of digital capture, providing large-size image files and much more to work with in postproduction—more flexibility, more control, and better image quality. If you want to make the best possible prints with the most control, shoot in RAW.

Because they contain so much information, RAW image files are much larger than JPEGs and relatively slow to process, download, and adjust on the computer. They also take up significantly more storage space.

RAW files are proprietary, which means that one camera maker's RAW formatting will be slightly different from another's. Even different camera models from the same manufacturer may use slightly different versions of RAW. This becomes an issue in postproduction, because you'll have to use image-editing software compatible with the RAW format your camera delivers. More on this later.

RAW files are identified by the file extension (suffix) associated with the camera you used to take the picture. So, if you shoot RAW with a Canon camera, the extension would be **.cr2**—as in IMG_0213.cr2. If you shoot with a Nikon camera, the extension will be **.nef**; with an Olympus, **.orf**; and so forth.

There are other file formats worth mentioning. These are sometimes available in digital capture, but mostly they are used in postproduction. **DNG** (digital negative) is a standardized RAW file format, which is uncompressed, information rich, and flexible. Unlike other RAW formats, DNG files are not proprietary. They are meant to be stable and widely compatible, and use the file extension **.dng**.

TIFF (Tagged Image File Format) is another information-rich file format, commonly a shooting option only in medium- and large-format cameras and a few professional DSLRs. TIFFs are widely used in postproduction. They use **.tif** as an extension.

In your camera menu, you can choose your file format—usually JPEG or RAW or both. You can also choose the size and compression level of the JPEG file—from large to small and lower to higher compression. In camera menus, JPEG is often represented by the sloping symbol ◢L. Here, the shape of the slope changes to indicate the level of compression—the jagged symbol means it will be more compressed and the rounder symbol means it will be less and retain more information. The L, M, and S indicate the size that the JPEG will be—large, medium, or small.

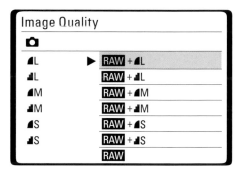

Image size

You can generally set the maximum size of your final image file in the camera menu, as you choose the file format. Most cameras offer a choice of small, medium, or large JPEGs. And many give you the option to choose the level of compression for each size—always choose the largest file size (lowest amount of compression) that you can. Some cameras offer even more choices, maybe five or six JPEG sizes, for example.

Small JPEGs allow you to capture many more pictures on your memory card. They also get recorded and processed faster than large JPEGs—and they are quicker to transfer and work on later in postproduction—or just to send in an e-mail. But be careful. In the future, you may regret that you have only a small file to work with—say, if you decide to make a large-format print of a picture. Almost always, you should set your camera to the largest image size offered. You can always reduce the image size later in postproduction, and not lose quality. Increasing it later is more dicey.

→ *large-format print, page 215*

For RAW image capture, you usually have a choice of one RAW size. But more advanced cameras may offer more than one choice. And most cameras allow you to record both a RAW and a JPEG file at the same time (RAW + JPEG). Having two versions is useful if you want to share your pictures quickly via e-mail after capture but also retain complete image information.

White balance

→ *light and color, pages 129–131*

Light has a strong effect on the color of your picture. Some light is neutral, without a noticeable color bias, whereas other light has a warm (yellow/orange) or cool (blue) cast. Most fluorescent lights produce a green cast, while tungsten lights are yellow-orange.

Your camera menu has a **white-balance** setting that allows you to match your image sensor to the color of your subject lighting in order to produce a picture with neutral color—or even "unmatch" it to produce

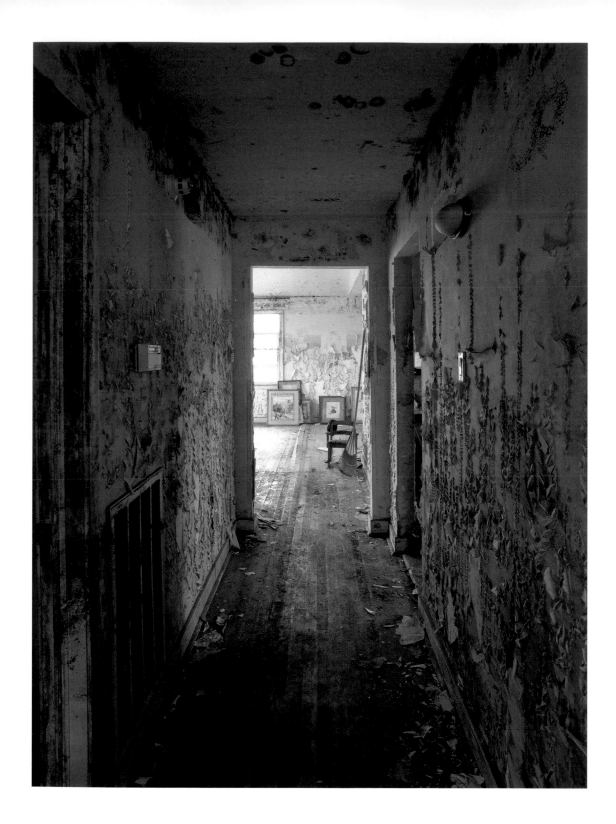

BIT DEPTH

Bit depth also (called **color depth**) generally refers to the amount of color information in an image file. The bit depth establishes how many colors the image can contain—the greater the bit depth, the broader the potential range of color.

In digital capture, the image sensor and the image processor determine the bit depth of your image file. More sophisticated cameras can generally produce files with greater bit depth than simpler models.

Bit depth is measured in bits, as in an 8-bit, 14-bit, 16-bit, or 32-bit file. A bit is a basic unit of measurement describing the smallest unit of computer data. Eight bits equal one byte; one million bytes equal one megabyte (MB); one thousand megabytes equals a gigabyte (GB).

Looking at an 8-bit image file versus a 16-bit image file, you probably won't see much of a difference. In fact, you may never actually see any difference between an image file of one bit depth or another. But your computer can tell the difference when you're working in postproduction. More bit depth gives your software more information to work with, which can help you when adjusting image color and tonality.

color that is deliberately off. The default menu setting is **auto white balance (AWB)**, which is the easiest way to achieve balanced color. Set at AWB, the camera will evaluate the light and make a white-balance setting for you.

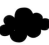

Sunlight Cloudy Tungsten Fluorescent light Flash

These are typical white-balance icons you'll find in the camera menu. With household bulbs lighting a scene, select "tungsten." On an overcast day, select "cloudy."

Most of the time, AWB will produce neutral color—or close to it. However, cameras typically offer a number of different white-balance settings that allow you to control the color more precisely. These settings are generally indicated with icons representing the dominant light source. For example, if you're photographing indoors with standard household bulbs, select the lightbulb icon in your camera's menu to make the warm tungsten light appear cooler and more neutral.

One easy way to neutralize the color in-camera is with **custom white balance**. Under the same light where you're going to photograph, locate a white wall or use a piece of white cardboard. Go into your camera's menu and choose the "custom white balance" option. Point your camera at the wall or cardboard and select it to tell the camera to read it. Then, the camera will evaluate the light and set the white balance for you.

Much is made of the need to set accurate white balance, but some photographers prefer to let the subject lighting define the color, rather than trying to neutralize it. Off-balance color often works well to emphasize mood or atmosphere or simply to best reflect what the color was like when the picture was taken.

John Woodin, "Memphis Street," New Orleans, Louisiana
Woodin is a landscape and still-life photographer whose work exploring Hurricane Katrina provides a dramatic example of culture and chaos coming together. Woodin had photographed the neighborhoods of New Orleans, his hometown, one year before Katrina struck, then returned after the hurricane to see the destruction it had caused. The resulting photographs, from his book *City of Memory: New Orleans Before and After Katrina*, documented a tragically altered landscape with pictures that show a certain grace and calm within the chaos.

Woodin set his medium-format digital camera to record in RAW. The combination of a large image sensor and RAW capture helped him reveal all the detail possible, from the deep shadows of the darkened hallway to the bright highlights of the room in back. *www.johnwoodin.com*

You can even deliberately unbalance the light by choosing the "wrong" icon. For example, to make late afternoon light even warmer, choose a daylight icon—either the sunlight setting or the cloudy setting.

Choosing to balance the color in-camera, before you photograph, slows down the picture-taking process. However, it's usually the best guarantee of good results—and it saves time in postproduction. White-balance adjustments in the computer are usually simple enough, but sometimes they can be time consuming and challenging or even impossible—especially if the subject has an extra-strong color bias. Still, a lot of photographers simply use AWB, preferring not to adjust white balance in-camera, but to worry about it later in postproduction.

The color of a photograph can look very different depending on the color of the light source. Ideally, you'll want to set a white balance to match the light you are photographing in. But sometimes "inaccurate" color actually works just fine, as in this shot of a parking lot in Branson, Missouri, depicting American icons John Wayne, Elvis Presley, Marilyn Monroe, and Charlie Chaplin. The lot is lit by vapor lighting, similar to that used by streetlights, and the color is a little odd, adding to the kitschy nature of the picture.

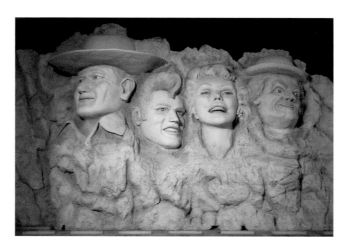

Miscellaneous camera settings

Various buttons, toggles, and switches on your camera offer you dozens of ways to control your pictures. And for further control, you can go into the camera menu and make any number of settings. Some you'll use all the time, and others you'll use only on occasion. And there are many more you'll never use at all.

Here is a short summary of the most common camera settings. Keep in mind that not all cameras offer all these controls—and some may use different terms for them, or offer totally different settings instead. And these settings are not always found in the same place on all cameras. For example, on most DSLRs, MF (manual focus) is set on the camera's lens—but on point-and-shoot models it's set in the camera menu.

AE lock. Lock in autoexposure.

AF. Activate autofocus.

TIP: BLACK-AND-WHITE CAPTURE

Most photographers make pictures in color, but some prefer traditional black and white, feeling it's more timeless, abstract, vintage, or even more "artistic." Whatever your reasons, you can set your camera menu for black-and-white capture. That way you won't have to convert from color in postproduction. Some photographers simply prefer to compose a scene the way they will eventually display it, so if they plan to print black and white, they like to shoot the same way.

If you're shooting in RAW, you can turn on your camera's black-and-white mode and this will give you black-and-white viewing, but your RAW files will still retain all the color information in the scene—just in case you change your mind and want color at a later date. If you shoot JPEGs instead, your image files will be black and white only, retaining no color information.

You can also choose to shoot normally in color and convert to black and white later in postproduction. This way you leave the option open to make your files—either JPEG or RAW—black and white at any time in the future.

AF lock. Lock in autofocus.

Aspect ratio. Select image proportions.

Autoexposure compensation. Make incremental adjustments in camera exposure, so your captured pictures become overall lighter or darker.

Autoreview. Play back the just-captured picture automatically every time a picture is taken.

Backlight. Provide additional exposure to compensate for backlit subjects.

Black and white. Allows you to make your pictures in black and white, rather than color.

Clock/date. Set the time and date on the camera.

Delete. Erase a single image, or all images, from your memory card.

Display brightness. Make the camera's LCD display lighter or darker for better viewing (brighter screen) or battery savings (darker screen).

Exposure mode. Choose from a wide variety of automatic, semiautomatic, and manual exposure options.

File format. Choose from JPEG or RAW formats.

Flash. Select from a variety of flash options, or turn off the flash.

Format. Erase your memory card entirely, and set it up to take more pictures.

Frames per second (fps). Choose from taking one picture at a time to several per second.

F-Stop. Select the size of the lens aperture (opening) when in aperture-priority or manual-exposure mode.

Histogram. Turn on a graph that maps exposure in a captured image.

Image size. Select how large or small you want your image file to be.

Image stabilization. Activate stabilizing mode to reduce camera/lens shake.

ISO. Control the image sensor's sensitivity to light.

Live view. Activate a preview of what the camera sees before you take the picture.

Macro. Set the lens for focusing close.

MF. Activate manual focus.

Review. Play back captured images manually.

Saturation. Adjust the overall color richness.

Self-timer. Activate a time delay of several seconds between pushing the shutter button and taking the picture.

Sensor cleaning. Begin automated cleaning procedure.

→ *shutter speed, pages 81–85*

Shutter speed. Set the exposure time.

Video. Turn your still camera into a video camera to capture moving pictures.

→ *color temperature, pages 129–130*

White balance. Adjust image color according to the color temperature of the light.

Zoom. Adjust the lens focal length for closer or wider views.

Memory Cards

Digital cameras use a **memory card** to record and store pictures. These small cards are removable and reusable devices which fit into a slot in the camera body. When the image sensor captures the picture, the camera processes it and creates an image file. Then, that image file is transferred onto the memory card.

In theory, pictures can remain on a memory card for an unlimited period of time, but in practice they should be downloaded to a hard drive, either your computer's or an external unit (or preferably both), as soon as possible. This frees up the memory cards so you can reuse them. It also makes pictures easier to organize and manage.

You can download directly from the camera, usually via a cable linking your camera to a computer, or better still with an accessory memory card reader. This device plugs into your computer, and may have several slots for reading different kinds of memory cards. Some computers have a memory card reader built in; you just put the card in a slot and proceed to download the image files.

There also are a multitude of kiosks at drugstores and other locations, as well as some models of printers, portable storage units, and other devices that incorporate a slot for the memory card. These provide direct access to images on the card, bypassing your computer altogether.

Memory cards are versatile and fairly economical. You can photograph until the card is almost full—it's generally best not to fill it entirely—or you can remove a card safely at any time. And you can choose to delete some, or all, of the images, then reuse the card indefinitely—or at least until it becomes corrupted or outmoded.

There are many varieties of memory cards, made by brand-name and off-brand manufacturers. The main ways to distinguish one from another are by the type, capacity, and speed of the card.

Memory cards come in two main types—compact flash (CF) and secure digital (SD).

Many computers have a built-in memory card reader. External models have slots for different kinds of cards and connect to a computer by means of a cable. To minimize transfer time, get the fastest reader you can—for example, a high-speed USB model.

Built-in
card reader

TIP: BACK UP RIGHT AWAY

It's your worst nightmare to find memory cards corrupted or storage drives crashed. Back up your pictures obsessively—and as soon as possible after you've taken them. A good strategy is to download pictures from your memory card to your computer, then copy those image files again to an external hard drive (or other storage unit). It's even better to have two or three backup hard drives, stored in different locations. But however you back up, do it right after you photograph, and do it as often as needed.

Format

Format card
All data will be lost!

1.86 GB used 1.89 GB

Cancel OK

DELETING OR FORMATTING

There are two ways to remove pictures from a memory card. You can delete them one by one, or all of them at one stroke. Or, you can format the card. Formatting removes all the pictures. It can be accomplished in-camera or on the computer. Formatting must take place in-camera by going into the camera menu.

Part of the reason for formatting is to make sure that the memory card is set up to your specific camera's standards. So, you should format all new memory cards, but you should also format all cards periodically. You should especially format when using a memory card with a different camera than it was originally formatted for. Doing so makes sure that the card is optimized for your camera, and improves its overall performance.

Before deleting all the pictures on a card or formatting it, make sure they are backed up elsewhere, either to a computer, external hard drive, or some other backup media. In fact, it's a good idea to wait to delete or format until you have two or more backups of all your pictures—just in case.

Type

You must use the memory card that fits your camera. Cards come in a variety of types, but the most common are **secure digital (SD)** and **compact flash (CF)**. Most cameras take only one type, though a few take two. There are also variations of each card type. For example, SDHC and SDXC are SD variants that provide expanded storage capacity.

Capacity

The capacity of a memory card refers to the amount of information (in short, how many pictures) a card can hold. For example, a 2-GB card holds 2 GB of information—a relatively small capacity compared to a 16-GB card, which can hold eight times as many pictures. GB stands for gigabytes, or one million bytes of information.

The maximum number of pictures a memory card can hold depends on many factors, such as the file format and image size and the camera's megapixel rating. Cameras with higher megapixel ratings will create larger files. RAW files take up more memory than JPEGs, and less compressed JPEGs take up more memory than highly compressed JPEGs.

Speed

Memory cards are rated according to their speed, or **data-transfer rate**—indicating how many bytes of information per second the card can handle. Memory cards with a high data-transfer rate are sometimes called **fast** cards. SD cards come in different classes—the higher the class, the faster the card. Some cards are labeled with their maximum MB/s rate, or by a number followed by an x, like 600x. The higher the number, the faster the card.

What's most important is that the higher the transfer rate, the more quickly the card runs. This affects matters such as how fast a card captures pictures. So you'll want a high transfer rate when photographing action subjects, such as sports or children playing. It also affects how fast the card can transfer pictures to a computer.

A fast memory card can be very useful, and even necessary, when you need to handle large amounts of data quickly—for example, when using a camera with a full-frame image sensor and a high-megapixel count or when taking pictures in rapid succession. Shooting RAW makes a fast card even more important, because the image files are so large.

Miscellaneous Capture Equipment

There are several camera accessories that might prove useful to you when photographing. Probably the most important camera accessory is a tripod. This will be discussed in detail later. Following are quick summaries of some of the other most widely used camera accessories.

→ *tripod, pages 91–93*

Extra memory cards

Memory cards are small and don't take up much room. Extra cards help guarantee you'll have more than enough space to record and store

TIP: THINK SMALL
There is a pretty good chance a memory card will fail or get lost at some point. For these reasons, it's safest to use multiple cards with a relatively small capacity than one with a large capacity—say a few 2- or 4-GB cards, instead of one 16- or 32-GB card. This practice is good protection against loss or failure. If a card disappears or fails, you'll lose fewer pictures.

Portable storage units are used for copying pictures directly from a memory card and storing them. This model has slots for the cards and a display so you can see what you have without attaching a computer.

This camera backpack carries a lot of equipment and distributes weight evenly for easier portability. But it's not especially convenient in use, as you have to take it off to get your things.

your captured pictures. It's good practice to have several memory cards available when shooting, preferably contained in a secure, waterproof case. You may need additional cards due to damage or loss—or if you have a particularly productive day photographing.

Extra camera battery

A dead battery inevitably leads to lost picture opportunities. You should always recharge your batteries before going out to photograph, and having a charged backup battery will guarantee you won't miss any pictures. While you're at it, owning an extra battery charger can't hurt, since a charger is easy to lose, and not always easy to procure when you most need it.

Portable storage units

These small hard drives have a memory card reader built in, and most have a screen for viewing what's on the card or on the drive. Convenience is the main reason to use a portable storage unit. It allows you to download and view your images without a computer, which is especially useful when photographing away from home. But you pay a price for the privilege. A standard portable hard drive is a lot more affordable, and works just as well when linked to a computer and memory card reader. If you use a hard drive for portable storage, get one that runs off computer power, so it doesn't have to be plugged in.

Camera bags, cases, and straps

A wide variety of camera bags and cases are available for protecting and carrying cameras and other equipment. You may want a case made specifically to fit your camera, but you should definitely have a bag to hold all the equipment you bring when photographing—camera, extra lenses, memory cards, and other accessories.

A soft, padded **camera wrap** is handy for protecting individual pieces of equipment. The cloth is easy to wrap and unwrap, and closes tightly with Velcro. Consider a deep-pocketed **camera vest**, instead of a bag, for more maneuverability and to allow you to spread out the weight you're carrying.

Most cameras come packaged with a **strap**, but you may want one that's more heavy-duty, versatile, or even fashionable. Whichever one you decide to go with, make sure it's strong enough to hold your camera securely and comfortably.

A viewing hood fits around the LCD screen and blocks light, making the screen easier to view.

Canned air (1) and a rubber air blower (2) are two cleaning tools that essentially do the same thing—blow dust and dirt off a camera or lens.

Viewing hoods

These gadgets fit around the LCD viewing screen to block extraneous light that can make the screen hard to read. There are many types, and usually they are made for specific camera models. A hood works well, but it may be slow and awkward to use, as you have to take it on and off the screen for shooting and viewing.

There are also many other viewing accessories, such as **loupes** that magnify the screen image, rubber eyecups that fit around the viewfinder and protective caps and skins for the LCD screen.

Cleaning materials

There are a variety of materials available to help keep the outside of your camera clean. Cleaning the image sensor is another matter, and covered in detail earlier in this chapter.

For the camera, an **antistatic cloth** is a good choice. Use it dry, or very slightly dampened, to wipe down the outside surface. Be careful to keep the cloth clean. Storing it in a plastic bag between uses is probably the simplest way to do this. Don't clean your lens glass this way, though. There are special wipes and liquids made for lens cleaning.

Canned (compressed) air also will do the trick. Simply use it to blow off dust from the various parts of the camera—but never inside, as the pressure can damage delicate parts. There are also rubber blowers that allow you to do the same thing manually, but with less air pressure. Note that tilted or shaken canned air can emit a harmful chemical propellant; hold the can vertically at all times and don't shake it. Avoid using canned air on any equipment that might be easily damaged.

The best way to keep a camera clean is to keep it stored in a clean environment, protected in a case. You might consider wrapping your camera in a sturdy plastic bag when not in use—to keep out the elements—and even when you go out to photograph in dusty, dirty, sandy, or wet conditions, such as at the beach.

Troubleshooting

There are many problems you might encounter when photographing with your digital camera. It's always possible that your camera is simply broken and needs repair. But these are a few common problems that are more easily solvable—and some suggested solutions:

Problem	Solution
Camera won't turn on.	1. Check and possibly recharge/replace your battery. 2. Remove your battery and then put it back and try again.
Camera won't take pictures.	1. Make sure your camera has a formatted memory card. 2. Check to see if your memory card is full. 3. If you are close up, move back a bit so the camera can better focus and fire.
Camera is running through battery power too quickly.	1. Get a new battery. 2. Turn off live view. 3. Don't use the on-camera flash. Consider using a battery-powered portable unit instead.
Computer won't recognize your camera when you connect it to download your pictures.	1. Make sure your camera is turned on. 2. Connect the camera to AC power, if your camera allows for it. 3. In some cases, you may need to update software (or firmware). 4. You may need to set your camera to PC-connect or some other setting to make the connection with your computer. 5. Use a memory card reader.
It takes too long for the captured images to show up on your camera's LCD.	1. Use a faster memory card. 2. Shoot more slowly—not in rapid succession. 3. Use a camera with a faster image processor.
It's hard to see the image on the LCD screen.	1. Use the viewfinder, if your camera has one, rather than the LCD screen, when taking pictures. 2. Use an accessory hood around the LCD screen to block out ambient light when viewing pictures. 3. Turn up the brightness level of your LCD in the camera menu. 4. View the screen in reduced light, such as shade or indoors.
Noisy image quality.	1. Reshoot with lower ISO. 2. Use a DSLR or a camera with a larger image sensor than the one you're using. 3. Make a longer exposure.

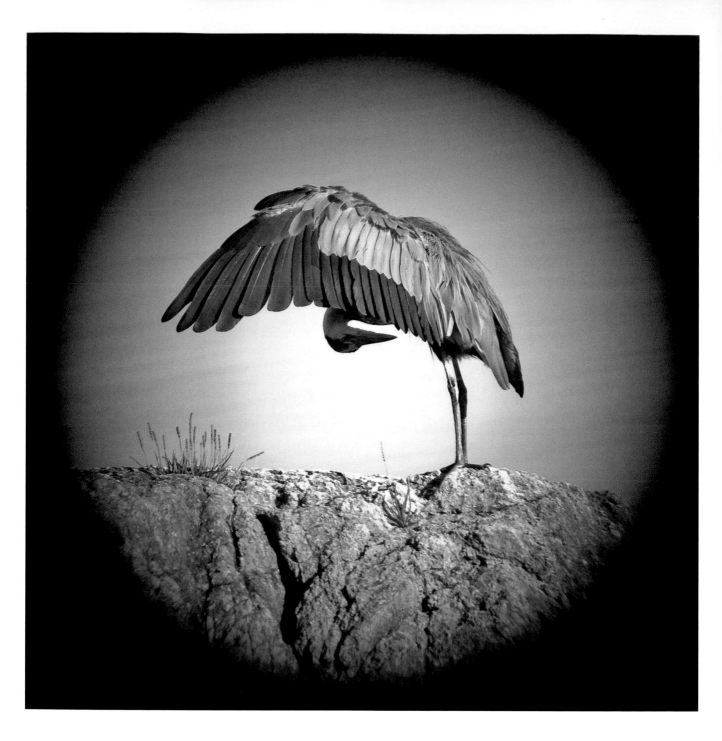

Chapter 2
Camera Lens

→ *depth of field, pages 69–73*

Jeannie Pearce, "Heron Wings"
Pearce is a compulsive collector, and in her *Birding Series*, Pearce uses a nontraditional telephoto approach to "collect" her bird-watching images. She positions the front of the digital camera's lens up against the eyepiece of a telescope to take her pictures. The technique produces a circular black border and also creates softness and other image distortions on the edges of the round frame. Pearce says, "Birds have been omnipresent in myths, fairy tales and symbolism and are icons for present environmental concerns. Using a telescope amplifies the power to observe, intensifies the detail, and invites a sort of voyeurism. For me, these images are ironic and humorous." *www.jeanniepearce.com*

The camera **lens** is an array of optics, called **lens elements**, in a barrel-shaped package, positioned on the front of the camera body. The most obvious thing a lens does is **focus** the subject—it makes it sharp, rather than blurry. A lens also controls the amount of light that gets through to expose the image sensor, determines how much of the subject will be included in the picture, and establishes **depth of field**—how deep the focus goes—from a scene's foreground to background.

Point-and-shoot cameras have a single lens permanently attached to the camera body. DSLRs and hybrids have **interchangeable lenses**, which allow for a great deal of creative control. You can remove one lens from the camera body and replace it with another for a wide range of uses. For instance, you can switch to a lens that's better in low-light situations, for working close up, or for photographing distant subjects.

When changing lenses, make sure the lens and camera are compatible. A lens from one camera manufacturer rarely fits a camera from another manufacturer. There are independent lens makers that produce excellent-quality and affordable lenses for a variety of different cameras, but even these are made for specific models.

Some older lenses made for film cameras may produce good results with your digital camera. However, newer lenses are optimized for digital capture and should produce better results. Also, older lenses may not allow you to use certain automatic controls on your DSLR (and in rare cases, may fit the camera but cause damage to its innards).

Regardless of type, all lenses control or affect these four basic functions: focus, exposure, angle of view, and depth of field.

Interchangeable DSLR lenses come in a wide variety of sizes and shapes for different purposes.

→ *manual focus, page 53*

There are several focus points spread out throughout the viewfinder to help autofocus systems determine accurate focus. But you may also decide to set a single focus point.

Focus

A lens gathers light rays reflected off the subject and focuses them on the image sensor. The lens elements are arranged to produce maximum image sharpness, contrast, and quality from edge to edge. But you don't have to understand optics to focus your lens. On nearly all cameras, focusing is simple, intuitive, and usually automatic—although you can also choose to focus manually.

Autofocus

Digital cameras feature **automatic focus (AF)**, usually called **autofocus**, in which the camera and lens work together to achieve a sharp image. Simply point the lens, frame the subject, and press the shutter button halfway down to catch focus. You'll see a small red or green light or some other indicator in the viewfinder or on the LCD, which indicates that the subject is in sharp focus. You also may hear a beep when focus catches, as most cameras have an audible option (which can be switched on or off). Once focus is set, press the shutter button all the way down to take the picture.

In autofocus mode, the camera will generally not take a picture unless something is locked in focus. However, you can set the camera for **shutter release lock** to release the shutter so it will fire anytime, or **continuous** to focus on moving subjects.

Autofocus systems in DSLRs use an array of **focus points** in the viewfinder, to determine what to focus on. The camera uses all the focus points at once, unless you set it otherwise. This works well for most situations, but there are times when you may want more control. At such times, select a specific point (or points) to catch focus. For example, if you want your focused subject to be on the edge of a picture frame, you might set a single focus point so it will focus only on that side.

If your main subject (the eye) is in the middle of the frame (1), you can select the focus point in the center of the viewfinder to achieve critical focus. But if your subject is on the side of the frame (2), you can select a focus point that will target that area.

1

2

Autofocus systems are quick and reliable in most cases, but there are times when they don't work well—or even fail completely. Put simply, autofocus relies on the contrast of a subject to set the focus, as well as its edges, differences in distance, and sometimes even color. When it can't detect any of these things, autofocus may well miss its mark. That's when it's time to switch to manual focus.

Following are some of the most common situations where autofocus might fail.

The focus point can miss its target when you have two (or more) main subjects, say a portrait of two people with one standing close to the

CONTINUOUS AUTOFOCUS

Subjects in action can move out of focus after you autofocus and before you take a picture. To deal with this, choose **continuous autofocus** or **AI servo focus** on your camera body or in the menu.

In this autofocus mode, the lens keeps focusing until you take the picture, as long as you keep the shutter button pressed halfway down (while focusing) or all the way down (while shooting). This will vary depending on your camera, so check your manual for specifics.

Continuous autofocus is useful when photographing virtually any moving subject. However, it's especially handy when shooting sports and wildlife—or domestic animals, for that matter. But watch out or you may end up with out-of-focus pictures. This is because the camera will fire whenever the shutter button is pressed all the way down—whether the subject is in focus or not.

With most DSLRs and some hybrids, you set automatic or manual focus by sliding a switch to choose AF to MF. With point-and-shoots, you'll have to go into the camera menu to set your focusing preference.

In the two images on the right, autofocusing missed the target and focused too close—on the fence, rather than on the bird (1). By using manual focus, you guarantee that your focus lands where you want it—on the bird (2).

1

2

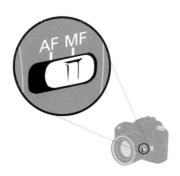

Photographing a mannequin through a store window can be a challenge, as autofocus may target the window, rather than what's behind it. Manual focus can help solve the problem.

camera and one further away. The autofocus point (or points) may land on the person in front, when you actually want to focus on the person that is further away. Cameras with a broad array of focus points should catch focus anyway, but you can't always count on it. And if you have set a single focus point, there's a chance you'll end up with focus falling in the wrong place.

Low light can sometimes cause a lens to move in and out in autofocus mode, as it searches, say, for contrasting elements to help it catch focus. You can use manual focus if you can see the darkened subject clearly enough. Or, if your camera has **autofocus assist**, a feature that throws out a beam of colored light to illuminate the subject for focusing, you can try that. While autofocus assist usually works, the light can draw attention, which is not ideal when you don't want people to know you're photographing, such as in a darkened theater. You can turn autofocus assist on and off in the camera menu.

Reflective surfaces, such as mirrors, chrome, or glass can confuse autofocus. The lens will search for contrast without being able to find it. You can get around this problem by manually focusing on the reflective surface, or past it—if your subject is positioned behind glass.

Another way to focus on reflective surfaces is to autofocus on a substitute subject the same distance away. For example, if your subject is a mirror in a frame, focus on the frame, hold the shutter button halfway down to lock focus, and then recompose to take a picture of the mirror.

Snow, sand, and sky all lack inherent contrast, sometimes making it difficult to autofocus. Search for a tree sticking out of the snow, shells in the sand, or clouds in the sky—any subject that has enough contrast to allow autofocus to work successfully. Or focus manually, if in doubt.

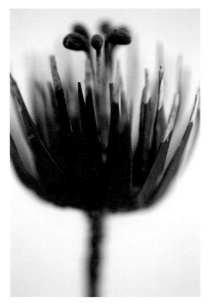

Manual focus is especially useful with close-up subjects, which can be difficult to autofocus. In a subject like this, you'll know better than the lens what part of the subject you want sharp.

Close-up subjects can also cause autofocus systems to miss their mark. You may find that the lens moves in and out, searching for focus. Again, the best strategy is manual focus. One way to make sure you are focused as close as possible is to turn the focusing ring to the closest (or near closest) focus the lens allows, then physically move yourself (and camera) toward or away from the subject slowly, until it appears sharp.

Manual focus

Another option is manual focus (MF), where you focus the lens yourself. Some photographers feel this gives them more control and precision than autofocus. It's a matter of individual preference.

With DSLRs and hybrids, manual focus is intuitive. You slowly turn a ring on the lens until you see the subject get sharp. Manual focus is usually slower than autofocus, but it's arguably less complicated. For instance, there's no need to select focus points. Also, there are some scenes where autofocus simply does not work well. In these cases, manual focus may be your best option.

Note that manual focus is rarely practical with point-and-shoots. With some models, you can go into the camera menu and choose manual focus, if you like. But in many cases you can't do more than set an estimated focusing distance, as point-and-shoot viewing doesn't actually show an image going in and out of focus.

ADVANTAGES OF HIGH-QUALITY LENSES

You can make good pictures with most lenses, assuming you focus well, hold the camera steady, and make accurate exposures. Many other factors also contribute, such as the quality of your image sensor and image processor, and your postproduction work.

However, good-quality lenses can make a difference. Lens quality varies widely from one manufacturer to another—and also within the offerings of each manufacturer. Many companies offer both entry-level and professional-level lenses. You can tell the difference by reading the specifications and user reviews, or by price—the best lenses are almost always more expensive. Here are some of the advantages you might expect from the highest-quality lenses:

– Wider maximum apertures
– Less **flare** (scattered and reflected light) and other image defects
– Faster autofocus
– Better and more even (edge-to-edge) image sharpness
– More contrast
– Better color saturation
– More rugged construction

Exposure

All lenses have an **aperture**, an opening created by a series of overlapping blades. The lens aperture is adjustable to allow varying amounts of light to reach the image sensor. Making the lens aperture larger ("opening up") allows a lot of light in, whereas making it smaller ("closing down") lets in less light. You can allow the camera to select the lens aperture automatically, or you can adjust it manually.

The amount of light reaching the image sensor is called the **exposure**, and the lens aperture is only one of several factors in determining that exposure. The others are subject lighting, shutter speed, and ISO.

You'll need a relatively large lens opening for good exposure when photographing in low light, and a relatively small lens aperture in bright light. **F-stop** is a measurement of the size of a lens aperture—and how much light it allows through. All cameras offer a wide range of f-stops. The range is somewhat variable from one lens to another, but these f-stops are commonly available:

→ *subject lighting, pages 124–151*
→ *shutter speed, pages 81–85*
→ *ISO, pages 98, 100–101*

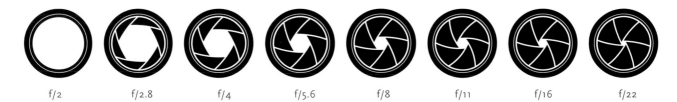

| f/2 | f/2.8 | f/4 | f/5.6 | f/8 | f/11 | f/16 | f/22 |

A lens aperture is an adjustable opening that lets light through to expose the image sensor. Small f-stop numbers indicate large lens openings, which allow a lot of light to pass through. Higher f-stop numbers indicate smaller openings and less light.

→ *stops, page 98*

Not all lenses offer this wide a range, particularly at the widest openings. For instance, the widest aperture on some lenses is f/1.4, whereas others start at f/4. And some lenses offer very small openings, such as f/32.

F-stop numbers are counterintuitive in describing the lens aperture: the higher the number, the smaller the opening. Thus f/16 lets in much less light than f/4. And f/5.6 lets in much more light than f/22.

Note that sometimes f-stops are simply referred to as **stops**. Other exposure factors, notably shutter speed and ISO, are also sometimes described as stops. More on this later.

The f-stops listed above, sometimes known as **whole f-stops** or **full f-stops**, have a specific relationship to each other, which is critical to understanding exposure and how to control it. Changing the lens aperture from one whole f-stop to another halves or doubles the amount

A fast lens comes in handy in low-light situations to capture enough light for good exposure, and also to freeze moving subjects. Note that opening a lens to its maximum aperture produces shallow depth of field—here, the musician is in focus and the fan blurred.

→ *supplementary lighting,*
pages 131–151

→ *image noise and ISO,*
pages 100–101

of light the lens lets through. Thus, changing from a lens aperture of f/8 to f/11 lets in half as much light, whereas changing from f/8 to f/5.6 lets in twice the light. Closing the lens aperture by two f-stops, from f/8 to f/16, reduces the light to one-fourth, whereas opening the lens from f/8 to f/4 allows in four times the amount of light.

This half-double relationship applies to the whole f-stops previously listed, but these are not the only available openings. A lens can be set at a **partial f-stop**—one that's in-between two whole f-stops. For example, f/6.7 is halfway between f/5.6 and f/8, and is referred to as a **half stop**. F/6.3 and f/7.1 are the **third-stop** intervals between f/5.6 and f/8.

Some cameras allow you to set in-between increments in half-stops, while others allow you to choose third-stop increments. And there are cameras that let you choose either. You'll find a list of full, half, and third f-stop choices on the next page.

Note that a lens is often described according to its widest f-stop, called the **maximum lens aperture**. One lens might be called an "f/2 lens" because it can open as wide as f/2, whereas another lens might be called an "f/4.5 lens" because it can only open as wide as f/4.5.

Lenses with a large maximum aperture are best for photographing in low light. They can open wide when you most need it, such as outdoors at night or indoors without flash (or other supplementary lighting). Such lenses are often called **fast lenses**; examples include lenses with a maximum aperture of f/1.4, f/2, or f/2.8. Fast lenses usually are among the highest-quality models—and the most expensive.

There are other advantages to a fast lens. For example, it may allow you to freeze subjects in motion (because you can use faster shutter speeds), and also to produce higher-quality image files (because you can use slower ISOs). These matters will be discussed in greater detail later.

MAXIMUM LENS APERTURE AND THE VIEWFINDER

Fast lenses offer an added advantage when using a DSLR: they make your viewfinder brighter. This is because DSLR lenses are designed to remain at their largest opening until the shutter button is pressed. As you push the shutter button to take the picture, the lens closes down to the f-stop you've selected so the picture can be taken, and then opens up again to its maximum aperture.

This means a fast f/2 lens will stay open to f/2 for viewing, regardless of the f-stop you set, and, therefore, will provide brighter viewing than a slower f/2.8, f/4, or f/5.6 lens. This makes it easier for you to see and compose the image, particularly when working in low-light conditions, when you most need the light. This advantage does not apply in live-view mode, as the LCD may simply brighten up when necessary for better viewing.

WHOLE AND PARTIAL F-STOPS

The f-stops described earlier are whole or full f-stops. But you also can choose partial f-stops, in-between settings in half- or third-stop increments—or both, depending on your camera. You'll see the whole and partial f-stops displayed on an LCD or in the viewfinder. The following chart lists available whole, half-, and third-stop choices. Note that not all model lenses offer all the choices listed:

Whole	f/2		f/2.8		f/4		f/5.6		f/8		f/11		f/16		f/22
Half ✳		f/2.4		f/3.5		f/4.8		f/6.7		f/9.5		f/13.5		f/19	
Third ✳	f/2.2	f/2.5	f/3.2	f/3.8	f/4.5	f/5	f/6.3	f/7.1	f/9	f/10	f/13	f/14	f/18	f/20	

✳ Approximate

A **slow lens** has a relatively small maximum aperture, perhaps f/4, f/4.5, f/5.6, or f/6.3. Such lenses don't let in as much light, so they may need brighter natural light or flash (or other supplementary lighting) for good exposure. Moreover, slow lenses may lead to blurred results (because they may require a slower shutter speed) or noisy image files (because they may require a high ISO rating).

To set the f-stop, you usually push a button and then turn a control wheel or adjust a toggle switch. The f-stop will be displayed in the viewfinder or on the screen on top of the camera.

Bruce Myren, "Fort Juniper"
Myren's work blends historical and personal meanings of the American landscape. By examining his subjects with his camera, he is also examining himself. In the series *Fort Juniper*, he returns to his hometown of Amherst, Massachusetts to photograph the home of reclusive poet Robert Francis—a "shelter and a lens through which he experienced the outside world."

Here, Myren photographs one of Francis's favorite paths, one of his many "short, short walks." The approach is straightforward. A normal lens produces a direct and undistorted view, which allows us to see the landscape much as the poet might have seen it so many years ago.
www.brucemyren.com

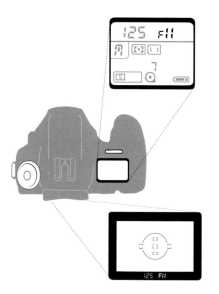

Setting the f-stop

The method of setting the f-stop varies from one camera to the next, so you may have to refer to your instruction manual for details. With most DSLRs and hybrids, you push a button and turn a control wheel or dial on the camera body. With a few models, you set the f-stop by toggling a switch. Regardless of how you set it, the chosen f-stop will be displayed on the LCD screen and/or in the viewfinder.

Note that with some point-and-shoots, you can set the f-stop yourself, but most times you won't want to. These cameras are generally designed to be used on full automatic for quick and simple operation, except for a few premium models intended for more sophisticated users.

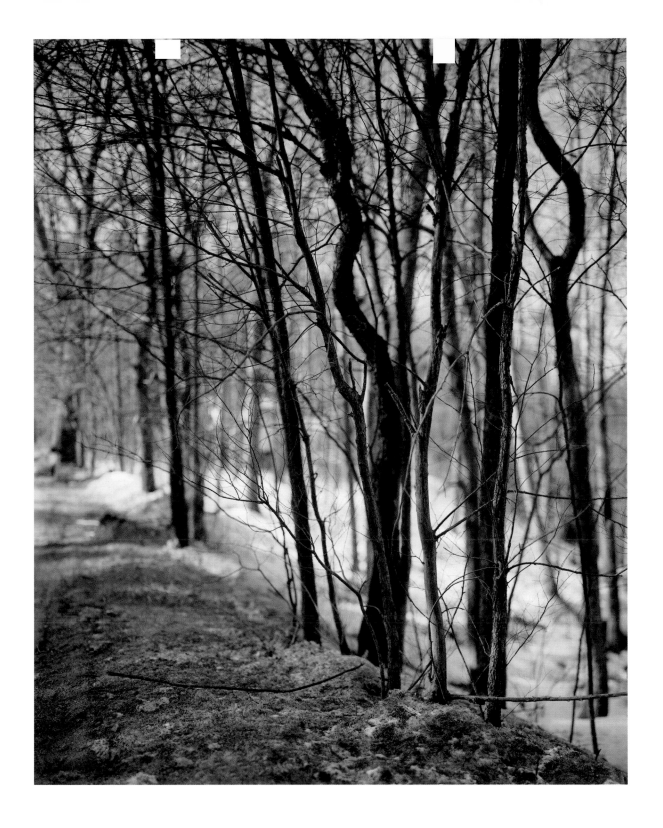

UNDERSTANDING F-STOP NUMBERS

At first glance, f-stop numbers can be confusing. To begin with, higher-numbered f-stops let in less light, and lower-numbered f-stops let in more. Moreover, the numbers seemingly make no sense. F/8 allows four times as much light to pass through a lens as f/16, even though mathematically 16 is only twice 8.

The f-stop represents the relationship between the size of the lens opening and its focal length. It is derived by dividing the measured diameter of a particular lens opening into the focal-length setting of the lens. For example, suppose you have a lens zoomed to a focal length of 60 mm. If the diameter of the lens opening measures 15 mm, you have an f-stop of f/4—60 divided by 15. A diameter measuring 10 mm is f/6 (between f/5.6 and f/8)—60 divided by 10.

60 mm (focal length)

÷

15 mm (lens aperture)

= f/4

TIP: THE BEST QUALITY IS IN THE MIDDLE

For best image quality, avoid extreme focal lengths or f-stops. This is especially true with less expensive lenses. It's usually best to shoot with a normal (or close to normal) focal length set at an f-stop in the middle of the aperture range. With wide or telephone zoom settings or prime lenses, you can expect some breakdown in image sharpness and maybe other distortions, such as vignetting, especially when you get very wide or very telephoto. The same thing goes when photographing with the lens wide open or closed down all the way.

The difference may be subtle and almost impossible to see, but it could make a difference especially with large-format prints. Of course, there are times when a little softness or distortion may work to your advantage. And there are other times when you don't have much of a choice—you'll probably need that long telephoto to capture a wild animal, or that wide f-stop in low light.

Focal Length

Lenses are generally categorized in terms of focal length, which is measured in millimeters (mm), such as 30 mm, 200 mm, and so forth. The most common lens type, called a **zoom lens**, provides a range of focal lengths, whereas a **prime lens** provides a fixed focal length; it does not zoom. Whether your lens zooms or not, focal lengths are usually described as **normal**, **wide-angle**, or **telephoto**.

Focal length is not a physical measurement of a lens, per se, but rather an optical measurement having to do with where light rays converge inside the lens. In simple terms, focal length is determined by measuring the distance between the optical center of a lens and the image sensor, when the lens is focused at its furthest focusing distance (infinity).

You don't have to be an optical engineer to understand focal length. All you need to know is that short-focal-length lenses produce a relatively wide view of a scene, and long-focal-length lenses produce a narrower view. Here, "short" and "long" refer to the optical measurement, not the physical size, of a lens. One 18-to-135 mm zoom lens may be physically longer or shorter than another 18-to-135 mm focal-length lens depending on how the optics are designed. And while a 300 mm lens has a longer focal length than a 200 mm lens, it may or may not be physically longer.

The view a lens provides is referred to as its **angle of view**—how much it sees and captures. Angle of view is associated with **image magnification**—how large or small the subject appears when you're viewing it. Short-focal-length lenses have a wide angle of view, which makes their subjects appear smaller and farther away, while long-focal-length lenses have a narrow angle of view and magnify their subjects, making them look larger and closer.

The angle of view and image magnification of a given focal length is directly related to the size of the camera's image sensor. If you have a large sensor, you'll need a longer focal-length lens than you would with a smaller sensor for an equivalent view and magnification. For example, a camera with a large, full-frame image sensor provides a 45° angle of view with a 50 mm focal-length lens. But a camera with a smaller APS-C image sensor needs only a 30 mm focal length to provide the same angle of view and magnification.

The size of an image sensor is sometimes referred to as its **magnification factor**, also called **crop factor** or **focal-length multiplier**. Most APS-C image sensors are called "1.6" or "1.5" sensors for the factor that makes their lens focal lengths roughly equal to those of a full-frame sensor. Here, multiply 30 mm by 1.6 and you get 48 mm—approximately the 50 mm that full-frame sensors need to produce the same angle of view and magnification as an APS-C sensor.

→ *image sensor, pages 15, 21, 29, 31–33*

APS-C AND FULL-FRAME LENSES
Some lenses are made specifically for cameras with a small (APS-C) image sensor, and others are made for cameras with full-frame sensors. The smaller sensor lenses have shorter equivalent focal lengths. You can sometimes use these shorter lenses on a camera with a full-frame sensor, but you will most likely get vignetted (darkened) corners or other distortions. On the other hand, lenses made for cameras with a full-frame image sensor can be used on cameras with an APS-C sensor.

This picture was taken using a camera with a full-frame image sensor, and a 30 mm zoom setting on a lens made for a camera with a smaller APS-C-size image sensor. The overall image quality is not bad, but the corners show some vignetting.

FOCAL LENGTH, ANGLE OF VIEW, IMAGE SENSOR SIZE

The focal length of your lens is a primary factor in establishing the angle of view of an image—how much of a scene it sees and captures. Regardless of the camera you use, a long focal length sees a narrower angle of view and magnifies the subject more than a short-focal-length lens. However, the specific angle of view and image magnification you'll get are directly related to the size of your camera's image sensor. Cameras with large image sensors need longer focal-length lenses than cameras with smaller image sensors for comparable results.

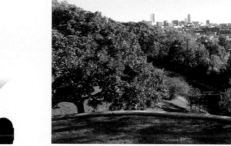

14 mm (APS-C) or 24 mm (full-frame) 84°

21 mm (APS-C) or 35 mm (full-frame) 63°

30 mm (APS-C) or 50 mm (full-frame) 46°

Following are examples showing how focal length affects angle of view with APS-C and full-frame DSLR images sensors. Note that these figures are approximations, as image sensor sizes vary from one manufacturer to another. Sometimes angle of view is measured as the diagonal from one corner to another, but more commonly it is measured horizontally or vertically, along the longest side of the frame.

60 mm (APS-C) or 100 mm (full-frame) 24°

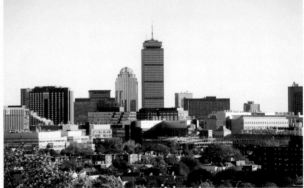

120 mm (APS-C) or 200 mm (full-frame) 12°

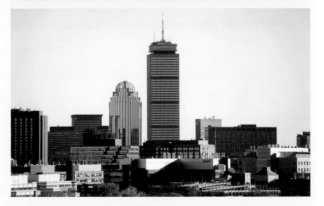

180 mm (APS-C) or 300 mm (full-frame) 8°

Normal

A normal focal length reproduces the subject much as your eye sees it—at a standard magnification, not bigger and not smaller. It provides an angle of view of about 45°. This is a good angle for a variety of purposes, including general photography of people, places, and landscapes. A normal focal length provides a nearly distortion-free view of the subject—it looks natural, not round or flat.

A DSLR with an APS-C image sensor provides a normal 45° angle of view at 30 mm, whereas a DSLR with a full-frame image sensor provides the same angle of view at 50 mm. This applies equally to a zoom lens set at the normal focal length, or a normal prime lens. Point-and-shoot cameras have the smallest image sensors, thus needing even shorter focal lengths for a normal view—about 15 mm, depending on the model.

Wide angle

A wide-angle focal length sees and records a broader view than normal, resulting in reduced image magnification. Subjects viewed at a wide angle appear smaller and farther away than they really are.

A wide-angle view is especially useful when you're working in a tight space and can't physically move back far enough to take in an entire subject, such as when photographing architecture (inside and out) and broad landscape scenes. It's also useful if you want to show context—what's going on behind, in front of, or around your main subject. Furthermore, with a wide angle, you'll get more of your subject in focus, foreground to background, because it provides greater depth of field, as discussed later.

A wide-angle view may produce a curved distortion, with subjects at the center of the frame popping out, and areas at the edges receding. This effect is especially noticeable with extreme wide-angles views, close subjects, and when the camera is tilted. Such distortion can be effective and even dramatic in some situations, such as photographing in close spaces or on the street candidly. It also can be unflattering—for example, making your portrait subject appear wider or rounder. So, be careful when photographing people and other subjects wide angle, unless you're okay with such distortion.

The available range of wide focal lengths and angles of view varies from a moderate 63° view to a more extreme 84°—and even wider. As discussed, the focal length needed for such views varies with the size of the image sensor. For instance, you'll need about a 21 mm focal length with an APS-C-sensor camera for a 63° view—and a 35 mm with a full-

→ *depth of field, pages 69–73*

TIP: USE A PRIME LENS
There are many more zoom lenses made than prime lenses, but for several reasons you should consider adding at least one prime to your camera kit, assuming your camera takes interchangeable lenses. Most prime lenses are not as bulky as zooms—and many produce pictures with greater image quality. But the real reason prime lenses are so useful is that they almost always have a larger maximum lens opening than zooms. This means prime lenses can let in more light—which is ideal when photographing in low-light situations, such as clubs or outdoors at night. For example, a 50 mm prime lens might open to f/2 or wider, whereas a 28-105 zoom might only open to f/5.6 at its 50 mm setting.

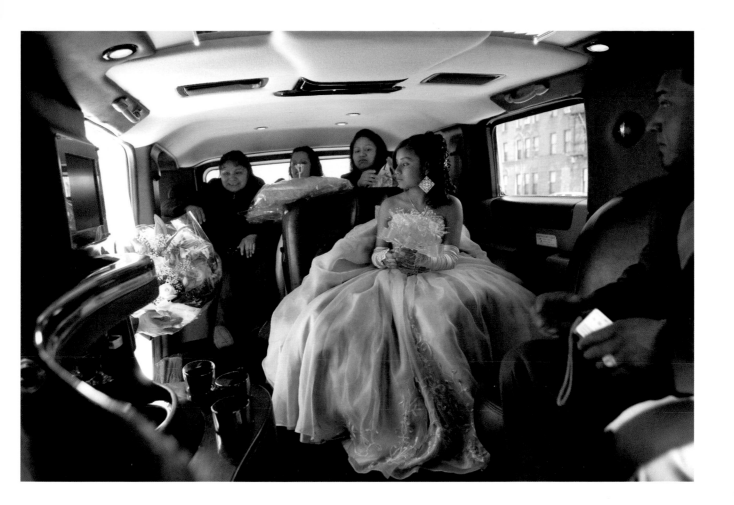

**Rebecca Greenfield, "Leslie's Quince,"
Brooklyn, New York**
Greenfield's specialty is documenting
typical American subjects, such as
yoga camps, cheerleaders, and twins
conventions. Here, she points her
camera at *quinceañeras*, coming-of-age
celebrations for Catholic girls of Latin
American descent.

Photographing Leslie's family on their
way to church, Greenfield chose a 21 mm
wide-angle lens for an extremely wide view,
so she could include the entire family
inside the limousine. Using a wide angle
this close to your subject can cause image
distortion, making a scene look curved and
deeper than it really is. Shooting straight
on and not tilting the camera helped
Greenfield to minimize any distortion.
www.rebeccagreenfield.com

frame DSLR for the same view. An 84° view requires about 14 mm (APS-C) or 24 mm (full frame).

Telephoto

A telephoto focal length sees and records a more narrow view than normal, resulting in greater image magnification. Subjects viewed through a telephoto appear larger and closer than they really are—much as they would through a telescope.

A telephoto view is especially useful when you can't get physically close enough to your subject, or when you don't want to, such as when photographing wildlife, sports action (from the sidelines), distant landscapes, or candid portraits (trying not to be noticed). Telephotos produce inherently shallow depth of field, allowing you to isolate your sharply focused subject from a blurry foreground or background—a useful effect, especially for shooting portraits.

Like a wide-angle, telephotos can produce image distortion, but of a different kind. A telephoto view makes the subject look closer and the space compressed, so the subject appears flattened. Foreground and background appear closer together. Such distortions are the opposite of a wide-angle effect, where the space appears deeper from foreground to background and the subject appear further away, smaller, and curved. The degree of image distortion varies with several factors. Mildly telephoto views show little distortion, but extreme views may show much more.

The available range of telephoto focal lengths and angles of view varies from a moderate 24° angle to a more extreme 8°—or even narrower. And as with all lenses, the focal length needed for such views varies with the size of the image sensor. For a 24° view, you'll need about 60 mm with an APS-C sensor DSLR, and 100 mm with a full-frame sensor DSLR. An 8° view requires 180 mm (APS-C) or 300 mm (full frame).

Many telephoto zooms and prime lenses are physically large, heavy, and bulky, therefore difficult to hold steady without a tripod or some other means of support. And because they magnify a subject, they also magnify the effects of camera movement. Take extra care to steady the camera (and yourself) when using telephotos, as any movement during exposure may cause blurry pictures. There are a variety of techniques to help you steady the camera, but a lens or camera with built-in **image stabilization** can be a big help. More on this later.

Zoom

A **zoom lens** offers a range of focal lengths, providing a broad range of angles of view and magnification. You choose the focal length you want,

TIP: USE A SHORT TELEPHOTO FOR PORTRAITS

Many portrait photographers like the small amount of image compression you get from a short telephoto—perhaps 50 to 85 mm (on an APS-C sensor camera) or 70 to 135 mm (on a full frame). The mild distortion often yields a more flattering portrait, making your subject look less rounded and bulky. It can even make big noses look smaller.

→ *steadying the camera, page 91*

Neal Rantoul, "Wheat, Near Pullman, Washington"

A career teacher (at Northeastern University), Rantoul uses his summers and vacations to take road trips around the world, partly because he loves to travel but mainly to produce work. In Washington State, he found these wheat fields and made a series of sumptuous landscapes. Working with a 70–200 mm telephoto zoom lens set at 110 mm, Rantoul was able to bring the fields closer. And he was also able to change their perspective. Telephotos flatten their subjects, here making the fields seem like they stack up rather than roll on into the distance, thus giving his subject a highly abstract quality.
www.nealrantoul.com

ACCESSORIES: LENS HOOD

Any lens might produce lens flare—scattered and reflected light—but wide-angle lenses are especially vulnerable. To help prevent flare, use a **lens hood** to shade the front of your lens, especially on bright days or with scenes that have a lot of reflected light and/or backlighting (when the main source of light is behind the subject) and when shooting wide angle. Another benefit of a lens hood is that it might help protect your camera or lens if it gets dropped or banged around.

Many new lenses come with a compatible hood. Some look like tubes, and some are flower-shaped to accomodate the range of focal-length settings of zoom lenses. Regardless of the shape, make sure you have the right hood for your lens. If the shade is the wrong size, it may cut off light from the edges of the image, causing vignetting—making edges and/or corners appear darker than the rest of the image.

Lens flare can occur when scattered light enters the lens at odd angles, such as in the accompanying picture.

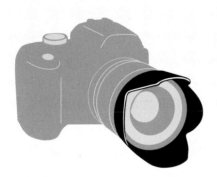

usually by turning a ring on the lens. But with some cameras (mostly point-and-shoots), you use a toggle switch or some other method to zoom in and out.

A zoom setting provides the same angle of view, image magnification, and distortion (curved or flattened images) as a prime lens of equal focal length. Thus, setting 85 mm on your 18-to-135 mm zoom gives you the same view and magnification as an 85 mm prime lens. And a 20 mm setting on your 18-to-55 mm zoom will produce the same type of image distortion as a 20 mm prime lens.

Zoom lenses come in many varieties. There are **standard** (wide-to-telephoto) **zooms** that range from slightly wide angle to slightly telephoto, with a normal focal length somewhere in between. And there

are **wide-angle zooms** that range only through wide focal lengths, and **telephoto zooms** that range only through telephoto focal lengths. DSLRs and other cameras with interchangeable lenses are often sold as a kit, packaged with a standard zoom lens. (Point-and-shoots have a standard zoom built in.)

There are many zoom lens choices, but these are some commonly available sizes for APS-C and full-frame image sensor DSLRs.

Standard zooms	Wide-angle zooms	Telephoto
17–85 mm	10–22 mm	55–250 mm
18–55 mm	12–24 mm	70–200 mm*
18–135 mm	16–35 mm*	70–300 mm*
18–200 mm	17–40 mm*	80–200 mm*
24–70 mm*	18–35 mm*	100–400 mm*
24–105 mm*		200–400 mm*
28–135 mm*		*** Full-frame zooms**
28–200 mm*		

The primary advantage of a zoom lens is convenience. You need only a single lens to cover a range of focal lengths, which could otherwise require three or four prime lenses. This means less bulk and weight to haul, but it also means you won't have to stop shooting to change lenses for a different angle of view. This is a huge advantage when working spontaneously or with quick-moving subjects. Also, by changing lenses less often, you'll help keep dust, dirt, hair, and other matter from accumulating on the image sensor.

Zoom lenses also work better than prime lenses for fine-tuning composition. By zooming in, you can tighten your framing to make the subject a little larger and closer with less background. By zooming out, you can loosen up the framing a bit, so the subject is smaller and further away with more background. Moreover, you can zoom in and out while standing in one spot, whereas you have to move physically closer and farther to fine-tune composition with a prime lens, which can be inconvenient and sometimes impossible.

In theory, you can set a zoom lens at any focal length within its range. For example, a 55-to-250 mm zoom can be set at 81 mm, 158 mm, or 205 mm—all focal lengths that aren't available as prime lenses. You don't really have to know the exact focal length you're setting, as you can

just zoom in or out until the picture is framed the way you want it. If you want to know the exact focal length you've zoomed to, you can find it in the metadata of the image file.

→ *metadata, pages 31,33*

Zoom lenses do have disadvantages. For one thing, you may need to use a flash or other supplementary lighting when photographing in low light with a zoom. This is because they have smaller maximum lens apertures than prime lenses. For instance, a 17-to-85 mm zoom, set at 50 mm, may open only as wide as f/4, whereas a 50 mm prime lens may open to f/2 or even f/1.4.

Also, some zoom lenses are slow when focusing in autofocus mode. And though modern zooms are excellent optically, comparable prime lenses may be a little better (this can vary from one lens to another). The best-quality zoom lenses are expensive and often relatively large and bulky. You'll have to be extra careful to steady the camera when shooting with a large zoom. Fortunately, most models offer image stabilization to help steady them.

ACCESSORIES: TELECONVERTER

A **teleconverter** is a tubelike accessory that fits between the camera body and lens and increases the effective focal length of that lens. The most common teleconverters are either 1.4X or 2X. A 1.4X converter makes the lens's focal length 1.4 times longer. So, a 55-to-250 mm zoom lens acts like a 75-to-350 mm lens. A 2X converter doubles the focal length, making the same zoom act like a 110-to-500 mm lens.

The major advantage of a teleconverter is cost. It is far cheaper to buy a teleconverter than to buy an additional long-focal-length lens. Moreover, teleconverters are comparatively small and light, so they are easier to carry around than separate lenses.

You'll probably get the best results using a teleconverter made by the same manufacturer that makes your lens. However, there are models made by independent manufacturers which provide good results at a lower price. Not all lenses are compatible with other manufacturer's teleconverters, however. And some lenses don't work with teleconverters at all.

There are two major disadvantages to using a teleconverter. One is reduced image quality—possibly reduced image sharpness and some optical distortions. Another disadvantage is that a teleconverter reduces light as it passes through the lens. A 1.4X model lets half as much light through as the lens without the converter, whereas a 2X model lets through only 1/4.

A teleconverter fits between the camera body and lens to increase the image magnification, bringing you closer to your subject.

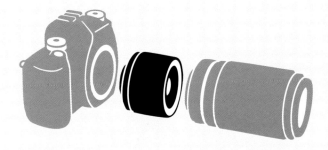

VARIABLE VERSUS CONSTANT MAXIMUM APERTURE

Some zoom lenses have a **variable maximum aperture**, which means their widest f-stop varies with different zoom settings—opening wider with short-focal-length settings than with longer settings. For instance, an 18-to-200 mm zoom might offer a maximum lens aperture of f/3.5 when set at 18 mm, and a maximum of f/6.3 at 200 mm. Such a lens would be designated as an 18-to-200 mm f/3.5–6.3 lens.

Lenses with a **constant** (or **fixed**) **maximum aperture** retain the same wide f-stop throughout the zoom range. Thus, an 18-to-35 mm f/2.8 lens has a maximum lens aperture of f/2.8 when set at 18 mm, 35 mm, or anywhere in between.

Most constant maximum aperture lenses are faster overall than their variable equivalents. This makes them better for working in low light, without flash or other supplementary lighting. Moreover, most are professional-level lenses—optically superior and more rugged. However, they also are relatively big, heavy, and expensive.

Depth of Field

Depth of field is the range of acceptable sharpness in an image—from the closest to the farthest part of the scene. For instance if you focus on a tree ten feet away, the tree will be sharp, but an area in front of the tree and in back will also be in focus. That front-to-back area is the picture's depth of field. A photograph that shows a lot of sharpness, front to back, has a lot of depth of field, and a photograph that has a sharply focused subject but a blurry foreground or background has a shallow depth of field.

Within limits, you can control the depth of field of your pictures to achieve a certain intent or visual style. For instance, you might want a lot of depth of field to reveal details throughout a scene. Or, you might want **selective focus**—limited depth of field—to make your subject stand out from a blurry foreground or background.

Three factors affect depth of field: lens aperture, focusing distance, and/or focal length.

Lens aperture

A small lens aperture produces greater depth of field than a wide one. Therefore, a lens set at f/16 provides a lot more front-to-back sharpness than the same lens set at f/4. Lens aperture is most often cited as the prime factor in controlling depth of field, but focusing distance and lens focal length are equally important.

Focusing distance

A subject focused at a long distance away has greater depth of field than a subject focused closeup. So, a 50 mm focal length focused on a subject twenty feet away produces greater front-to-back sharpness than if it were focused five feet away.

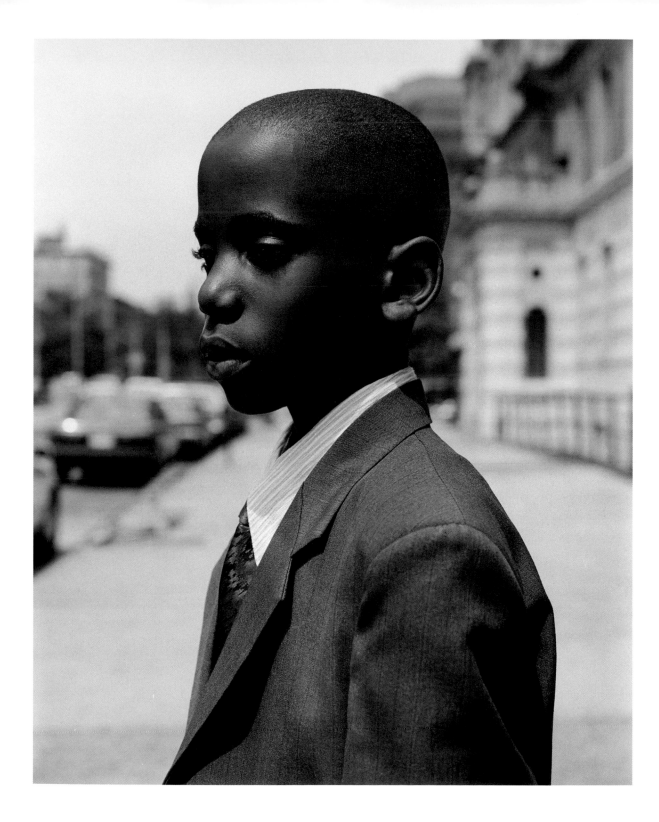

Focal length

A short-focal-length lens produces greater depth of field than a longer lens. For instance, a 24 mm wide angle produces much more front-to-back sharpness than a 200 mm telephoto.

Note that these depth-of-field factors are interrelated. A small lens aperture always provides greater depth of field than a wide lens aperture, as long as the other variables are constant. However, if you close down your lens aperture to achieve greater depth of field, but also change your zoom setting from wide angle to telephoto, you may end up with less depth of field. The same goes if you move closer to your subject, thereby decreasing your focusing distance and your depth of field.

The ability to render your entire subject in sharp focus is one of photography's great strengths, and most often you'll want as much depth of field as the situation allows. For maximum depth of field, set a small lens aperture, focus on a subject that's not too close, and/or use a wide-angle zoom setting or prime lens. However, sometimes selective focus makes a picture more effective and expressive—in which case, set a wide lens aperture, focus at a close distance, and/or use a telephoto.

Often factors come into play that may limit your ability to control depth of field. For example, in bright outdoor light, you usually set a small lens aperture for good exposure, which will likely produce a lot of depth of field—whether you want it or not. ISO is another consideration. If you set a low ISO setting, such as ISO 100, you may need to set a wide lens aperture to produce good exposure, which may produce shallow depth of field. Furthermore, with close-up subjects, such as flowers, you're likely to get shallow depth of field—because of the close focusing distance. And with landscapes or other distant subjects, you're likely to get a lot of depth of field.

The size of your camera's image sensor also affects depth of field. Cameras with a small image sensor tend to deliver a lot of depth of field, regardless of other factors. In fact, it can sometimes be difficult to selectively focus with a small-image-sensor camera. This is because small image sensors use shorter focal-length lenses than large sensors for the same view of a scene. For example, a DSLR with an APS-C image sensor needs only a 30 mm focal length for a normal view, whereas a DSLR with a full-frame sensor needs 50 mm for the same view—and the shorter 30 mm lens inherently produces greater depth of field. Point-and-shoot cameras have much smaller image sensors than APS-C cameras, so they inherently produce a lot of depth of field.

→ *close up, pages 77–78*

Noe DeWitt, "A Boy in Harlem"
DeWitt was walking around Harlem with his camera on a Sunday afternoon when he spotted a father and son walking home from church. He was struck by how nice the boy's suit looked on him and his big eyes, so he asked permission to make a portrait.

"Usually when I make a tight portrait, I focus on eyelashes—everything from that point falls away perfectly for me. I shot this at f/5.6 with a 105 mm lens." The combination of a fairly wide aperture and a telephoto lens produced a sharp subject with a soft background, emphasizing the boy and blurring the busy scene behind him.
www.exposureny.com

THREE WAYS TO CONTROL DEPTH OF FIELD

1. Lens Aperture. The primary control of depth of field is the f-stop setting. Opening up to a wide lens aperture, here f/2, produces very little depth of field (1). Closing down to a small lens aperture, here f/22, produces a lot of depth of field (2). Both photographs were made using the same focal-length lens (50 mm) at the same distance to the subject (one foot).

2. Distance-to-Subject. Depth of field is also affected by the distance from camera to subject. The further you are from your focused subject, the greater the depth of field. The picture taken from four feet away (1) produces much less depth of field than the picture taken from fifteen feet away (2). Both photographs were made using the same lens aperture (f/8) with the same 50 mm lens.

3. Lens Focal Length or Zoom Setting. Depth of field is also affected by the lens focal length or zoom setting. The longer the lens or zoom setting, the less depth of field. Here, the picture taken with the 85 mm zoom setting (1) produces much less depth of field than the picture taken with a 35 mm zoom setting (2). Both photographs were made using the same lens aperture (f/8) from the same distance (five feet).

HOW DEPTH OF FIELD WORKS

Depth of field works approximately in a 1:2 ratio based on where you focus. If you focus sharply on a subject, and the area two feet in front is sharp, then the area four feet behind also will be sharp. The exact ratio can vary, but thinking of it as 1:2 is a good guideline.

For maximum depth of field, focus about one-third into the area you want sharp.

This means you should make a practice of focusing approximately one-third into your needed depth of field. Let's say you want to photograph a parked car from the front and achieve sharpness from front to back. Focus on the car's

windshield, about one-third into the subject, so the hood of the car, as well as the trunk, will be in focus. Of course, your lens aperture, focusing distance, and focal length will also be factors in determining how much depth of field you'll actually get.

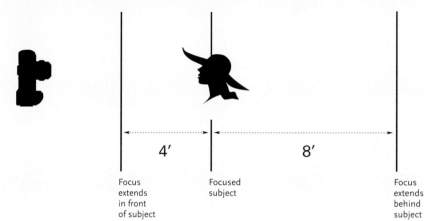

| 4' | 8' |

Focus
extends
in front
of subject

Focused
subject

Focus
extends
behind
subject

Specialized Lenses

With DSLRs and (to a lesser degree) hybrids, you can choose from a wide variety of zoom and prime lenses. Most are typical focal lengths, offering normal, wide, and telephoto angles of view. But there also are several specialized lenses that offer a little extra. Following are some examples.

Macro lens

A **macro lens** looks and acts much like any other lens, except that it allows you to focus very close to your subject—often just one to two inches away. It's the best close-up option for a number of reasons, including its ability to focus at any distance—from very close up to infinity. With the other close-up options discussed below, you can focus only at limited close ranges.

Many popular zoom lenses are designated as "macro," and some do focus quite close, but with many models, lens makers are stretching the point. Most true macros are prime lenses, with focal lengths such as 30 mm, 50 mm, 60 mm, 100 mm, and longer. Expect to pay a premium for a true macro lens, but you'll also get high-quality optics that can capture subjects at any distance.

You'll have to use a macro lens, preferably a prime lens, to focus this close to your subject. Expect very little depth of field when focusing this close.

Image-stabilized lens

Most modern lenses or cameras offer some sort of **image-stabilization (IS)** technology to help steady the lens and/or camera for sharpest results. The methods used vary from one manufacturer to another; most companies build stabilization into their lenses, whereas a few build it into the camera body. Image stabilization also may be called **vibration reduction (VR)**, **optical stabilization (OS)**, **vibration compensation (VC)**, or some such, depending on the manufacturer.

→ *camera shake, page 88*

Image-stabilized lenses are particularly useful in situations that might otherwise cause camera movement, also called **camera shake**, when you're taking a picture. Camera shake can occur for a number of reasons, such as when you're using a slow shutter speed (in low light) or a bulky lens (difficult to hold steady). Usually, you turn stabilization on or off using a switch on the camera lens or body. With point-and-shoots, you probably have to go into the camera menu to make the setting.

→ *shutter speed, pages 81–85*

Image stabilization is no guarantee of a sharp picture. For instance, it won't help freeze a subject in motion. But it will help you to hold the camera steady at a slower shutter speed than you could with a nonstabilized lens—about one or two stops longer, depending on the lens. For instance, an image-stabilized lens at a shutter speed of 1/30 should provide the same amount of steadying effect as a nonstabilized lens at 1/60 or 1/125. Much more on shutter speed in the next chapter.

Ultrawide/fisheye lens

An **ultrawide** lens has a very short focal length, either as a zoom setting or prime lens. It provides an extremely wide-angle view, generally from about 100–180°. Ultrawide focal lengths range from about 4–8 mm on a camera with an APS-C image sensor to 8–16 mm on a camera with a

An ultrawide fisheye lens often gives the picture a unique circular shape—a convex view where the middle of the image seems to pop out and the edges recede.

full-frame sensor. Note that these very short focal-length lenses produce maximum depth of field, so almost everything is in focus when you use an ultrawide lens.

A **fisheye lens** is an extreme type of ultrawide lens, so named because it produces a high degree of wide-angle distortion that appears as curvature or a bulbous effect and in some cases, a circular image with a black frame. This circular effect is most likely to happen at the widest focal lengths.

Ultrawide lenses produce a strong visual distortion, in which the image appears convex, bulging out at the center, and bending back toward the edge of the image frame. This distortion is often the reason photographers use these lenses. But if you're not careful, the impact can be overwhelming.

Lensbaby

The **Lensbaby** is a proprietary lens that produces a signature selective-focus look. Basically, after focusing on an area of the image, you bend an attached bellows to blur the areas around it, either in a subtle or extreme manner. There are several Lensbaby models, offering features such as brighter viewing, telephoto or wide effect (including fisheye), and close-up focusing.

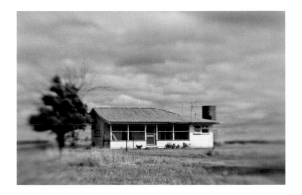

This picture of an Australian country house shows off the soft and selective focus unique to the Lensbaby.
© Philip Andrews
www.betterphotoshoptechniques.com

You focus the Lensbaby differently, depending on the model. With some, you bend the flexible bellows that holds the lens—up, down, or side-to-side—until the part of the picture you want sharp comes into focus. Then, hold the bellows in place, and take the picture. Other models use an attached ball and socket that allows you to tilt the lens freely and then focus manually turning a ring located around the lens.

Only a few Lensbabies have a variable lens aperture, so to adjust exposure you usually have to use changeable aperture disks. Also, not all camera meters are Lensbaby compatible, so you might have to guess at exposure or use a handheld light meter for guidance.

→ *handheld light meter, page 123*

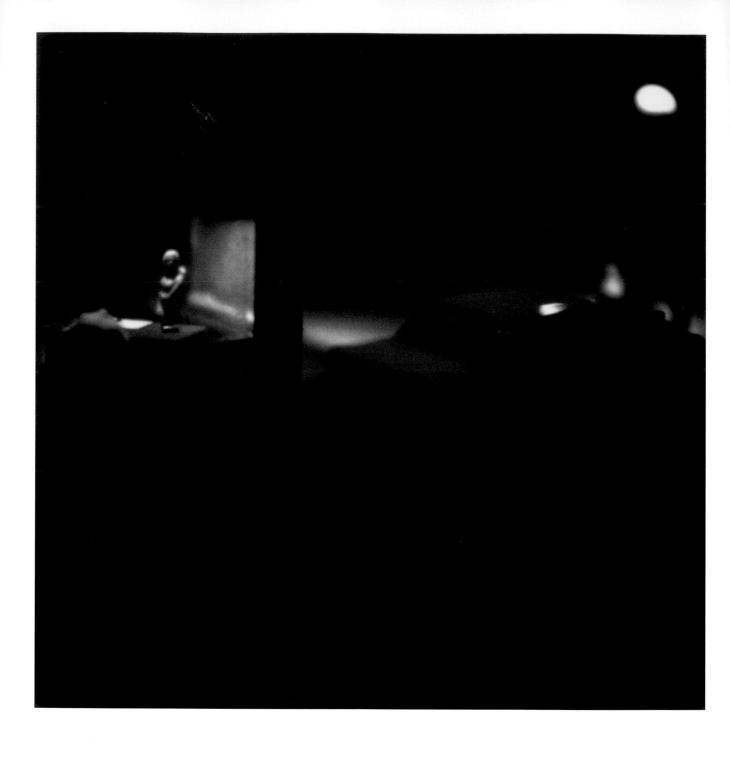

Close-Up

Most of the time, you can focus as close to your subject as you need to. You can get closer by using a macro lens—or setting a macro mode in the camera menu. But if you want to get even closer, you may need additional equipment, such as a supplementary close-up lens, extension tubes, or extension bellows.

Extension tubes fit between the camera body and the lens (1).

Extension bellows also fit between the camera and lens, and move along a rail for adjusting focus (2).

1

2

A **supplementary close-up lens** is a clear magnifying lens, which fits in front of the camera lens just like a filter. Each lens is rated according to its close-focusing capability. A +1 supplementary close-up lens allows you to focus up close to your subject; a +2 allows you to focus even closer—and so forth. You can stack two or more lenses for even closer focusing, but you risk reduced image quality when you do so.

Supplementary close-up lenses are inexpensive, but they focus only at a specified range of distances—not any closer or farther away. Furthermore, even if you get the most expensive close-up lenses, you can expect somewhat diminished image quality, such as vignetting and decreased overall sharpness.

An **extension tube** is an accessory that fits between the lens and the camera body, increasing the distance between the lens and image sensor to allow closer focusing. As with supplementary close-up lenses, you can only focus at the close distances specified for each tube—not closer or farther away.

Extension tubes are more expensive than close-up lenses, and they can produce excellent-quality pictures. However, they are bulky and awkward. You'll probably need to put a camera with a tube on a tripod for steadying. Extension tubes are rated according to their length. A 36 mm extension tube allows you to focus closer than a 12 mm tube.

An **extension bellows** is an accordion-like cardboard or cloth tube mounted on an adjustable rail. Like an extension tube, it fits between the lens and the camera body, increasing the distance between the lens and image sensor for closer focus.

David Levinthal, "Modern Romance"
Levinthal's "toy stories" were highly influenced by watching soldiers, cowboys, and Indians in movies and on television. His subjects are custom-made figurines embodying icons and myths of American popular culture.

Focusing close with a wide lens aperture for a shallow depth of field, Levinthal focuses selectively to establish his ethereal, moody images. "I have always been intrigued with the idea that these seemingly benign objects could take on such incredible power and personality simply by the way they were photographed," he says.
www.davidlevinthal.com

TIP: MOVE BACK

Depth of field is inherently shallow when focusing close-up. If you want more depth of field, move back for a broader view of the scene. By increasing the distance to the subject, you will produce greater depth of field. Then, in postproduction, crop the image to the closer view you originally wanted. A drawback is the potential loss of image quality when you crop.

Extension bellows are the bulkiest of the close-up options, and they are costly. But they do provide high-quality results with a range of close-up possibilities in a single unit. In use, place the camera, extension bellows, and lens on a tripod, which attaches to the bottom of the bellows rail. Then, focus on the subject by turning a knob on the rail of the bellows so it will expand or contract.

Regardless of whether you use a macro lens, supplementary close-up lenses, extension tubes, or extension bellows, there are several things you should know for better close-up results.

Hold the camera steady. Camera shake and subject movement are magnified and exaggerated the closer you focus. Use a tripod for sharpest results.

Use a small f-stop. Focusing at a close distance produces shallow depth of field. If you want more depth of field, use a smaller f-stop. Be careful, though, as a small f-stop may require a long shutter speed, which may produce camera shake—or a high ISO, which may produce increased image noise.

Be careful of underexposure. Focusing close increases the distance the light travels to the image sensor. Your camera's light meter should compensate for this, but double-check, as you may have to add a little extra exposure anyway.

Focus manually. Some autofocusing systems have trouble catching focus close up. You can get around this problem by focusing manually.

Lens Filters

Looking much like a supplementary close-up lens, a lens filter can be attached to the front of your lens for a wide variety of purposes. Probably the most common use is protecting the front glass of your lens from damage. But you can also use a filter to modify exposure or the quality of the light in order to control such matters as contrast, glare, or to produce special visual effects. You can accomplish some of these same effects in postproduction, but not all of them, and you may get better results and save computer time by using a filter when taking pictures.

The most commonly used filters are made of glass and mounted inside a threaded rim. You screw the filter onto the front of the lens. Glass filters are sized in millimeters, according to their diameter, which must match the diameter of the front of the lens. Common sizes include 49 mm, 52 mm, 58 mm, 62 mm, 67 mm, and 72 mm. If you own more than one lens, you may have to buy different size filters for each, if they have different diameters.

The diameter of a filter must match the diameter of the front of the lens.

Be careful not to confuse filter sizes with the focal length of your lens. A 55 mm filter, for example, may fit on a 35–80 mm or 70–200 mm zoom lens, but it also may fit on a 50 mm or 105 mm prime lens—or on any number of other zooms or primes.

Filter types

There are dozens of types of filters available. These are some of the most useful.

A **lens-protecting filter** is a clear (or almost clear) filter that protects the front glass of the lens from scratches, smudges, and other damage. The most common lens-protecting filters are either totally clear or designated UV (ultraviolet or haze) or 1A (skylight) filters. None of these have an appreciable effect on the way a picture looks.

A **polarizing filter** can reduce glare from the subject or remove reflections from smooth surfaces, such as glass, plastic, and water. The filter attaches to the front of the camera lens, like any other filter. The best models have two parts: one that screws into the front of the lens and the other that rotates to reduce or eliminate glare and reflection. A polarizing filter also can significantly darken blue skies and water for more dramatic effect.

A **diffusion filter** reduces the overall sharpness of the image and lowers contrast. This can make subjects appear a bit dreamy and romantic, and with portrait subjects helps hide skin blemishes and wrinkles.

A **fog filter** is a diffusion filter that simulates the effects of a foggy day, producing a misty glow from highlight areas of the subject—as well as lowering both overall contrast and sharpness.

A **graduated filter** selectively reduces exposure in portions of an image. Half of the filter is clear and the other half is either colored and/or has a **neutral density** to reduce exposure—with the two halves blending together in the middle. There are many types of graduated filters. One popular type darkens skies without affecting the rest of the scene, making it especially useful for photographing landscape scenes.

A **multi-image filter** has contoured prismatic surfaces that create repeating images. The shape and amount of repetition depends on the particular type of multi-image filter you use—and there are many variants.

A **star filter** produces streaks of light that appear to emanate from bright highlights within the image. The effects assume various shapes and levels of exaggeration, depending on the type of star filter you use.

TIP: POLARIZE AT AN ANGLE

Polarizing filters don't have much effect unless you point them at an angle to the surface of your subject. If you're trying to eliminate reflection from a store window, for example, don't point your camera straight-on at the window; stand to the side and take your picture at that angle. A 30–35° angle maximizes the polarizing effect, though most any angle will reduce some degree of glare and reflection.

Focal plane shutter

Image sensor

The focal-plane shutter is located in front of the image sensor in a DSLR.

John Supancic, "Gray Seals, Muskeget Shoals"
Supancic was flying his two-seat Cessna when he saw this long sandbar near Nantucket Island. "I was struck by the shape," he says. "Then I noticed the reflective quality of the light, highlighting the green sea and the foam outlining the shoal." He dropped down to get closer and then noticed the resting gray seals all around the edge of sandbar.

Usually a photographer has to worry about freezing a subject in motion. But in this case Supancic was moving as he flew along, and he had to worry about freezing his own motion. So, he used a fast shutter speed, at least 1/1000, to keep the picture from becoming a blur. *www.supancic.com*

Chapter 3
The Shutter

Every camera contains a **shutter**, a shield that blocks light from reaching the image sensor until you're ready to take the picture. DSLRs have a **focal-plane shutter** that sits in the camera body, behind the lens and directly in front of the sensor. When you press your camera's **shutter button**, it opens the shutter and lets the light traveling through the lens expose the sensor.

The amount of time the shutter stays open is called **shutter speed**—and it is variable. Your camera can set the shutter speed for you automatically, or you can set it for yourself on all but a few fully automated point-and-shoots. Automatic settings work well much of the time, but if you want more control over the shutter speed, you'll want to set it yourself.

The shutter has two main functions. It controls **time**, or how much exposure to light the image sensor receives. And it controls **motion**, whether the picture looks sharp or blurred.

Controlling Time
The primary function of the shutter speed is to control the time of exposure. Your time will depend on several factors, most especially the subject lighting. In low light, you'll generally need a **slow shutter speed**, so the shutter will stay open for a relatively long time to allow enough light to reach the image sensor. In bright light, you'll need a **fast shutter speed**—a relatively short time to let less light in.

Note that handholding a camera at slow shutter speeds will likely cause the image to blur. Most photographers can't hold a camera steady at shutter speeds much slower than 1/30 or 1/60, unless the lens or camera incorporates stabilizing technology.

Shutter speed is invariably linked to lens aperture and ISO. Each has a noticeable effect on exposure and you must balance one against the other. For example, setting a wide lens aperture means more light will reach the image sensor, allowing you to shoot at a relatively fast shutter

speed. A small lens opening requires a slower shutter speed, because less light will travel through the lens.

In a similar way, setting a high ISO allows you to shoot at a fast shutter speed. A high ISO makes the image sensor more sensitive to light, so less light is needed. A lower ISO setting requires a slower shutter speed, because the sensor needs more light.

Whether you set the shutter speed automatically or manually, cameras commonly offer the choices listed below—in descending order, from slow to fast:

→ *ISO, pages 98, 100–101*

1 second **SLOW**
1/2 second
1/4 second
1/8 second
1/15 second
1/30 second
1/60 second
1/125 second
1/250 second
1/500 second
1/1000 second
1/2000 second **FAST**

The shutter speed is displayed in various ways, depending on the camera. It might be on a screen on top of the camera body (1), and/or in the camera's viewfinder, if it has one (2), and/or on the LCD screen on the back of the camera (3). Sometimes shutter speed is displayed as its fractional number (such as 1/125), and sometimes as a full number (such as 125, to represent 1/125).

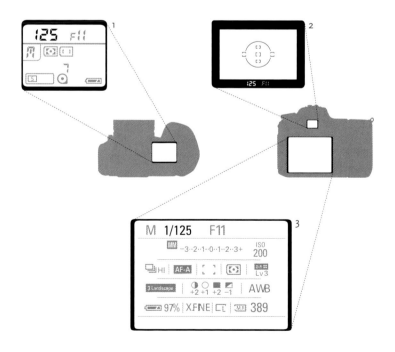

Some cameras display shutter speeds as fractional numbers, but others display them as full numbers, with the fractional symbol (1/) dropped—for instance, 1/250 second may be displayed as 1/250 or simply 250, and 1/2 second may be displayed as either 1/2 or 2.

Many cameras offer shutter speeds faster than 1/2000, such as 1/4000 and 1/8000, while some models can only be set as fast as 1/500. The more high-end your camera, the more shutter speed options you're likely to have. You also might be able to choose shutter speeds longer than 1 second, such as 2, 4, 8, or more seconds.

Setting the shutter speed

→ *exposure modes, pages 104–106, 108–109*

There are various ways to set your shutter speed, depending on the camera used. But to begin with you'll have to set your exposure mode. If you want your camera to choose the shutter speed automatically, set **P** (program autoexposure), **AUTO** (full autoexposure), or **A** or **Av** (aperture-priority autoexposure). If you want to set the shutter speed yourself, choose **S**, **T**, or **Tv** (shutter-priority autoexposure) or **M** (full manual).

Check your camera's instruction book to find out how to set the exposure mode. With many cameras, you set the mode with a control wheel or dial located on the top of the camera body. You'll see the chosen shutter speed displayed on the camera's LCD and/or in the viewfinder. With most point-and-shoot cameras, you set the exposure mode in a camera menu. This isn't as convenient, but it's not a big deal because you'll often work in full automatic mode unless you have a sophisticated point-and-shoot model.

How shutter speeds relate

The relationship among shutter speeds is essential to understanding exposure. Each full shutter speed doubles the time of the setting on one side, and halves the time of the setting on the other. Thus, 1/2 lets in light for twice as much time as 1/4, and 1/250 lets in light for half the time as 1/125.

This half/double relationship should sound familiar. Full f-stop settings have the exact same relationship. A lens set at f/5.6 lets in twice the light as a lens set at f/8, and half as much light as a lens set at f/4. This half-double relationship allows you to control exposure by balancing the amount of light let in by the shutter speed and lens aperture.

→ *stops, page 98*

Note that double and half increments of shutter speed are sometimes described as **stops**—in the same way that f-stop and ISO may be described. So, if you halve the amount of exposure by setting 1/60 instead of 1/30, you are making a change of one stop. If you increase the amount of exposure, by setting 1/125 instead of 1/500, you are making a two-stop change.

More shutter speed choices

The full shutter speeds listed previously are not your only choices. Cameras also offer partial shutter speed settings—intermediate increments in either halves or thirds, or sometimes both. For instance, 1/90 is a halfway setting between 1/60 and 1/125. And 1/80 and 1/100 represent thirds, in-between 1/60 and 1/125. These partial settings allow more fine-tuned exposure control by letting in light for a bit more or a bit less time—but not twice or half as much. Following are the choices available on many cameras. Note that some camera makers may use slightly different increments, but the practical effects are generally the same.

WHOLE, HALF, AND THIRD SHUTTER SPEEDS

In the chart below, full shutter speed settings are listed on the top line, partial half shutter speed settings on the second line, and partial third shutter speed settings on the bottom.

1/1000		1/500		1/250		1/125		1/60		1/30		1/15		1/8	1/4
	1/750		1/360		1/180		1/90		1/45		1/22		1/12		1/6*
1/800	1/640	1/400	1/320	1/200	1/160	1/100	1/80	1/50	1/40	1/25	1/20	1/13	1/10	1/7*	1/5*

* These speeds may also be expressed as decimals—
for example, 1/2 may be 0"5 on your camera.

Shutters often also offer a **B** (bulb) setting, and a very few have a **T** (time) setting. Both allow you to keep the shutter open for very long exposures—as long as you want—so you can photograph in extremely low light. This also helps you produce pictures with a significant amount of blur or motion, if you choose.

When set at B, the shutter remains open for as long as you keep the shutter button pressed all the way down. When you release the button, the shutter closes. The T setting has the same function as B, but operates differently. The shutter opens when you press the shutter button, and closes only when you press the button a second time.

→ *time exposure, page 92*

Very long exposures are sometimes called **time exposures**. You'll need to use a tripod or some other means to steady your camera so it won't move during a time exposure, because any camera movement at all can produce a blurry image. Sometimes blur can be an effective visual element in a picture, but generally you should do your best to avoid it.

Almost all cameras offer a **self-timer**, which allows you to (among other things) sneak into the picture frame and make pictures with you in them. Put the camera on a tripod (or maybe a tabletop), frame the scene, lock in focus where you want it, and set the self-timer. Then, press the shutter button and move quickly into the picture. The self-timer provides a ten-second (or so) delay between the time you press the shutter button and when the shutter actually fires. On many cameras you can choose among a few different delay lengths.

→ *tripod, pages 91, 93*

DSLRs and many other cameras allow you to make either single exposures or shoot continuously. Most of the time, you'll want to be in **single-shot** mode, where you have to press the shutter button every time you want to take a picture. When photographing action, you might want to switch to **continuous-shot** mode, where the camera keeps firing as long as you keep the shutter button pressed down.

Controlling Motion

Besides controlling the time of exposure, shutter speed controls the appearance of motion or movement in a picture. There are a lot of factors to consider. But generally you'll get sharpest pictures when you set a fast shutter speed, and blurriest when you set a slow speed. Note that using flash is another way to freeze motion and produce sharp pictures, as discussed later on.

→ *flash, pages 131–143*

Taking pictures can potentially produce two kinds of motion—one caused by **subject movement** and the other caused by **camera movement**. Both are controllable, to a large degree, with your choice of shutter speed, but you'll be more likely to control it if you set the shutter speed yourself, rather than letting the camera do it for you. To set the shutter speed, you'll have to choose either shutter-priority autoexposure (S, T, Tv) or manual (M) exposure mode.

→ *shutter-priority autoexposure, pages 106, 108*
→ *manual exposure, pages 108–109*

Subject movement

You will probably get a blurred image if your subject is in motion when the shutter is open—whether your subject is a person, an animal, or a windblown tree. Most of the time, you'll want to freeze that motion, so you'll need a fast shutter speed. Just how fast depends mostly on your subject— in general, the faster the movement, the faster the required shutter speed.

You may be able to freeze a walking dog at 1/250, for example, but you'll probably need 1/1000 or faster to freeze a sprinting racehorse. On the other hand, you can use a slower shutter speed with less active subjects, such as someone eating or buildings and other subjects that don't move at all.

TIP: BLUR IS SOMETIMES OKAY
Some photographers are obsessed with sharpness, feeling that every part of an image needs to be tack sharp or the picture is a failure. But sometimes sharpness is overrated. If you accept some image softness, including blur, you might better emphasize subject movement and perhaps add a little moodiness or atmosphere to your picture.

Most of the time, you'll be trying to freeze movement to make the sharpest possible pictures. However, you also can deliberately create blur within sharp surroundings, to highlight subject motion, or simply create a particular mood or feeling. There are many ways to do this, but the most common is to set your camera on a tripod (or other steadying surface). This will ensure that buildings, parked cars, rocks, or other stationary subject areas remain sharp when you take the picture. Then, set a slow shutter speed, perhaps 1/15 or slower, to make moving subjects blur.

While the speed of the subject is very important, it's not the only factor to consider. The direction of the movement and the distance from the camera both affect how fast or slow a subject appears to move—and these factors are sometimes just as important as the actual speed of movement.

→ *horizontal motion, page 89*

Subjects traveling horizontally from right to left, or left to right, relative to your camera, appear to move faster than subjects moving at, or away from, the camera. Therefore, you'll need a faster shutter speed to freeze horizontally moving subjects. Say your subject is a car, moving from the left side of the picture frame to the right at sixty miles per hour. You may need 1/2000 to freeze its motion. But if you're standing behind the same car at the same speed, you can use a slower shutter speed to freeze it, perhaps 1/250, as it moves away from you.

Similarly, a subject close to the camera appears to move more quickly than the same subject positioned further away. Therefore, you'll need a faster shutter speed to freeze close moving subjects. A close-up of a dog wagging his tail may require 1/250 to prevent the tail from blurring. But the same dog, photographed ten feet away, may need only 1/60 to produce the same sharp tail.

Sometimes blur works out well. Here, a skateboarder fell as a passerby stopped to watch. With the camera on a tripod, the shutter speed was relatively slow (1/15) so the falling person was captured as a blur, creating a nice contrast with the motionless, sharp person in the foreground.

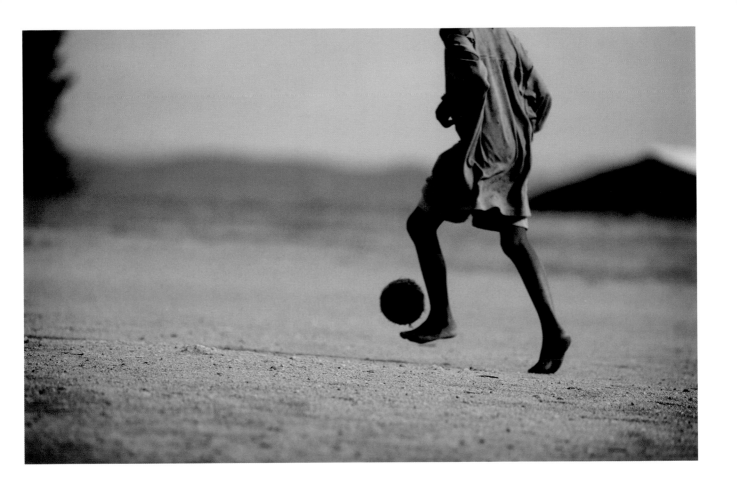

Charles Harris, "Soccer, Rwanda"
Harris shot this image while on
assignment for a nonprofit agency that
assists underdeveloped countries with
medical and humanitarian needs. The goal
was to show everyday people living their
lives, as opposed to the suffering so often
shown in places like Rwanda.

"I generally try to keep images very
simple," Harris says, "while trying to
evoke a mood, feeling, or sense of place."
Here, he uses selective focus to simplify
the scene. Setting a fast shutter speed to
freeze the action of the soccer player and
ball allowed him to open his lens aperture
and produce a shallow depth of field.
www.charlesharris.com

Sometimes you'll get subtle subject movement when you least expect it—for example, with landscape and seascape scenes. Generally, such subjects aren't obviously in motion, but sometimes they really are. For example, a strong wind can easily stir grass, foliage, and tree branches—or create waves in water. So, you may have to use an unexpectedly fast shutter speed to guarantee a sharp image, especially on windy days.

Camera movement

If the camera moves when you press the shutter button, the entire image will blur. Sometimes called camera shake, this is one of the most common of all picture-taking problems, and it happens because it can be difficult to hold a camera steady due to minor movements of your hands, vibrations where you are standing, and any number of other factors.

Camera shake most commonly occurs when you set a slow shutter speed—usually about 1/30 or slower, depending on the camera, lens, and circumstances. With slow speeds, there is a good chance the camera will move somewhat during the time the shutter is open. In fact, cameras can sometimes move even if you set a faster shutter speed, particularly if the camera or lens is bulky or not steadied.

→ *wide-angle, page 62*
→ *telephoto, page 64*

Wide-angle focal lengths and zoom settings are usually easier to hold steady than telephoto focal lengths. The lenses tend to be smaller and easier to handhold, thus less likely to show camera shake. It also helps that the subject is reduced in size, so any shake will be less likely to show up. Telephoto focal lengths are larger, heavier, and magnify the effects of shake.

→ *image-stabilized lens, page 74*

Most modern camera systems offer image stabilization built into their lenses, or into the camera body itself, for a steadying effect. This allows you to use a slower shutter speed than you normally could, without shaking the camera. With image stabilization you can usually hold the camera at a shutter speed at least one to two stops slower than you could without. So, you might be able to use 1/60 or even 1/30, instead of 1/125, and get sharp results. Note that image stabilization can help minimize blur due to camera shake, but it doesn't help with the blur caused by a subject in motion.

Some photographers use camera shake for effect, deliberately moving the camera when taking a picture—the greater the movement, the greater the blur. After some experience, you should be able to predict the degree of blur you'll get, but it can be hit or miss. Chances are you'll end up with several unsatisfying pictures for every good one, so shoot a lot of pictures to increase your odds.

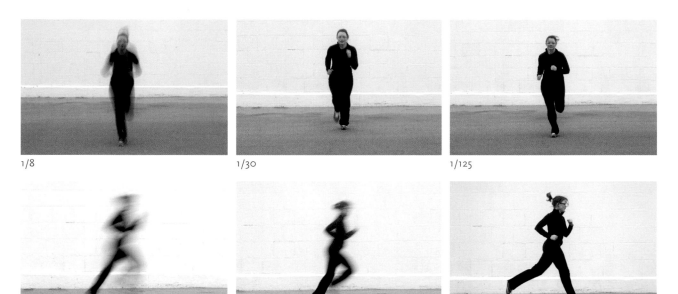

1/8 1/30 1/125

1/30 1/125 1/500

The direction of subject movement is an important factor in the shutter speed you'll need to freeze motion. When the subject is moving from left to right or right to left across the frame, you'll need a faster shutter speed than when the same subject is moving toward you at the same speed.

Panning is a method of creating blur of a different kind, by freezing a moving subject while blurring the rest of the scene. To pan, you move the camera in the same direction as the moving subject. It only works when the subject moves from left to right, right to left, or up and down, across the viewfinder. Imagine your subject is a girl on a bicycle. If you move your camera in the same direction as she rides by, you'll freeze rider and bicycle, and the camera motion will cause the background and other nonmoving subjects to blur. You'll usually get best results if you keep the moving subject in the center of the frame as you pan.

It's important to pan the camera so it simulates subject movement, more or less. You don't have to be totally precise, but you will need a speed that's slow enough to allow the shutter to stay open while you move the camera. Try 1/4, 1/8, or 1/15, but experiment with slower speeds—faster speeds don't allow enough time for a good pan. Note that you should turn off image stabilization when panning, unless your camera or lens offers a panning mode.

Panning is usually used strictly for visual effect—to render a sharp picture of a moving subject in blurry surroundings. But it also is useful to freeze high-speed subjects when the light level is too low to allow a fast enough shutter speed. This happens a lot with sports and wildlife subjects—for example, at a basketball game while players are fast-

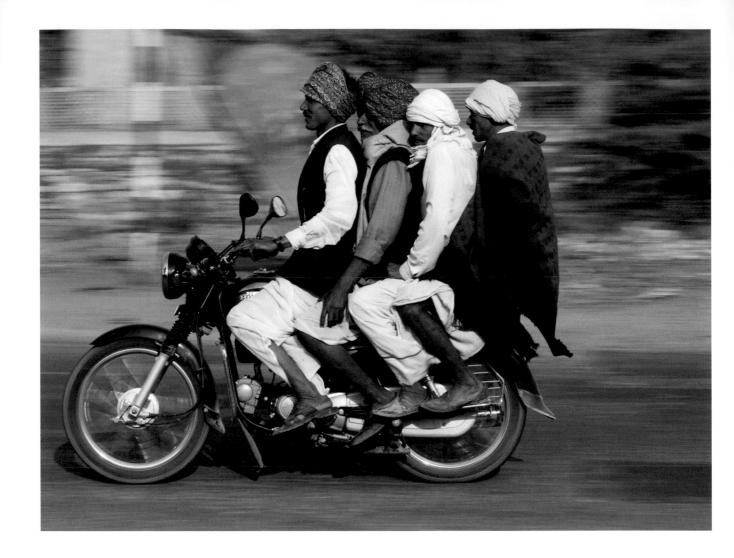

David Wells, "Gang of Four," Rajasthan, North India

Wells specializes in international cultural issues. He sometimes works on assignment, but mostly he dreams up his own projects and finds support from various granting sources.

Photographing in northern India one day, he set a slow shutter speed, about 1/8, and started panning as scooters sped by. Wells says, "They all took the same path so I focused manually on the place where I knew they would show the most panning motion. Then I looked right, found a cycle coming in, followed it trying to keep the cycle in the same place in my frame." *www.thewellspoint.com*

breaking down the court or on a beach with sea birds flying away. You may be able to stop such action at 1/1000, but in low light you may not be able to set a shutter speed that high.

Note that there are ways you may be able to set a fast shutter speed even in low light. For instance, you may be able to set a wider lens aperture or a faster ISO. But these strategies have consequences, such as limited depth of field or increased image noise, and may not always be practical, depending on your camera, lens, and the circumstances.

→ *lens aperture, pages 54–56*
→ *ISO, pages 98, 100–101*
→ *image noise, page 34*

STEADYING THE CAMERA

The best way to avoid camera shake is to learn good steadying technique. The most obvious way to hold a camera steady is to put it on a tripod. If a tripod is not available, or impractical to set up, try bracing your camera against whatever support you can find—tree, car roof, kitchen counter, or back of a chair. For additional cushioning, you can place a beanbag or pillow between the support and camera. There are even camera-friendly beanbags sold for this purpose.

If you can't steady the camera against anything, do what you can to steady yourself. Set your feet firmly on the ground, spaced comfortably apart. And don't talk, move, or even breathe much, just before and just after taking the picture.

Use your viewfinder to compose your subject, rather than the LCD—if your camera offers a choice. With an LCD, you have to hold the camera away from you, and your arms or hands can make subtle movements that shake the camera as you take the picture. A viewfinder can provide more stability, by allowing you to rest the top of the camera against your forehead, right above your eye.

As a general rule, don't handhold a camera at speeds slower than 1/30 or 1/60. You'll need even faster shutter speeds with bulky cameras and lenses. The ability to handhold a camera steady varies from one person to another, but using fast shutter speeds always makes camera shake less likely.

A **tripod** is an adjustable three-legged stand, used primarily to hold a camera steady. Every photographer should own one. It helps you make pictures that will have maximum sharpness, especially when photographing at slow shutter speeds. But no matter what the shutter speed, a tripod is the most effective way to steady the camera. Note that most of the time, you should turn off image stabilization when using your camera on a tripod.

By holding the camera in position, a tripod also helps you to compose your subject by maintaining the framing until you take the picture. Handholding a camera makes precise composition a little more difficult and subject to subtle changes, as you may inadvertently move the camera a bit before you press the shutter button.

Most modern tripods are made of metal, carbon fiber, or graphite. There's a screw on the top that fits into a threaded hole, almost always located at the center/bottom of the camera body (and in some cases

TIP: SETTING UP THE TRIPOD

A tripod is most stable when its legs are spread wide apart. First, extend the legs and then the center post, which is the pole that holds the tripod head that the camera sits on. Don't raise the legs or center post any higher than you need to, or you may make the camera less stable.

William Hannigan, "Untitled #34"
Hannigan used a twenty-seven-minute time exposure for this picture. He needed the long shutter speed to capture the low light, and also to set a small f-stop to maximize depth of field from the beginning of the basketball court to the house in back.

While waiting, Hannigan saw a deer walking through the scene. But since it was in the frame only briefly, it didn't show up in the picture. Long exposures can cause unexpected problems. Use a sturdy tripod so that vibrations from trucks and people (or deer) walking by don't shake the camera and cause the image to blur. *www.williamhannigan.com*

A tripod helps keep a camera steady to avoid camera shake.

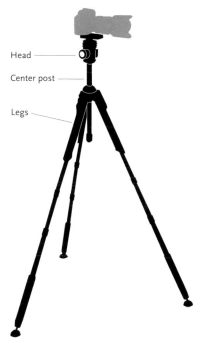

Head
Center post
Legs

A monopod is easier to move around and more lightweight than a tripod, but less steadying. However, it's very useful when photographing with a large bulky lens.

at the bottom of large, bulky lenses). Once the camera is secure on the tripod, you are ready to compose and take your picture.

A tripod is especially useful when you are magnifying a subject, such as when photographing close-up or with a long telephoto—say, 200 mm or longer. When an image is magnified, even the very smallest amount of camera movement is also magnified.

Setting up and photographing with a tripod takes longer than handholding a camera. This makes a tripod best for still subjects, such as landscapes, still lifes, and formal portraits. It is less useful for spontaneous and candid pictures because of the setup time, and also because it may attract unwanted attention as you work.

Using a tripod, you can press the shutter button to take the picture, much as you do when handholding a camera. However, whenever possible, it's best to use a cable release or remote shutter release to avoid shaking.

Tripods are available in many different sizes and models. All have adjustments for lifting, turning, and tilting the camera. There are three main parts to a tripod—the **head**, **legs**, and **center post**. The head is the part that attaches to the bottom of the camera, and it sits on top of the three legs, which adjust for height. The head and the legs come as a package on most tripods, but for higher-end models they are often sold separately. The center post comes as part of the leg system and can be adjusted separately for height.

The most important consideration when buying a tripod is that it is stable enough to hold your camera steady. A small, inexpensive tripod is adequate to hold most point-and-shoot and hybrid models, as well as many DSLRs. But you may need a heavier tripod if you're using a larger camera and/or bulkier lenses—or simply for more stability. The heavier the tripod, the more stable it is.

For photographers who need to steady the camera but still work quickly, there is a one-leg tripod variant called a **monopod**. Monopods help steady the camera, but they have only the single leg, so you still have to hold the camera up to help support it. Monopods add a measure of stability when using a slow shutter speed; they also may help in situations where using a tripod is impractical or impossible to set up, such as with sports or wildlife photography.

Steve Smith, "Deer Creek, Utah"
Smith chronicles the evolving American
West landscape and its transition into
suburbia, comparing the new architecture
of housing developments to the western
landscape they are built on. Here, we see a
metal relief sculpture of the mountains of
Utah mounted on a modern driveway gate.
In this image, Smith says, "You begin to
think about the effect that the developers
have on the landscape and also the effect
humans have on the land they occupy."
Smith's work uses classic photographic
technique, such as tight framing, accurate
and rich color, and spot-on exposure—
providing full detail throughout, from
bright highlights to deep shadows.
www.stevesmithphotography.net

Chapter 4
Camera Exposure

Suggested Workflow: Autoexposure

1. **Set the ISO**, or let the camera set it for you.

→ *evaluative metering, pages 115–116*
→ *spot metering, page 116*
→ *centerweighted metering,*
pages 116–117

2. **Choose your metering mode**, either **evaluative**, **spot**, or **centerweighted**. Or, use the camera's default mode—usually evaluative.

3. **Choose your autoexposure mode**, either full automatic, program, aperture priority, or shutter priority.
 a. If you choose aperture priority, set your desired f-stop.
 b. If you choose shutter priority, set your desired shutter speed.

4. **Point the camera** and compose your subject.

5. **Focus the subject.**
 a. For autofocus, press the shutter button halfway down.
 b. For manual focus, adjust the focusing ring on your lens.

6. **Take a meter reading** by pressing the shutter button halfway down. (Note that in autofocus mode the camera takes the reading at the same time as the lens focuses.)

7. **Press the shutter button all the way down** to take the picture.

8. **Make sure your exposure looks accurate**, either:
 a. Visually, by checking the LCD screen right after taking the picture.

→ *histogram, pages 110–113*

 b. More accurately, by calling up and evaluating the histogram on the screen.

→ *autoexposure compensation,*
page 114

9. **Fine-tune the exposure** if needed by adjusting the autoexposure compensation scale.

10. **Retake the picture** and check it again to make sure the exposure is accurate.

Suggested Workflow: Manual Exposure

1. Set the ISO.

2. Choose your metering mode, either evaluative, spot, or center weighted. Or, use the camera's default mode—usually evaluative.

3. Select manual exposure from your exposure mode settings.

4. Point the camera and compose your subject.

5. Focus the subject.
 a. For autofocus, press the shutter button halfway down.
 b. For manual focus, adjust the focusing ring on your lens.

6. Take a meter reading by pressing the shutter button halfway down. (Note that in autofocus mode the camera takes the reading at the same time as the lens focuses.)

7. Check the light meter's suggestions, and set your f-stop and shutter speed accordingly.

8. Press the shutter button all the way down to take the picture.

9. Make sure your exposure looks accurate, either:
 a. Visually, by checking the LCD screen right after taking the picture.
 b. More accurately, by calling up and evaluating the histogram on the screen.

10. Fine-tune the exposure if needed by adjusting your f-stop and/or shutter speed.

11. Retake the picture and check it again to make sure the exposure is accurate.

Camera exposure refers to the amount of light that strikes the image sensor when you press the shutter button to take the picture. For correct exposure, you must let in the appropriate amount of light to record the scene accurately. Too little light reaching the image sensor will cause **underexposure**, resulting in a dark picture. Too much light will cause **overexposure**, or a light picture.

 Both under- and overexposure can be problematic. While you can correct a certain amount of inaccurate exposure in postproduction, you'll always get the best results if you start off by making good exposures when you're taking your pictures. And you will also save time and effort when working on the computer later on.

 There are many strategies to ensure that you get the best possible exposures with the greatest consistency. The simplest is to select

autoexposure, and trust the camera to deliver good results automatically. Your camera offers several autoexposure modes, such as full automatic, program, aperture priority, and shutter-speed priority.

Autoexposure works well much of the time, but there are good reasons not to trust it always. For one thing, autoexposure doesn't necessarily guarantee success. It sometimes produces under- or overexposure. Moreover, if you set full autoexposure mode, you'll sacrifice any manual control of how the picture will look. Setting other autoexposure modes does give you much more control.

You'll learn more about these matters later in this chapter, as well as how to ensure consistently accurate exposures. To this end, you'll read about the factors that control exposure, and how to evaluate and solve exposure problems under difficult lighting conditions. You also will learn how to check to make sure you've captured the right amount of light immediately after taking a picture.

Exposure Factors

There are several factors that affect camera exposure, most notably subject lighting, lens aperture, shutter speed, and ISO. All have been covered in detail in previous chapters, but following is a brief review and an explanation about how they affect each other. These factors are interrelated, and all are equally important for good exposure. If you adjust one factor, it's likely to affect another.

Subject lighting

→ subject lighting, pages 124–151

The fundamental factor in camera exposure is subject lighting. You have to select your lens aperture, shutter speed, and ISO settings according to the lighting conditions. In low light, you'll have to give your image sensor a lot of exposure by opening your lens aperture, slowing your shutter speed, and/or setting a higher ISO. In bright light, you'll need to provide less exposure by closing down your lens aperture, making your shutter speed faster, and/or setting a lower ISO.

Lens aperture

→ lens aperture, pages 54–56

The lens aperture is the opening you adjust to let more or less light through the lens into the camera to expose the image sensor. F-stop is the measurement of that opening. A low f-stop number (for example, f/2.8 or f/4) stands for a wide lens opening, allowing a lot of light through the lens, whereas a high f-stop number (say, f/11 or f/16) represents a small opening and less exposure.

→ *shutter speed, pages 81–85*

Shutter speed

The shutter is a shield in the camera (or in the lens) that opens to let in light for an adjustable period of time when you press the shutter button. This allows light traveling through the lens to expose the image sensor. Shutter speed is a measurement of that time, usually in fractions of a second. So, a slow shutter speed (for example, 1/15 or 1/30) allows more light into the camera and therefore produces more exposure than a fast shutter speed (say, 1/1000 or 1/2000).

ISO

ISO is a numerical rating describing an image sensor's sensitivity to light, therefore indicating how much light it needs for correct exposure. ISO is an adjustable measurement. The higher the ISO, the greater the sensitivity. You can set a high ISO (such as ISO 1600 or ISO 3200) so you won't need much exposure, and this allows you to use a relatively small f-stop and fast shutter speed. Or, you can set a low ISO (say, ISO 100 or ISO 200), so you can use a relatively large f-stop and slow shutter speed to provide a lot of exposure.

ISO stands for International Organization for Standardization—a worldwide association of scientists that sets standards for photography and many other industries. Here, the standard means that ISO 800 on one camera will be the same as ISO 800 on another.

STOP

Photographers use the term **stop** in several ways, but always to represent the doubling or halving of light. For example, you might say "give it one more stop," or "cut exposure by a couple of stops."

Probably the most common use of "stop" is to indicate a change in the lens aperture, where each full f-stop increment is called "one stop." Therefore, f/16 provides one stop less light than f/11; f/4 provides two stops more light than f/8. Again, here is a possible range of full f-stops, each representing a doubling or halving of exposure by one stop:

f/2, f/2.8, f/4, f/5.6,
f/8, f/11, f/16, f/22

You also may use the term stop when adjusting shutter speed, to double or halve the time for which light strikes the image sensor. Changing the shutter speed from 1/250 to 1/125 increases exposure by one stop. Adjusting it from 1/125 to 1/500 decreases it by two stops. Again, here is a range of full shutter speeds, each representing a doubling or halving of exposure by one stop:

1 second, 1/2,1/4, 1/8, 1/15, 1/30,
1/60 , 1/125, 1/250, 1/500, 1/1000

You also can use the term stop to describe ISO settings. ISO 400 is one stop faster than ISO 200, because it makes the image sensor twice as sensitive to light. Likewise, ISO 400 is two stops slower than ISO 1600—indicating a quarter of the light sensitivity. Simple math will tell you how much faster one ISO setting is than another. Selecting ISO 400 makes your image sensor twice as fast (more sensitive to light) than selecting ISO 200 (4 x 200 = 800).

Moreover, the term stop also can refer to the subject lighting—for instance, when the light is brighter on the right side of a portrait subject's face than on the left. If it's twice as strong, it's one stop brighter. And if it's half as strong, it's one stop darker.

Combining F-Stop and Shutter Speed

The relationship between f-stop and shutter speed is key to understanding exposure. It's the combination of these two controls that determines just how much light reaches the image sensor. As discussed, each full f-stop or full shutter speed setting halves or doubles light; a lens aperture at f/8 lets in half as much light as one set at f/5.6, and twice as much as one set at f/11, whereas a shutter speed set at 1/125 lets in light for half the amount of time as 1/60, and twice the time as 1/250.

Thus, f-stop and shutter speed have a reciprocal relationship. By adjusting one setting in a particular direction, you can adjust the other in the opposite direction to deliver an equivalent quantity of light to the image sensor. Setting your lens aperture and shutter to f/8 at 1/125 produces the same amount of exposure as setting it to f/11 at 1/60. At f/11, the lens aperture is one stop smaller than (and lets in half as much light as) f/8, and 1/60 is one stop slower than (and lets in twice as much light as) 1/125. In fact, all the following reciprocal combinations of f-stop and shutter speed settings should produce the same exposures:

> f/22 at 1/15 (small lens aperture and slow shutter speed)
>
> f/16 at 1/30
>
> f/11 at 1/60
>
> f/8 at 1/125
>
> f/5.6 at 1/250
>
> f/4 at 1/500
>
> f/2.8 at 1/1000 (wide lens aperture and fast shutter speed)

There is no single, absolute f-stop and shutter speed combination for a given scene. Many combinations will produce correct exposure. Here, each image was shot with different f-stops and shutter speeds, but each combination received the same overall amount of light—so all exposures pretty much look the same.

f/8 at 1/125

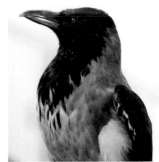

f/5.6 at 1/250

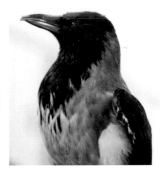

f/4 at 1/500

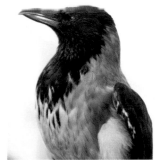

f/2.8 at 1/1000

By choosing one setting over another, you can control your picture's depth of field and appearance of motion. For instance, if you want everything in a landscape to be in focus from a nearby tree to a faraway mountain, you can maximize depth of field by choosing a small lens aperture, such as f/16 or f/22. Or, to freeze the movement of a running horse, choose a fast shutter speed, such as 1/1000 or 1/2000.

Selecting one f-stop or shutter speed over another may have an unwanted effect. For example, if you choose a small lens aperture to achieve greater depth of field, you may have to set a shutter speed so slow that it produces image blur, either because of subject movement or camera shake. Or, choosing a fast shutter speed to stop motion may require a lens aperture so wide that it produces unacceptably shallow depth of field. Often these unwanted effects make no difference at all to the final picture, but sometimes they do.

→ *depth of field, pages 69–73*
→ *motion, pages 85–91*

ISO

ISO plays an important role in exposure, and often in the visual impact of your pictures. In terms of exposure, it helps determine your f-stop and shutter speed settings. The higher the ISO, the more sensitive the image sensor is to light. This means that at high (fast) ISO settings, you'll need less light for correct exposure, and at low (slow) ISOs, you'll need more light.

Consequently, your selected ISO can have a critical effect on the way your picture looks. Since you need a smaller lens aperture or faster shutter speed with high ISOs, you may end up with greater depth of field and/or sharper results. Lower ISOs may result in less depth of field and/or more image blur, because of wider lens apertures or slower shutter speeds.

The higher the ISO, the greater the image noise.

Detail at ISO 100 Detail at ISO 6400

Selecting one ISO over another has an additional, but very important, consequence. It will probably affect your picture quality. High ISO settings produce more image noise (and other digital artifacts) than low ISO settings.

→ *image noise, page 34*

You'll get best quality results by keeping your ISO as low as the light allows. But keep in mind that some cameras produce more image noise at high ISO settings than others. There are many reasons for this, but generally the larger the image sensor, the less noise it will produce.

The following chart suggests ISOs for different lighting conditions. The image quality will vary at different ISO settings, depending on the camera used. But generally the lower the ISO, the better the quality. Note that each of these ISOs represent a doubling or halving of the sensitivity of an image sensor to light. Not all cameras offer the exact range of choices listed below. Some offer less and others offer more. And many allow settings in between, for example ISO 160 or ISO 1000.

ISO	Subject Lighting
50	very bright
100	very bright to bright
200	bright to medium
400	medium to low
800	low
1600	low to very low
3200	very low
6400	extremely low
12,800	near darkness

The light meter's f-stop and shutter speed settings may be displayed in the camera's viewfinder (1), on the LCD screen on the back of the camera (2), or on a screen on top (3).

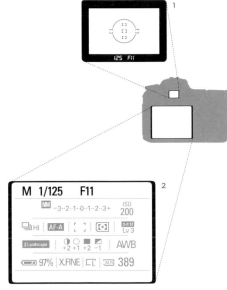

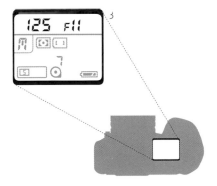

Light Meter

A **light meter** measures the subject lighting and suggests a combination of f-stop and shutter speed that should produce correct exposure for the ISO you've set. Cameras have a light meter built in, and these meters are generally very accurate—in part because they measure only the light traveling through the lens as it reaches the image sensor.

Light meters typically display the suggested f-stop and shutter speed settings in the camera's viewfinder and possibly on a screen on the top or on the back of the camera. The settings you use are also encoded in the metadata of the image file.

Setting the ISO

The f-stop and shutter speed setting suggested by your light meter are linked to ISO. In order to get an accurate reading, the light meter has to know what ISO you're using. You can let the camera set the ISO for you automatically, or you can set it manually. Automation is easiest, and is usually reliable, but it won't always deliver the best results. Setting the ISO manually is simple enough and gives you more control of the picture-taking process.

The ISO is set differently on each camera. Sometimes it's a button and a control wheel or a toggle switch on the camera body, and other times it's in the menu. If in doubt, check your camera manual for instructions on how to set the ISO.

Taking a light meter reading

Once the ISO is set, you're ready to take a light meter reading—or let your camera do it automatically. The meter is in the camera, so to take a reading aim the camera at the subject, compose the picture, and then press the shutter button halfway down. This will activate autofocus (unless you've set the lens for manual focus), but it also will activate the light meter so it suggests an f-stop and shutter speed. This suggestion is based on how much light reflects off of the subject, enters the camera, and strikes the image sensor. In dim light, the meter will suggest a wide f-stop and/or a slow shutter speed to compensate for the lack of light. In bright light, it will suggest a smaller f-stop and/or a faster shutter speed.

If you use the camera on automatic, you simply have to compose the picture, press the shutter button, and the camera does the rest. While the meter is generally accurate, it's dependent on the information you feed it. It reads light according to where you point the lens.

→ common exposure problems, pages 117–121

You won't always get the best results by following the meter's suggested f-stop and shutter speed blindly, whether you're working in automatic or manual mode. Sometimes these settings can produce inaccurate exposures. There are a number of reasons for this, including difficult lighting, user error, and subjects that are overly bright or dark. More on these later.

Also, keep in mind that "good" exposure is not an absolute. To a degree, it's interpretive. Some situations may call for a little underexposure and some for a little overexposure—depending on the final results you hope to achieve. A light meter is the best guide to setting exposure, but sometimes you'll have to fine-tune its suggested settings to get the results you want.

Sarah Small, "Two Mollys on Blue"
Small is known for staging elaborate
tableaux, art performances featuring an
odd cacophony of Balkan music and
male and female nudity. She has long
"engaged in an ongoing pursuit to find
and photograph enchanting people,
animals, and candy colors—exploring the
unlikely interactions born when dissociated
characters are brought together into the
same space."

These Mollys, finding themselves in
the same improbable position, are a good
case in point. Small's sense of hilarity and
spontaneity are well served by her bright
and "open" camera exposure, where
all detail is revealed and dark shadows
avoided. *www.sarahsmall.com*

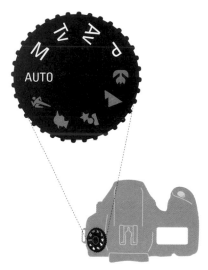

On many cameras, you set the exposure mode using a simple dial on top of the camera. On other models, you use a control wheel and a screen display on top of the camera, or you may have to go into the menu to change the setting. Keep in mind that Tv (shutter priority) may appear on some cameras designated as S or T, and Av (aperture priority) may appear on some cameras designated as A.

→ *flash off, pages 133–134*
→ *autoexposure compensation, pages 114–115*

Exposure Modes

Cameras offer several different methods of setting and controlling f-stops and shutter speeds. These different methods, called exposure modes, include several autoexposure options—full automatic, program, subject-program, aperture priority, and shutter priority—as well as full manual.

These exposure modes offer a range of control. In full manual mode, you have all the control; in full automatic, the camera makes all the decisions. The other modes are more blended—some of the choices are under your control while the rest are under the camera's. In theory, all these modes should produce similar exposures of the same subject, assuming they are used correctly. Depending on how you like to work, and the nature of the subject, you may prefer to use one exposure mode every time you take a picture—or you may choose different modes for different situations.

The way you set your exposure mode varies depending on your camera. The controls are usually on the camera body, with a dial, a button, and a control wheel, or somewhere in the camera menu. Most cameras display the chosen mode in the viewfinder or on the camera's LCD screen.

Full automatic (AUTO, A, or the symbol ■)

In full automatic mode, your camera chooses the f-stop and shutter speed for you, as well as other settings such as ISO and flash. You just frame your subject, and press the shutter button to take the picture. You'll probably see the chosen f-stop and shutter speed in the viewfinder or on the camera's LCD—but you won't be able to adjust them.

The most obvious advantage of full automatic mode is its simplicity. Just focus and take the picture. You should get a good exposure for most "average" subjects—those that have a good balance of dark, middle, and light tones.

The most obvious disadvantage of full automatic mode is precisely this lack of control over exposure. Some subjects are not average, and require adjusting the f-stop or shutter speed for best results. There are also reasons other than exposure to choose a certain f-stop or shutter speed— for example, to increase or limit depth of field or to freeze or blur a subject.

Program autoexposure (P)

Program autoexposure is usually called just **program**. This is also an automatic mode, where the camera sets both the f-stop and shutter speed for you. Probably the greatest advantage of program over full automatic is your ability to control ISO and white balance, turn the flash off and on, and override autoexposure settings using autoexposure compensation.

In program, you can just point, compose, and take your picture, if you like. Or, you can choose a specific f-stop or shutter speed with each exposure, and the camera will adjust the corresponding setting automatically. This feature is sometimes called **program shift**.

Setting a specific f-stop or shutter speed gives you the same exposure as you will get in full automatic mode, but it allows you more control over the visual elements of your pictures. Let's say the full automatic setting is:

<div align="center">f/8 at 1/250</div>

→ *depth of field, pages 69–73*

In program, you can use the suggested exposure as is, or you can change the f-stop to f/16 for greater depth of field. If you do, the camera will adjust the shutter speed to maintain the same exposure. So you'll get:

<div align="center">f/16 at 1/60</div>

Or, you can change the shutter speed to 1/1000 to freeze motion. If you do, the camera will adjust the f-stop accordingly, so you'll get:

<div align="center">f/4 at 1/1000</div>

You'll probably have to adjust the program settings with each exposure. This is because the camera reverts to program's original f-stop and shutter speed setting after you take each picture.

Subject-program autoexposure
In subject-program autoexposure, a variant of program, the camera optimizes the settings for a specific type of subject, such as portrait, landscape, sports, and others. You set the subject type by selecting an icon, and the camera sets the exposure according to predetermined standards for that subject.

If you set **portrait mode** (a head icon), the camera will select a wide lens aperture to achieve minimal depth of field, so the subject is in focus and the background blurred. In **landscape mode** (mountain icon), the camera selects a small lens aperture for a lot of depth of field so the whole landscape will be sharp. In **sports** or **action mode** (running figure icon), the camera selects a fast shutter speed to freeze motion. In **macro mode** (flower icon), the camera chooses a wide aperture to create selective focus similar to portrait mode, but it also links to autofocus for better close-focusing results. In **night mode** (person with a star icon), the camera sets a long shutter speed to handle low light.

While you can accomplish similar results using any exposure mode, subject-program autoexposure makes these decisions for you—but be careful. The settings the camera chooses may not suit your intentions. For example, you may want your portrait subject to have more depth of field than you'll get in portrait mode, or you may want to blur a subject in motion, whereas sports mode might aim to freeze it.

These icons are commonly used for subject-program autoexposure modes.

portrait

landscape

sports

macro

night

Aperture-priority autoexposure (A or Av)

When you set **aperture-priority autoexposure**, you choose the f-stop you want and the camera automatically selects the corresponding shutter speed. This gives you the advantages of autoexposure (simple and spontaneous operation) with direct control over depth of field and low-light situations. (Program also allows you to set a specific f-stop, but only on a picture-by-picture basis. It reverts back to the exposure it originally suggested after each picture is taken.)

For example, if you set the lens aperture to f/16 for a lot of depth of field for a landscape subject, or to f/4 for shallow depth of field for a portrait, the camera will set the shutter speed automatically. Similarly, in low light, if you set the lens aperture to a wide f-stop to capture as much light as possible, perhaps f/2, f/2.8, or f/4 (depending on your lens's maximum aperture), the camera will set the needed shutter speed for you. Once you've set your f-stop in aperture-priority mode, it stays set until you change it.

Be careful you don't set the lens aperture too small or too large for the lighting situation. If you set a small f-stop (for example, f/22) in dim light, your camera may set a shutter speed too slow to freeze the subject (for example, 1/2). Or, in bright light, if you open up your lens aperture too much (for example, f/4), your camera may not be able to set a fast enough shutter speed to prevent overexposure. You may be able to overcome this problem by adjusting your ISO. Use a high ISO if you want to use a smaller lens aperture, and a low ISO for a larger lens aperture.

Note that some cameras alert you when you've set an f-stop that requires a shutter speed that is too slow to avoid camera shake, often with a warning in the viewfinder or on the LCD display—for instance, a shaking hand icon or a beep—if the camera can't set the shutter speed you want. If this happens, some cameras won't allow you to take a picture at all.

Shutter-priority autoexposure (S, T, or Tv)

When you set **shutter-priority autoexposure**, you choose the shutter speed you want and the camera automatically selects the corresponding f-stop. Like aperture priority, this offers the simplicity and spontaneity of autoexposure, but with more direct control—in this case, over camera or subject movement.

For example, if you're concerned about holding the camera steady, you can set a shutter speed fast enough to avoid camera shake—say 1/125 or faster—and expect that the camera will adjust the f-stop accordingly.

→ *camera shake, page 88*

John Goodman, "Ballerina"
One of the biggest problems when photographing in low light is holding the camera steady enough at a slow shutter speed to avoid camera shake. Goodman turns disadvantage to advantage in his signature "moving picture" style, even slightly shaking the camera deliberately at times for effect.

Goodman says he looks for "the shadow and the light and the mystery. Don't tell the whole story. You can have an ill composed, out of control picture and it can still resonate with people." This lack of sharpness and detail in low light help make his pictures seem private, ambiguous, and intriguing. *www.goodmanphoto.com*

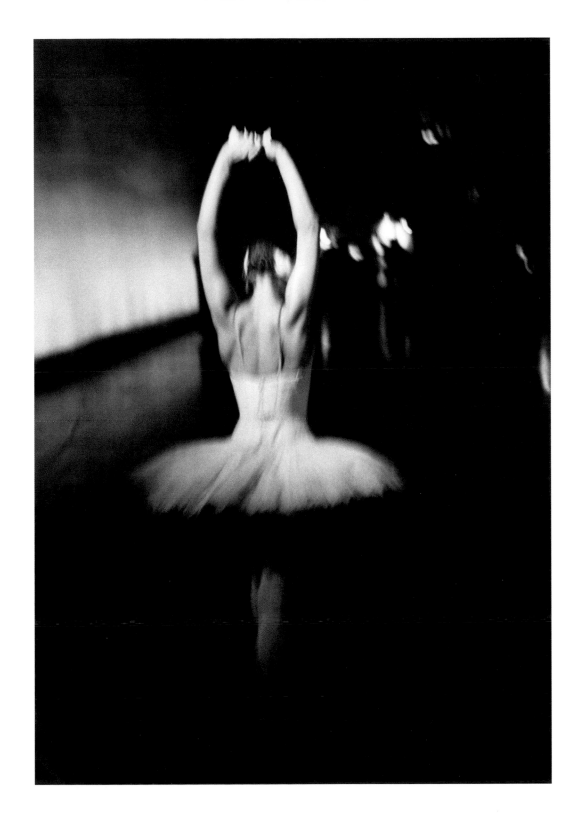

A more common use of shutter priority is when you need a fast shutter speed to freeze action. If you need to stop the movement of a runner at a track meet, set the shutter speed to 1/1000, 1/2000, or faster—letting the camera adjust the f-stop as needed. Alternatively, you can choose to make the same runner a blur by setting 1/4, or some other slow shutter speed. (If you do this, you may want to steady the camera with a tripod or some other stabilizing device, so you only blur the subject in motion and not the whole picture—unless overall blur is your goal.) Once you've set your shutter speed in shutter-priority mode, it stays set until you change it.

→ *steadying the camera, page 91*

Be careful you don't set the shutter speed too fast or too slow for the lighting situation. To stop action in low light, for example, your lens aperture may not open wide enough to allow 1/1000 or another fast shutter speed. To blur action in bright light, the lens aperture may not close down enough to accommodate a slow shutter speed, such as 1/8.

As with aperture priority, either problem may set off a beep or display warning—and some cameras may not allow you to take a picture at all, unless you've set a workable shutter speed. You may be able to overcome this problem by adjusting your ISO. Use a high ISO if you want to use a faster shutter speed, and a low ISO for a slower shutter speed.

Manual exposure (M)

With **manual exposure**, you set both the f-stop and shutter speed yourself, guided by a light-meter reading. The camera's meter is connected to the lens and shutter, so as you set different combinations of f-stop and shutter speed, you can see a display in the camera's viewfinder or LCD to guide you to the correct exposure.

There are different ways that your camera's light meter indicates exposure in manual mode. One common approach uses a horizontal or vertical scale running along an edge of the viewfinder and/or on the camera's LCD screen. The scale has a center marking, indicating correct exposure, and markings on either side, to represent full and partial stops of underexposure (-) and overexposure (+). As you set the f-stop and shutter speed, a marker moves along the scale to show if the exposure is correct (when in the center) or by how much it is off (on the minus or plus side of the scale).

Working in manual mode, the f-stop and shutter speed are set independently, which means you have maximum control over your exposure—as well as depth of field and motion. You're making the decisions, not your camera. The downside is that you can too easily set the wrong f-stop and shutter speed, especially if you are working quickly.

In manual exposure, the f-stop and shutter speed you select may show up in the camera's viewfinder (1), on the display on top of the camera (2), and/or on the LCD screen (3). In each case, you'll see the f-stop and shutter speed you've chosen, as well as the light-meter scale—with the marker in the middle if you've set the meter's suggested exposure.

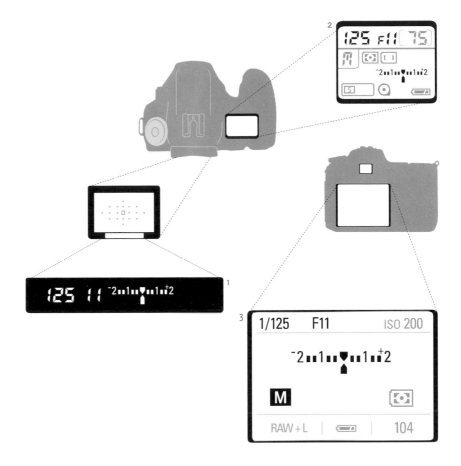

If you understand the basic principles of exposure, manual mode gives you the most flexibility and control over the final results. For example, you can make subtle adjustments when necessary by setting the f-stop and shutter speed to the meter-recommended exposure, then tweaking one setting or the other to let in slightly more or less light. Manual exposure also may help you better understand how exposure works, because you see more clearly how f-stop and shutter speed affect each other—and your pictures.

Checking and Fine-Tuning Exposure

One of the great advantages of digital photography is the ability to see your results immediately after taking the picture—and to make sure your exposure is accurate. There are two main ways to check—by viewing the captured image on the LCD screen and by examining its **histogram**.

TIP: DON'T CHIMP
It's great to be able to check your results immediately on your camera's LCD screen, but it's not always a good idea. Oftentimes, uninterrupted shooting is the best way to guarantee that you're getting good pictures. Obsessively checking your shots, sometimes called **chimping** (referring to the behavior of chimpanzees), can cause you to miss opportunities while your eyes are on the screen, rather than on the subject. And there are times when the action doesn't pause long enough for you to check—for example, if you're photographing an event, such as a football game or a wedding.

→ *hood or loupe, page 46*
→ *zooming the LCD, page 25*

Viewing on the LCD screen

Most people instinctively look at the image on the screen right after they take a picture. The screen image provides a general sense of what the picture looks like—whether the subject looks "good," if it's in focus, or if it's well framed. It also can give a good approximation of exposure. If it looks dark on the screen, it may be underexposed. If it looks light, it may be overexposed.

However, it's usually best not to rely on what you see on the screen when evaluating exposure. For one thing, the screen image can be hard to read, especially in bright light. And even large LCD screens are relatively small, which makes it hard to discern image detail—for example, whether or not you've retained enough information in the **shadows** (dark areas) or **highlights** (light areas).

To better view the screen, you can block ambient light somehow—maybe with a jacket, by moving to a shady area, or by using a viewing accessory, such as a hood or loupe. And to see detail better, you can enlarge the displayed image, usually by pressing or toggling a zoom button or switch on the back of the camera.

A further problem with LCD viewing is that the screen brightness can be adjusted in the camera menu. This adjustment could cause a too-dark picture to look okay, or a well-exposed picture to look too light.

Checking the histogram

A more accurate method of checking exposure is to examine the image's **histogram**—a graph that plots your picture's exposure. You can see the histogram on the LCD screen of most cameras (except some point-and-shoots) after you take your picture—and also later, in postproduction. You can set your camera so that the histogram appears on the LCD screen automatically when the picture is taken or played back. Or, you can call it up by pushing the information or display button on the camera, which allows you to see the histogram on the screen, displayed with or without the captured image.

The histogram charts the actual data in the image file, making it an objective and dependable guide to accurate exposure. LCD viewing is more subjective, because it can be so hard to read the image, particularly in bright light and because LCD screens vary in brightness.

In a histogram, exposure information is represented on the horizontal axis and picture information (pixels) on the vertical axis. The area on the left of the graph represents shadows, with the far left representing the deepest possible black. The area on the right represents the highlights, with the far right representing the brightest possible white. The area in between represents **midtones**—all colors and tones between deep black and bright white.

The higher the histogram goes, the more pixels there are at that level of brightness. For instance, if the left side is high, there is a lot of picture information in the shadows. If the right side is low, there are fewer pixels and less information in the highlights.

For correct exposure of an average scene, you'll usually want a good range throughout, from the left to the right of the histogram. The graph should usually look a little like a range of hills or mountains—with a low level of pixels on the left and on the right, and most of the pixels in the middle. This is because for average scenes most of the picture information is in the midtones, and not in the darkest or brightest areas. Note that there are some situations in which a well-exposed image may display a very different-looking histogram, as discussed below.

A photograph with good overall exposure generally shows good detail throughout—from darks to lights. The corresponding histogram shows many more pixels in the middle of the graph (midtones), and far fewer on the left (shadows) and right (highlights).

Generally you'll want a histogram that looks like a hill that is fairly well balanced, left to right. But subject contrast can markedly affect that look—even if the histogram indicates good overall exposure. In flat light, such as on a gray, rainy day, the histogram will seem more like a plateau than a hill. There will be few, if any, peaks and valleys,

An underexposed photograph has little or no detail in the shadow areas. The corresponding histogram shows many more pixels on the left (shadows/chocolate frosting), and far fewer on the right (highlights/vanilla frosting).

and the left and right sides will have relatively few pixels—indicating a low-contrast image. In harsh light, such as on a bright, sunny day, the histogram will seem more like a valley with a large buildup of pixels on the left and right, and relatively few in the middle—indicating a high-contrast image.

An overexposed photograph with no detail in the highlight areas (eggshells). The corresponding histogram shows many more pixels on the right of the graph (highlights), and far fewer on the left (shadows).

A well-exposed but low-contrast image with no deep shadows or bright highlights. The corresponding histogram has most of its pixels in the middle of the graph (mid-tones), with few on the far left or right.

A well-exposed but high-contrast image with dark shadows and bright highlights. The corresponding histogram has many more pixels on the left and right of the graph than in the middle, indicating high contrast.

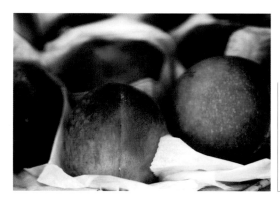

TIP. OVEREXPOSE FOR SHADOW DETAIL

You'll often get better exposures if you overexpose very mildly when you take a picture. This will help guarantee good detail in your shadows, keeping them from becoming too dark and rendering as black with no image detail. If you lose shadow detail when taking a picture, you can't create it later.

A good mild overexposure strategy is to keep your autoexposure compensation scale set at +1/3 or +2/3 at all times. This broad approach usually works well enough for most purposes, but be sure you are working in program, aperture-priority, or shutter-priority autoexposure. Autoexposure compensation doesn't work in full autoexposure mode.

The downside of overexposing is the risk of clipped highlights. Check your LCD from time to time to make sure you're not getting a blinking signal. But adding 1/3 to 1/2 stop should not cause clipping except in rare instances. As always, shooting in RAW gives you more latitude (room for error) and more possibilities for correcting problems when image editing.

MORE ON HISTOGRAMS

A histogram graphs the exposure of an image. It does so by charting a range of 256 levels distributed from pure black (0) to pure white (255)—and also describing approximately how many pixels are in each level. While you can't distinguish all 256 levels on your histogram, it still provides a highly reliable overview of exposure.

It's important to understand that there is no standard or "perfect" histogram. Two different images may display two very different-looking histograms—yet both may be well exposed. There could be many different reasons for this, including the subject itself. One subject may be higher in contrast than another. The same goes for subject lighting conditions—some light is high contrast and some is low. Or, it could be a subjective matter, with one photographer preferring slightly darker or lighter images than another.

It's up to you to interpret the information a histogram provides. As a general rule, you'll want to stay away from capturing subject areas as pure black or pure white, because they will lack information or detail. Shadows that are totally black (underexposed), or highlights that are pure white (overexposed) are referred to as **clipped** shadows or highlights.

Clipped highlights are the bigger problem. (Though, of course any clipped information is lost forever.) Most digital cameras can show you a highlight or shadow clipping warning to signal over- or underexposure in either live-view or playback mode. The areas that lack detail will blink or be outlined in color, which tells you to adjust exposure so you can retain detail. In any autoexposure mode (except for full automatic), you can use the autoexposure compensation scale to reduce or increase exposure when the highlight or shadow clipping warning is displayed, or you can do it manually.

Note that clipped shadows and clipped highlights don't always indicate bad exposure. Sometimes, parts of a scene really do contain dark areas that are totally black, or bright areas that are totally white. For instance, a well-exposed street scene at night may include a completely dark sky or very bright street-lights, both of which may contain no detail whatsoever.

Clipped highlights indicate overexposure. The scene on the left shows a bright area in the center that lacks detail due to overexposure. Your camera's LCD (right) will most likely display a highlight clipping warning for these areas in a color, such as red—and/or by blinking.

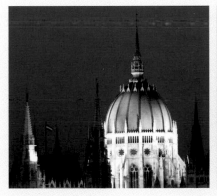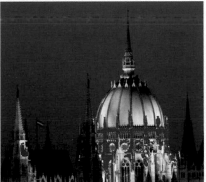

→ *backlight, pages 117–119*

Fine-tuning exposure

Evaluating exposure is not always a straightforward matter. It can be interpretive. You may have to choose one exposure over another to achieve your desired results. For instance, when a subject is backlit you may have to choose whether to retain detail either in the shadows or highlights. You may not be able to get detail in both.

Regardless of the circumstances, if you check your LCD screen or your histogram and don't like what you see, you can fine-tune the exposure and possibly retake the picture. Of course, some subjects are in motion and some situations are spontaneous, and these can't be reshot. But if they can be, you can fine-tune exposure in either autoexposure or manual mode.

If you are in any autoexposure mode, except for full automatic, the easiest way to fine-tune is to use exposure compensation. If the picture is a little dark, set the compensation to a plus setting. When set at +1/3 or

AUTOEXPOSURE COMPENSATION

One of the best ways to fine-tune your exposure is to use your camera's autoexposure compensation scale. You can set the scale to allow in more or less light, and the camera adjusts exposure accordingly and automatically every time you take a picture. The scale works in most autoexposure modes—program, aperture priority, and shutter priority, but not in full automatic.

The scale has a zero point representing the light meter's suggested autoexposure. On either side of the zero, there are markers indicating adjustment increments, usually up to two stops but sometimes more—for instance, from -3 to +3—in half- or third-stop adjustments. One side represents less (-) exposure and the other side more (+). To reduce exposure and make the picture darker, select a "-" increment. To increase the exposure and make the picture brighter, select a "+" increment.

You can change your adjustment from one exposure to the next. Or, you can leave it in place and the camera will compensate with every shot, until you change it. Some cameras reset the scale when turned off and on, while others remember the last setting. You may want to make sure it's set back to zero when you are done shooting, so you don't forget next time.

Autoexposure compensation can be useful when you're shooting successive pictures in a particular situation, and you want all of them a little darker or a little lighter. For example, say you're on a beach on a sunny day and autoexposure is providing slightly dark pictures. Set your autoexposure compensation to +1 for a little more brightness—and keep it set there for all your pictures in this scenario.

You can use autoexposure compensation for significant exposure changes, up to two stops

and sometimes more. However, you're more likely to use it for fine-tuning in fractional increments of +/- 1/2 or 1/3.

Note that there is also an exposure compensation scale linked to your flash, allowing you to adjust its light output. It works independently, but in a similar manner as autoexposure compensation, except it decreases or increases the strength of the flash output.

The autoexposure compensation scale allows you to fine-tune autoexposure in small or large increments. You activate the scale by pushing a button or otherwise selecting the autoexposure compensation symbol (below). Setting the "-" side of the scale provides less exposure and the "+" side provides more. Here, the scale is set at -1/3 stop.

+1/2, the image will be brightened slightly; set at +1 or +2, it will brighten significantly. On the other hand, if the picture is a little bright, set the compensation to a minus setting. When set at -1/3 or -1/2, the image will darken slightly; set at -1 or -2, it will darken significantly.

If you are in manual mode, you can fine-tune exposure either by adjusting the f-stop or shutter speed. If the picture is a little dark, give it a little more exposure by opening up the lens aperture—by 1/3 to 1/2 f-stops for slight brightening or 1 to 2 f-stops for more. Or, use an equivalent slower shutter speed adjustment for a similar effect.

On the other hand, if the picture is a little bright, give it a little less exposure by closing down the lens aperture—by 1/3 to 1/2 f-stops for slight darkening or 1 to 2 f-stops for more darkening. Or, use an equivalent faster shutter speed adjustment.

Metering Modes

Cameras offer a variety of metering modes that you can set either on the camera body or in the menu. Evaluative metering divides the viewfinder into sections and analyzes each one separately. Spot metering reads and evaluates light from a small circle in the center of the viewfinder. Centerweighted metering reads and evaluates light from the entire viewfinder, but places the most weight on an area in the center of the frame.

Be careful which metering mode you use. Different modes may provide different f-stops and shutter speed combinations, even when pointed at the same subject with the same framing. Often such variations aren't extreme, but they may make a noticeable difference in the accuracy of your exposure.

Evaluative metering

An evaluative-metering mode is variously called **segmented**, **multisegment**, **matrix**, or **pattern** metering. This mode divides the viewfinder into several sections—sometimes three or four, but even as many as dozens. The segmented areas vary in size and shape.

With evaluative metering, the meter reads light from the entire viewfinder. Then it analyzes each section, using many factors, including what you're focusing on and sometimes even colors. It uses that information to determine which sections to give the most weight to as it calculates an f-stop and shutter speed combination. For instance, if your picture includes a very bright sky in one corner or a very dark tunnel in another, an evaluative meter may discount the influence of these extreme tones or, depending on your composition and focus, it may choose to give importance to one or the other.

Metering Modes

Evaluative

Spot

Centerweighted

Using spot or centerweighted metering will help guarantee that your meter provides a good exposure reading for the most important part of the picture—here, the peach-colored wall.

Evaluative metering is the default mode for most cameras, and it's usually the most accurate, especially in autoexposure. It works well in almost all situations, but it is especially useful for scenes where light and dark areas are unevenly distributed, such as when your subject is backlit or when you have extreme lights or darks in any part of your picture. Nonetheless, evaluative metering is not foolproof. You may still have to adjust your exposure at times, particularly when your main subject is strongly backlit or when it occupies a relatively small portion of the picture frame, which would make the meter more likely to discount it.

Spot metering

A spot-metering mode reads only a small area of light, indicated by a circle, in the center of the camera's viewfinder, and ignores the rest of what's in the frame when calculating an f-stop and shutter speed combination. The size of the circle varies depending on your camera, but it usually represents about 2 or 3% of the central viewfinder area. Broader spot-metering modes, sometimes called **partial metering**, may read about 10 to 15% of the center of the viewfinder.

Spot metering is most useful when making readings of specific areas in the scene, particularly an area that is darker or lighter than the rest. This might include backlit or high-contrast situations, where you want to make sure the meter reading is concentrated on what is most important. For example, a musician onstage may be brightly lit, but surrounded by a dark background. If you use the reading in evaluative mode, the musician may render too bright, because evaluative metering considers the entire viewfinder, even the dark areas. A spot-meter reading, however, considers only the light falling on the musician, making it more reliable in this situation.

Note that you must make sure that the meter covers only the area you want to read. If it's pointing elsewhere, you'll likely get an inaccurate reading. For that musician onstage, you may need a telephoto lens to bring you close enough to take a spot-meter reading.

Centerweighted metering

A centerweighted-metering mode averages all the light in the viewfinder when calculating exposure. It gives the most weight to areas in the middle, and proportionally less to areas toward the edges of the frame.

Centerweighted metering works best when the main subject of the photograph is in the middle. This is a reasonable assumption, since many photographs are composed that way—think of simple portraits and snapshots. It also works well for average subjects with no

unusually dark shadows or bright highlights—in which the average of all the tones is approximately a middle gray, more or less, such as on gray, cloudy days.

Camera makers use various ways to design their centerweighted systems. One may assign 60% of their calculation to the area in the center of the frame, while another may assign 80%.

Common Exposure Problems

Some exposure problems result from a faulty camera. For instance, your shutter could be misfiring, or the meter may need adjustment. These are problems that can only be solved by a camera repair shop. You may be able to find one where you live, but often your best bet is to send it to the camera manufacturer, after checking their website for details on how to send it in.

But user error or mishandling tricky lighting situations are more common problems. Perhaps you made a mistake when metering your subject or you made a wrong adjustment in the camera menu. These are common enough errors, especially since some subjects are inherently difficult to meter correctly, even when the camera is working well and you are doing everything according to the book. Two of the most common problems come from backlighting and shooting in low light. In each case, you may have to take your light meter reading, then adjust that reading to better fit the circumstances.

Backlighting

A scene is effectively backlit any time the light behind the subject is brighter than the light in front. Backlighting is one of the trickiest and most common exposure challenges. When taking a picture of a backlit subject, chances are that the overall scene will be well exposed, but the subject will be too dark—or sometimes totally silhouetted with no detail whatsoever.

The reason for this is that the rest of the picture has plenty of light, and quite possibly a good balance of lights and darks. But the backlit subject gets little, if any, direct light and falls into shadow. In effect, the backlit subject is underexposed, even when the rest of the picture has perfectly good exposure.

A classic backlit situation can occur when you shoot into the sun—with the sun shining on the back of your subject. If you can do it, the simplest solution is to reposition your subject, or yourself, so the sun falls on the side or front of the subject.

TIP: TOO MUCH SKY

If your subject includes a lot of bright sky, there's a good chance that whatever is on the ground will be backlit and underexposed. The solution is to adjust the light meter reading and let more light in—by setting autoexposure compensation to +1 or +2 (in any autoexposure mode other than full auto) or by opening up the lens aperture or slowing the shutter speed by a stop or two (in manual exposure mode). This will brighten up the entire picture, providing more detail on the ground and a brighter sky, which may have to be darkened later in postproduction.

Lauren Greenfield, "Models for Alexander McQueen's Spring Show"

Greenfield's documentary work often focuses on aspects of American culture. It includes several books and films about youth, chronicling the lives of girls in the shadow of Hollywood (*Fast Forward*), as well as those with eating disorders (*Thin*) and too much money (*kids + money*).

Here, Greenfield photographs models on a walkway, backlit by a live-feed video broadcast of the show in progress. McQueen's collection imagines what people would look like had we evolved from sea creatures. Greenfield had to give her backlit subjects extra exposure so they didn't become silhouetted. The extra exposure causes the backdrop to "blow out" and retain virtually no detail, helping to produce a surreal effect.
www.laurengreenfield.com

Backlighting occurs when most of the light is behind the subject. This scene (1) is well exposed overall, but the statue is too dark because it's in shade and not directly lit. To lighten the statue (2), you have to provide more exposure when photographing than your meter may suggest. The easiest way to do this is to use +1 or +2 or some other increment in autoexposure compensation (in any autoexposure mode except full automatic) or simply set a wider lens aperture or slower shutter speed (in manual mode).

1

2

However, backlit situations are not always so obvious. And they don't always happen when the sun is facing the camera. For instance, a scene that includes a lot of sky may cause your subject to be backlit, simply because the light from the sky is dominant.

A comparable situation occurs indoors, when your subject is positioned in front of a window with bright outdoor light coming through. You may get good exposure on the outdoor scene at the expense of underexposing your subject—making it look too dark.

It often comes down to a choice between retaining detail in the shadows or highlights, keeping in mind that you may lose detail in one or the other. If you take the picture at the suggested settings, you'll probably get a silhouetted figure against a bright background. If you want detail in the shadows, you'll have to adjust your exposure to let in more light, so the shadows will brighten up. In doing so, the highlights may "blow out" and become totally white. Adjust exposure by adding more light in autoexposure compensation, or by opening the aperture or slowing the shutter speed in manual mode.

A totally different approach to dealing with backlight is to balance the foreground and background by "filling in" (adding) light to the darkened subject. You can use flash, called **fill flash**, or another supplementary light source to add light to the foreground. The next chapter discusses using flash in detail.

→ *fill flash, page 134*

Low light

In theory, you can take a picture of almost any subject, even when the light is extremely low. But in practice, a dimly lit scene may present daunting challenges—too often leading to underexposed results. After all, good exposure depends on enough light reaching the image sensor, which can be a problem when there's not much available light to begin with. This is why most pictures taken in low light are shot with flash to provide extra light for a good exposure. But flash light looks very different from natural light. Following are some hints on photographing effectively in low light without flash (or other supplementary lighting).

Use a high ISO—800, 1600, 3200, or higher. This makes your image sensor more sensitive to light, so it needs less exposure than it would when set at a lower ISO. Keep in mind the potential consequences. Using a high ISO usually leads to lower image quality, such as weaker color, higher image noise, and possibly other digital artifacts.

Use a wide lens aperture or a slow shutter speed, or both, to let in as much light as possible. Again, there are consequences: a wide lens aperture produces shallow depth of field, and a slow shutter speed increases the chances of image blur.

Set your camera on a tripod, so you can use a slower shutter speed to let in more light without causing camera shake during exposure. This can allow you to use a lower ISO for less image noise. It also can produce increased depth of field by allowing you to set a smaller lens aperture with a longer shutter speed. As long as you have a good tripod to steady the camera, a long shutter speed shouldn't cause camera shake (but it also won't freeze subject movement).

→ *flash, pages 131–143*

Photographing at night or other low-light situations can be challenging.

LOW LIGHT AND IMAGE NOISE

There are a lot of reasons why low-light subjects may produce more image noise than more brightly-lit subjects. High ISOs are usually the culprit. The higher the ISO, the greater the noise, even though some cameras handle high ISOs better than others. Underexposure is another cause of excessive image noise. Low light often causes some measure of underexposure. Even when the overall exposure is adequate, the shadow areas of a subject may still not get enough light, in which case they would be underexposed and quite possibly noisy.

Moreover, long shutter speeds can sometimes produce excessive image noise, because some cameras simply don't process long exposures as efficiently as short exposures. The latest model cameras work better in this regard than earlier models, but it still makes sense to keep your shutter speeds relatively short to help keep noise to a minimum. Or, if your camera has it, you can turn on a long exposure noise reduction setting, which may help considerably, although it may also make in-camera image-processing times longer.

TIP: IT'S OKAY TO GUESS

Don't be afraid to guess at low-light exposure. You can always see the results right away or check the histogram to make adjustments, if needed.

Oftentimes light meter readings are less reliable in dim light than in bright light. For one thing, there's less light to read. Also, low-light scenes often have a lot of contrast, which can throw off your meter. For example dark areas can be easily underexposed in a room that contains both very dark shadows and very bright highlights, such as lightbulbs.

Try ignoring the meter entirely and making an educated guess at exposure. Set your camera in manual exposure mode and your ISO at a high setting—ISO 800, ISO 1600, or even higher, if the light is especially dim. Then, open your lens to its widest f-stop—perhaps f/2, f/2.8, or f/4. Now, set a slow shutter speed, perhaps 1/60 or 1/30 or even 1/15—hopefully one that doesn't cause blur. An image-stabilized lens, a tripod, and a stationery subject will help. Then, compose, focus, and take your picture. Don't worry too much about overexposing the scene. In low light, underexposure is far more likely than overexposure.

TIP: SHOOT RAW

In low light, you often need all the help you can get. This could include high ISOs, large lens apertures, slow shutter speeds, and so forth. But your best safety net may be to shoot in RAW, rather than JPEG. RAW basically retains all the information the image sensor gathers. This means that in postproduction, you will be able to pull out detail in underexposed shadow areas that you might otherwise lose with JPEGs.

Turn on image stabilization (IS) if your lens or camera offers it. This should better allow you to hold the camera steady at slow shutter speeds—again, to allow more light to reach the image sensor. It's usually best not to use image stabilization when your camera is on a tripod, unless your lens or camera has a tripod setting, as using both together may cause some IS systems to act erratically.

Use prime lenses, not zoom lenses, because most prime lenses open up to a wider maximum lens aperture, so they can capture more light than a zoom. Keep in mind that a wide lens aperture is great for capturing much needed light in dimly lit scenes, but it also produces shallow depth of field—an advantage or not, depending on your desired results.

More on Exposure

Autoexposure lock (AEL)

Your camera's meter changes its exposure recommendations continually in all autoexposure modes as you move the camera to frame your subject. In most cases, this helps produce the most accurate results, because you may need different f-stops and shutter speeds even if you adjust your framing only slightly. However, if you take a meter reading and don't want it to change when you adjust your composition, you can lock it in by setting your camera to **autoexposure lock (AEL)**.

Point your camera at the area of the subject where you want to take the meter reading. Press the shutter button halfway down to take the exposure, then press the AEL button on the camera body. As long as you hold down the AEL button, the camera will lock in the f-stop and shutter speed until the picture is taken. Now recompose the subject and take the picture.

If your landscape subject is a row of trees against a bright sky, take a light meter reading of the trees only by pointing the camera down so the viewfinder doesn't include the sky. Then, lock in that reading with AEL, recompose so the sky shows in the frame, and take your picture.

You also may be able to walk right up to the main subject to take the meter reading, so you measure only the light from the subject and avoid light from the background. You can retain that exposure reading by using AEL, and then move back to take the picture.

Bracketing exposures

One method of guaranteeing good exposure is **bracketing**, making three (or more) exposures of a scene at a range of f-stop and shutter

Bracketing

f/8 at 1/125

f/5.6 at 1/125

f/11 at 1/125

speed settings. Bracketed exposures generally include the meter's suggested f-stop and shutter speed, one stop more light, and one stop less. Some photographers make brackets of two stops with more or less exposure—and still others make brackets with third- or half-stop increments.

By bracketing you can pretty much ensure that you'll get at least one ideal exposure. Bracketing is usually used only when necessary with challenging exposure situations or critically important subjects—when you need to guarantee the best possible exposure.

If you're shooting RAW, you may not need to bracket often, if at all, especially if the lighting isn't too extreme. Your image files will probably have all the information you need to produce a well-exposed image—after you've worked on them in postproduction. If you're shooting JPEGs, bracketing makes more sense. By making multiple exposures of the same subject, you're more likely to get at least one that will provide perfect results—with little or no postproduction needed.

There are many ways to bracket exposures. In program, aperture-priority, or shutter-priority mode, you can use autoexposure compensation. For instance, to make a one-stop bracket, take an initial exposure at whatever the camera meter suggests, then take a second exposure with exposure compensation set at +1 (for one stop more exposure), and a third exposure set at -1 (for one stop less).

In manual exposure mode, the easiest way to bracket is to adjust the f-stop and/or shutter speed incrementally. For a one-stop bracket, take an initial exposure at whatever the light meter suggests, say f/8 at 1/125, then take a second exposure adding one stop more light at f/5.6 at 1/125, and finally, take a third exposure with one stop less light at f/11 at 1/125. Of course, you also can adjust the shutter speed instead of the lens aperture.

Your camera probably offers **autoexposure bracketing (AEB)**, allowing you to vary the bracketed exposures up to two or more stops on either side of the meter's suggested exposure. Press the shutter button once, and the camera fires three times in succession—or more depending on how you've set it up. Make sure you hold the camera steady during all the bracketed exposures, using a tripod or image-stabilized lens when possible.

Bracketing works especially well for still subjects. Candid or moving subjects may not sit still long enough to maintain the exact same framing throughout all the brackets, although autobracketing does allow you to take three or more shots very quickly.

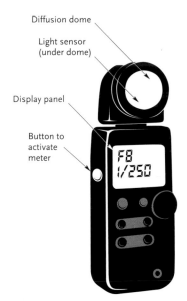

Diffusion dome

Light sensor
(under dome)

Display panel

Button to
activate
meter

F8
1/250

Handheld light meters usually read reflected light, but most have a diffusing dome or panel that can be positioned for reading incident light.

Handheld light meters

Your camera's built-in light meter should provide consistently good results in either autoexposure or manual exposure mode. However, some photographers prefer a separate, **handheld light meter** for more controlled readings.

There are two basic types of handheld meters. One is a **reflected light meter**, which reads light that bounces off your subject. This also is the way your in-camera meter works. The second type is an **incident light meter**, which reads the light that falls on your subject. While you use each type a little differently, there are similarities in operation. In both types, you set your ISO on the meter, position it to read the light, and take the reading. With your camera in manual exposure mode, you then set the f-stop and shutter speed according to the meter's recommendation, totally ignoring your in-camera meter. If the handheld meter reading suggests settings of f/8 at 1/250, use this combination—even if the in-camera meter suggests f/16 at 1/250.

With a reflected light meter, point it toward your subject to read the light bouncing off. There are many ways to use a reflected meter, but you can use these simple suggestions as a guide. Be careful where you point the meter. In particular, avoid bright or dark areas, or you may get an inaccurate reading. For example, if a landscape scene includes a bright sky, point the meter toward the ground below. Or, with a portrait, walk up to your subject and take a reading that doesn't include much, if any, background.

To use an incident light meter, place it at the subject position—or as close to the subject as you can get, so long as it's in similar light. Point the meter so it reads the light that falls on the subject, and take your reading. Incident readings are more generalized. They can't be fooled by mostly light or dark areas in a scene, since they don't read light reflecting off of specific areas of a scene.

Most handheld light meters can read either reflected or incident light. They have a diffusing dome or panel that can be positioned over the meter's light-gathering sensor for reading incident light, or removed for reading reflected light.

Note that some handheld meters display their reading digitally, while older types use a needle display—with one needle matching another (or some other indicator). A variety of models are available, ranging from simple and inexpensive to sophisticated and costly. A very few handheld light meters even cost more than a decent DSLR.

Chapter 5
Subject Lighting

Suggested Workflow: Subject Lighting

1. Look over the scene you want to photograph.

2. Determine if there is enough light. If there isn't much light, use a slow shutter speed with your camera on a tripod or a high ISO setting or both. Or, add flash or other supplementary lighting to the scene.

3. Decide if you like the characteristics of the subject lighting, such as the quality and direction of the light and its contrast and color. If need be, adjust the white balance, come back later when the light has changed, or add flash or other supplementary lighting to the scene.

4. If using flash, set it on autoflash or manual flash mode.

4a. In autoflash mode, consider setting your flash exposure compensation scale to minus if your subject is close-up and to plus if it's far away. Check the LCD screen or histogram and adjust the exposure if the picture looks too bright or too dark.

4b. In manual flash mode, set your shutter to the correct synch speed (usually 1/125 or 1/60 or slower). Then, set the f-stop according to the distance the light will travel from flash to subject. Check the LCD screen or histogram and adjust the exposure if the picture looks too bright or too dark.

5. If circumstances allow, bring studio lights to your subject or bring your subject to a studio, and use continuous lights or strobes for more control over the characteristics of the light and exposure.

6. Take your picture.

→ *white balance, pages 37, 39–40*

Todd Hido, "# 3212–b," Belle Island, Michigan
Sometimes color that is a little "off" makes for better pictures than color that is spot on. Hido often photographs bad weather and late afternoon or evening light to make his evocative landscapes. The scenes are usually quite ordinary—maybe just a tree, or a house in a normal neighborhood—but it's the way he photographs them that makes them "work."

"People ask me how I find my pictures, Hido says, "I tell them I drive around." Here, during a late afternoon rainstorm, he photographed through his car window, picking up drops of rain which blur the scene and mute the colors to add a sense of mystery and melancholy. *www.toddhido.com*

Light is the most fundamental component of a photograph. It creates a picture by reflecting off the subject and traveling through the lens to expose the image sensor. Moreover, the nature of the light goes a long way toward establishing the look and feel of a picture—such matters as color, sharpness, and contrast.

This means that learning to see and work with the subject lighting is a critical skill for making effective pictures. Most of the time, your subjects will be lit by **natural light** from the sun or **available light** from lightbulbs, streetlights, fluorescent lamps, or a combination of natural and artificial sources. But there are times when you'll want to use **supplementary light**, various types of lighting made especially for photography, such as on-camera **flash** or studio lights.

→ *flash, pages 131–143*

For the best pictures, you should learn how to assess the light and predict how it will affect the results. Then, you can adjust your composition accordingly. Or you can use flash or other supplementary lighting to modify the natural or available light. For example, if the sun is behind your subject, causing it to fall into shadow, you can reposition him or her—or you can use a flash to brighten (fill in) the shadows.

This chapter will cover essential information about light. There is a lot to know and it may take a while for you to begin to understand it. But if you look carefully before you shoot, you'll soon be able to see what the light is doing—and what you need to do to make the picture you want.

Characteristics of Light

Some of light's most important characteristics include its intensity, quality, direction, contrast, and color. Keeping all these in mind every time you take a picture can be daunting. However, you should try your best, because all these traits affect the final look of your pictures.

Some of these characteristics can be simulated in postproduction— but some cannot. And you'll almost always get more convincing results, and better quality, if you capture the light the way you want it when taking the picture. Also, you'll save a lot of time in postproduction.

Intensity

Some light sources are inherently stronger than others. Midday sun is stronger than light from fluorescent bulbs, stadium lights are brighter than candlelight, and so forth. The intensity of the light will have an effect on how your pictures look, sometimes in obvious ways and other times more subtly.

TIP: TAKE IT NOW OR TAKE IT LATER

Most of the time, it's best to take a picture when you see it, and not wait until later. Often, "later" never comes. You forget about the picture, or you just never get around to it.

Sometimes you'll see a good subject, but it will be in bad light—light you can't control. In this case, take the picture to be sure you have it, but make a note of it and return at another time to rephotograph it in more favorable light.

Imagine a beautiful landscape scene with morning sunlight reflecting right at the camera lens. If you take a picture, the landscape will fall in shadow—and you may get undesired lens flare from the sun. Make a note of the subject and return on an overcast day or in the afternoon, when the sun's position has shifted so it more fully illuminates the landscape.

This strategy works best with subjects that stay put, such as landscapes and buildings. Moving and candid subjects probably won't be available when you return—at least not in the way you initially saw them.

Allen Frame, "Veronesa, Mexico City"
Frame's subject is sitting in a patch
of late-afternoon sun. The dappled
light creates dark shadows and bright
highlights, giving the picture a strong
three-dimensional quality and evoking a
romantic or ambiguous feeling. Although
they are dark, most of the shadows retain
some detail, but the subject's head falls
into moody darkness.

"I like it when my portrait subject
is looking elsewhere, lost in thought,"
says Frame. Here, the subject's hidden
face "puts an emphasis elsewhere and
creates some mystery." *www.allenframe.*

For example, a bright day on the beach can strongly illuminate a subject, revealing a lot of detail, which may help make a picture feel welcoming and "open." On the other hand, a dimly lit nightclub scene may have a lot of shadowy areas, with only a few bright patches of light. This can produce a mysterious, romantic, or even edgy mood.

Keep in mind that the strength of light in a scene also has important technical implications in terms of depth of field, motion, and image quality. Bright light, for example, allows for a smaller lens aperture, faster shutter speed, and/or lower ISO. Low light requires a wider lens aperture, slower shutter speed, and/or higher ISO.

Quality

Light quality is often characterized as either **hard** or **soft**. Hard light travels uninterrupted from its source to the subject, as happens in bright sunshine, or with a spotlight, and produces pictures with good contrast and sharpness. By creating bright highlights and deep shadows, hard light also emphasizes texture and depth. For example, in late afternoon, sunlight on a subject's face may be bright on one side and dark on the other, making the subject seem three-dimensional rather than flat, with features defined by light and shade.

Light is soft when it is diffused, or interrupted, as it travels from its source to the subject, such as when sunlight is scattered by clouds on an overcast day or in the shade of a tree. Softened light produces less contrast, less defined edges, and fewer dark shadows. In soft light, a face is more evenly illuminated, with little difference between both sides, often creating a somewhat flat, two-dimensional effect.

Direction

The direction of the light can emphasize the surface texture of a subject, create a hyper-dramatic effect, make it seem flat, and so much more. Most of the time, you'll want light to strike your subject from the front, or close to it. Frontal lighting generally illuminates what's important in a scene, and reveals the maximum amount of subject detail.

However, different angles of frontal lighting produce very different effects. For example, light that strikes the subject from the front, at an angle, can emphasize depth and surface texture. And light striking straight on can flatten its appearance and obscure textural qualities. On the other hand, backlighting, light striking a subject from behind, can cause silhouetting and other forms of darkness that obscures subject detail.

1

2

The direction of the main light source has a pronounced effect on the textural quality of the picture. When the light shines directly at a subject (1), you'll see far less texture than when the light comes from the side, skimming across its surface (2). This **sidelight** could happen in the late afternoon on a bright sunny day when the sun is low in the sky, or in a studio setting, such as in these pictures.

→ *backlight, pages 117–119*

Contrast

Contrast is the difference between the highlights (light areas) and shadows (darks) of a scene. High contrast, sometimes called **harsh**, **hard**, or **contrasty**, occurs when highlights are relatively bright and shadows dark. Low contrast, sometimes called **soft**, **flat**, or **diffuse**, occurs when the scene lacks bright highlights or dark shadows.

Pictures shot on a day with bright sun generally display high contrast. But if clouds set in and diffuse the sun, you'll get less contrast. Rainy days are generally even grayer, more flat, and overall a little blue in color.

A rainy day produces gray, flat light, with a mild bluish cast.

Contrast is affected by many factors other than subject lighting. For example, some subjects simply have inherently more contrast than others; a fair-skinned person wearing a light T-shirt will have less inherent contrast than that same person wearing a dark shirt.

Most often, you'll want your image to have a good range of tones from shadow areas to highlights—not too much contrast and not too little. However, you might reasonably decide that a harsh or flat look works best for a picture you're trying to make.

Color

Light may be color neutral, with no apparent tint, or biased toward **warm** (yellow/orange) or **cool** (blue). The color of light is described as **color temperature**, and rated in degrees **Kelvin** (K). A sunny day around noon generally produces neutral color, at about 5000–6500K. Light at sunset is lower in color temperature, about 3200K, and therefore is yellow/orange. A mildly rainy day has a high color temperature, around 8000K, and produces a blue cast.

TIP: GOLDEN LIGHT

You can take good pictures in most any type of light, but many photographers favor the yellow-orange glow of early morning and late afternoon—when the sun is low in the sky. These times of the day often provide the richest, warmest light possible. There's no guarantee, however. Early morning on a cloudy day can take on a blue cast and kill the warming effect.

Color temperature is measured along the Kelvin scale, from warm light sources to cool ones.

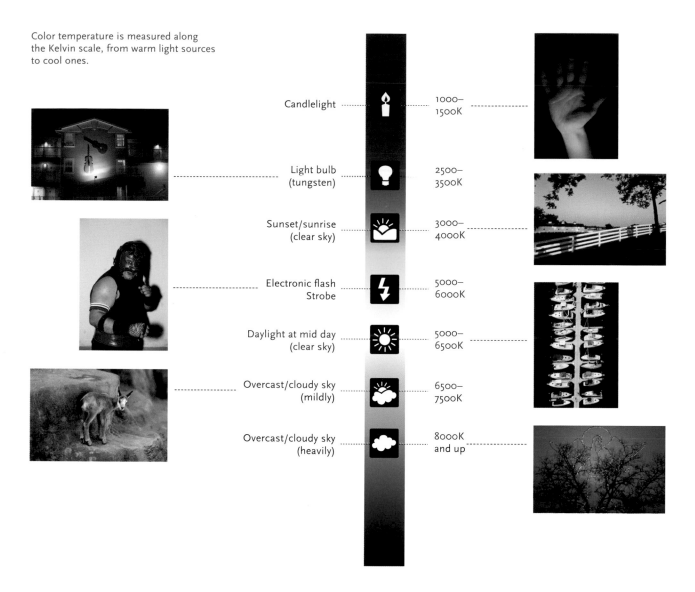

		
Candlelight		1000–1500K
Light bulb (tungsten)		2500–3500K
Sunset/sunrise (clear sky)		3000–4000K
Electronic flash Strobe		5000–6000K
Daylight at mid day (clear sky)		5000–6500K
Overcast/cloudy sky (mildly)		6500–7500K
Overcast/cloudy sky (heavily)		8000K and up

TIP: LET THE COLOR OF LIGHT SET THE MOOD

Some photographers are obsessive about color balance, often going to great lengths to make sure the color in their pictures is perfectly neutral (balanced). But sometimes it's best and most natural to let the color be whatever it wants to be. Cool light before the sun comes up can be eerie, while a warm, late afternoon sunset can feel romantic.

These Kelvin temperatures are variable. Not all days at noon produce exactly the same color, and the same goes for sunset or rainy days. There are many factors involved, including time of day, weather, season, angle of light to the subject, geographical location, and even environmental conditions. You don't need to know all the Kelvin values. It's just as helpful to know the relative warmth and coolness of different kinds of light.

8 am

10 am

12 pm

2 pm

5 pm

8 pm

The time of day has an important effect on the way your picture looks. Above is a series of pictures taken at different times—from the flat, blue early morning to the rich evening light.

Flash

The most common supplementary lighting is flash. Usually, flash is used to add a strong blast of light in low-light situations when you otherwise don't have enough light for good exposure. Other uses of flash include freezing the motion of a moving subject and filling in (brightening up) dark areas, due to harsh light on a bright sunny day or indoors when the available light only partially illuminates your subject.

Flash is linked to your camera's shutter. When you press the shutter button, a gas-filled tube inside the flash unit emits a burst of light for a very short duration, which can range from about 1/125 to 1/10,000 of a second, and even shorter. A reflector behind the tube directs the light forward toward the subject. This instantaneous burst is so quick that a flash can freeze the motion of a moving subject.

Types of flash

There are three main types of flash: **built-in**, **portable**, and **studio**. The simplest type is built-in flash, which is integrated into the camera body. Built-in flash is convenient and automatic, but it's not very powerful or versatile. Its useful range is generally ten feet or less, and it only allows you to aim the light directly at your subject, not at an angle.

There are two main ways to freeze the action of a subject. You can use a fast shutter speed or you can use a flash. The burst of light from some highly specialized flash units is so brief that it can even freeze a bullet in motion. Here, the burst from a simple portable flash is fast enough to stop the action of the shuffling cards.

Built-in flash

Portable flash

Portable flash units that attach to the camera body are less convenient to use than built-in flash, and can be relatively pricey, but they are much more variable and powerful—some have a range up to thirty feet or more. Portable units can be used on- or off-camera, and often tilt and swivel, so can be aimed at a ceiling, wall, or elsewhere for a variety of lighting effects.

For even more power and flexibility, there are studio strobes, which are made for working professionals. Most models are not very portable but they are very powerful, light up large areas, and can be moved around and adjusted for almost any use.

Parts of the flash
1. Flash head
2. Reflector (in back of flash tube)
3. Hot shoe mount
4. Flash tube
5. LCD screen
6. Light sensor
7. Buttons for settings

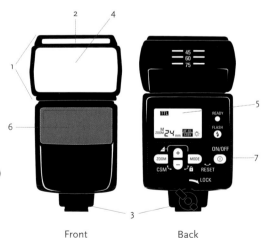

Front Back

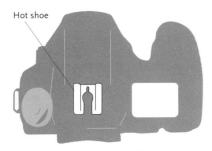

A hot shoe sits on the top of the camera, and has a slot to hold and connect a portable flash unit.

Hot shoe

Even though these flash types are very different, they all provide a short burst of light, and they have other things in common as well. For instance, a flash must always **sync** (synchronize) with the camera's shutter—that is, it must fire when the shutter is wide open. This is not a problem with a flash built into the camera, because it is a dedicated system—everything works together, as it should. But with a portable flash, you have to slide the unit into a **hot shoe**—a bracket located above the lens on top of the camera. The hot shoe has an electrical contact to the camera's shutter, which signals the flash to fire when the shutter button is pressed.

To sync with the flash, the camera's shutter speed must be about 1/60 or 1/125 or slower. If you use a faster speed, the shutter will reveal only part of the image sensor by the time the flash fires, leaving you with only a partial image. You usually don't have to worry too much about this, because most of the time you'll be using your flash in automatic mode, and your camera will set the sync speed itself. But if you're using your flash in manual mode, you may need to set a shutter speed yourself. Note that a few cameras do allow for a faster sync speed—usually 1/250. And very few camera models sync at any speed.

Built-in autoflash

Built-in flash units can be used in **autoflash** (automatic flash) mode, which has a range of options. You usually select these options somewhere on the back of the camera. You'll see a dedicated flash-mode button, often illustrated with a lightning-bolt symbol. Press the button to navigate through a series of choices. On some cameras, the button may be located elsewhere, or the options may be offered in the camera menu.

Note that some cameras offer all the options below, but some do not. And some flashes offer options not even mentioned here. Check your camera and/or flash manual for specifics.

Flash off keeps the flash from firing at all.

TIP: FLASH OFF

Most pictures taken in low light are lit by flash to ensure a good exposure. Your camera may even automatically activate its built-in flash when it thinks you need it. While flash may significantly improve your chances of achieving adequate exposure, it will also alter the picture's mood. Existing light almost always feels more natural. It can create dimensionality, nuance, drama, and any number of visual and emotional qualities.

Sometimes, there are practical reasons for not using flash. You may not want a distracting burst of light when photographing candidly, such as in a theater or other darkened venue. And there are times when you may not have a flash on hand—and you'll have to make do with whatever light is available.

Turning off the flash and photographing the piano player with available light makes the scene look more natural, three-dimensional, and moody.

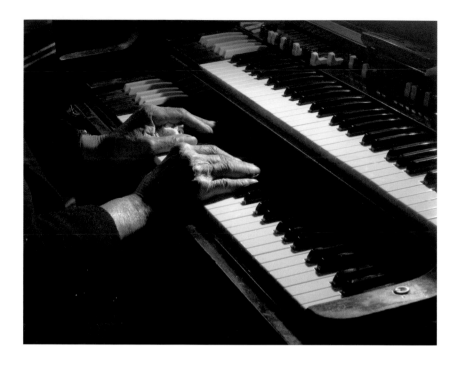

 Auto/automatic (Auto or A) flash mode allows your camera's flash to fire anytime it decides more light is needed to make a good exposure. If it decides light isn't needed, it won't fire. As in any automatic operation, this option often provides good results—but not always.

 Forced flash, also called **fill flash** or **flash on**, triggers the flash all the time, regardless of how much light the camera senses. Usually, you'll only use this setting in low light, but you can also use it in situations where you might otherwise expect no flash would be needed, such as in bright sunlight. The sun can create unflattering dark shadows on the face of a portrait (or other subject). Forced flash will fill in (lighten) these shadows and also soften the contrast.

Red-eye reduction reduces the likelihood of **red-eye**, which occurs when the flash fires at a dilated pupil. Pupils dilate (open) in low light to make seeing easier. The light passes through the open pupil and reflects off the back of the eyeball, causing it to appear red. Red-eye is especially common with built-in flash, since the flash's light strikes the eye from the same direction that the lens captures the picture. Note that point-and-shoot-cameras are especially likely to produce red-eye.

The most popular way to eliminate or reduce red-eye is with your camera's red-eye-reduction setting. In this mode, your camera will fire one or more short bursts of light to cause your subject's pupils to contract before taking the picture. This strobelike effect can be annoying to those around you, so you might want to use red-eye reduction sparingly. And make sure you don't move the camera until the final burst of flash, which is when the picture is actually captured. Otherwise, you might mess up your composition or produce a blurry picture.

One good reason not to use red-eye reduction is that it often doesn't work very well, if at all. A better solution is to use a portable flash unit off-camera so the burst of flash reaches your subject at a different angle than the lens sees—reducing the amount of light reflected directly towards the lens by the subject's eyes. Finally, you can always retouch red-eye in postproduction. Most image-editing programs have an automatic red-eye-reduction tool that can get the job done—or you can simply retouch the red manually.

→ *image editing, pages 168–203*

Red-eye can occur when a subject's eyes are dilated, especially if the flash is aiming at the subject at the same angle and direction as the lens. ©Jesse Stansfield

→ *inverse square law, page 137*
→ *shutter speed, pages 81–85*

Slow shutter sync is sometimes called **nighttime flash mode**. Flash often gives you a well-exposed foreground, but a dark background. This is because light from the flash falls off (gets dimmer) with distance: the further the subject from the flash, the darker the result, as described by the **inverse square law.**

Using a slow shutter speed with your flash better balances the light from the foreground and the background. With slow shutter sync, light from the flash will expose the foreground correctly, and the slow shutter speed will allow in enough ambient light to improve background exposure.

There are two slow shutter sync options in autoflash: **rear curtain sync** and **front curtain sync**. Your camera may offer one or the other or both. "Curtain" refers to the shutter, which opens and closes to allow light in. And "sync" refers to synchronizing the flash, so it fires when the shutter is fully open.

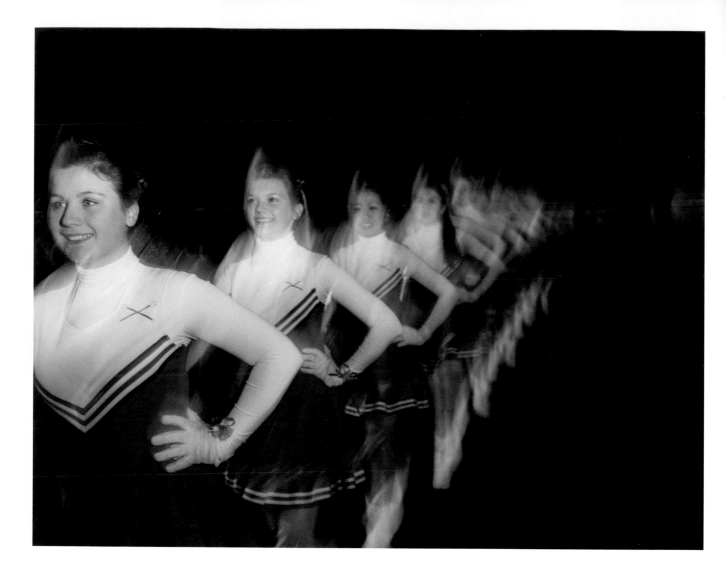

**Mary Beth Meehan, "Half-Time Show,"
Brockton, Massachusetts**
Meehan's work "addresses issues of
immigration, culture and change, and the
emotional charge surrounding them."
This image is from *City of Champions*, an
ongoing series about her hometown of
Brockton, Massachusetts—its people,
places, celebrations, and rites of passage.
Using a portable flash in manual mode,
Meehan set the lens aperture at f/8 and
shutter speed at 1/8. The flash froze parts
of the subject while the slow shutter speed
let in enough ambient light to produce a
blur and give the cheerleaders a boost of
energy. *www.marybethmeehan.com*

INVERSE SQUARE LAW

The closer the light source is to the subject, the stronger the light. When you move it further away, it weakens significantly. This applies equally with portable flash or a continuous light source—or for that matter, the sun.

The effect is very striking and follows the **inverse square law**, which says that the brightness of the light is inversely proportional to the light source's distance from the subject. For example, if you double the distance between the light source and your subject, the light falling on the subject will be reduced to just one-quarter of its original brightness. If you halve that distance, the brightness of the light is increased four times.

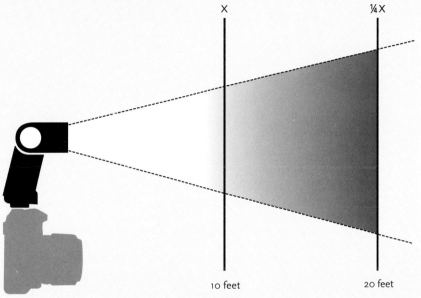

X ¼ X

10 feet 20 feet

Setting rear curtain sync will cause the flash to fire just before the shutter closes. Setting front curtain sync will cause the flash to fire just as the shutter opens. In both cases, the flash will mix with the ambient light, but the results could be very different, depending on how and when the subject—or camera—moves during exposure.

Note that the flash exposure will freeze the foreground subject, but the slow shutter speed may cause the rest of the picture to blur due to camera shake or subject movement. Putting your camera on a tripod should help reduce blur from camera shake. There's not much you can do about subject movement, except hope that the blur will serve as an effective visual element.

 Flash compensation allows you to increase or decrease flash output, along a scale ranging from -2 to +2 stops, and sometimes wider, with half- and/or third-stop increments in between. The scale is usually

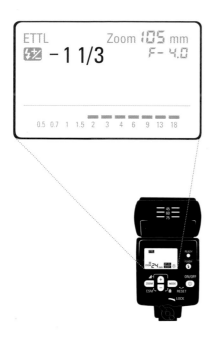

ETTL Zoom 105 mm
⚡⚡ $-1\ 1/3$ $F-4.0$

0.5 0.7 1 1.5 2 3 4 6 9 13 18

separate from the flash-mode menu. It may have its own button, or it may be found in the camera menu or also on a portable flash.

The most common flash exposure problem is overexposing the foreground—when the subject is too bright and lacks detail. Flash compensation can help. As with autoexposure compensation, set the scale at -1 for less flash output and darker pictures—or -2 to make the picture even darker.

Similarly, flash is often too weak when used at a distance, causing the subject to be underexposed—too dark. Set your flash compensation setting to plus (+1 or +2) to increase the flash output and brighten the picture. Note that many flash units, especially flash built into the camera body, are useless at distances beyond ten to fifteen feet; their output is simply too weak, even with a +2 compensation.

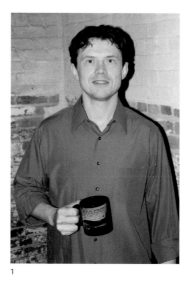

1 2

Using flash often results in the subject becoming too bright (1). When this happens, adjust the flash compensation scale to minus, and reshoot for a darker picture (2). In the image on the right, the scale is adjusted to -11/3, but sometimes you'll need -2 or even more, if your flash permits, to adequately darken "blown out" subjects.

Sarah Stolfa, "Jesse Schabel"
Stolfa tended bar in Philadelphia before deciding to become a photographer, a decision that changed her attitude about her work and her customers. "Something I did not intend on when I started was giving my regulars...a stoic formal visual grace that revealed their individualism and dignity."

Keeping her camera handy, Stolfa started to make a "catalog" of her customers, calling the series *The Regulars*. Using a portable flash at the camera position starkly highlights the expressive features and gestures of her subjects, while letting the background disappear into relative darkness. *www.sarahstolfa.com*

Portable flash

With portable flash units, you generally have a choice of exposure modes. Simpler models have a full automatic mode that functions just like built-in autoflash. When your flash fires, a sensor on the flash unit reads the light reflecting back from the closest subject, and adjusts its output to make the exposure.

Both portable and in-camera flash units may offer **TTL** (through-the-lens) autoflash. In this mode, you set aperture-priority, shutter-speed-priority, or manual exposure mode, and the camera and flash work together to read the light that actually travels through the lens and strikes the image sensor. This provides a more accurate way of determining exposure. TTL

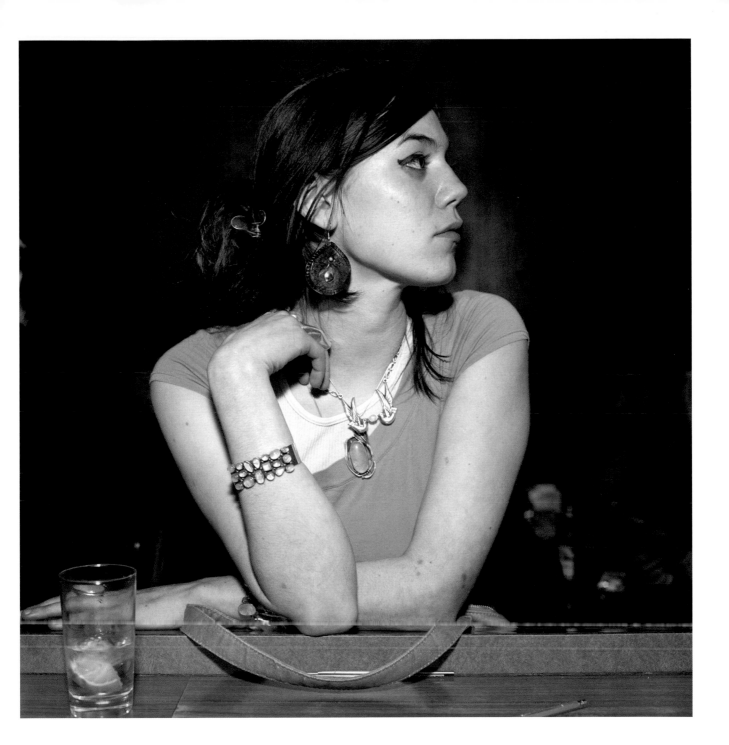

goes even further than determining just the power of the flash. In calculating exposure, it takes the existing light into consideration and balances it with the flash output.

In **manual-flash mode**, the flash output is constant. You have to set the shutter at its sync speed—usually at 1/125 or 1/60—or slower. This leaves three exposure factors to consider: distance to subject, lens aperture, and ISO. Since light diminishes with distance, you must set a relatively large f-stop if the flash is far away from your subject. If the flash is close, you'll need a smaller lens aperture. The higher the ISO, the smaller the needed lens aperture.

To calculate flash exposure manually, you can read a chart or dial, usually located in the flash's instruction manual—or on the flash itself in older units. The chart will tell you what f-stop to use when the flash is a certain distance away, according to a particular ISO. For example, on a flash set at ISO 100, the chart might look like this:

Flash-to-subject distance	Lens aperture
32'	f/2.8
22'	f/4
16'	f/5.6
11'	f/8
8'	f/11
5.5'	f/16
4'	f/22

Flash aimed directly at the subject produces a distinctive look—harsh, flat, and usually brighter in the foreground than in the background. This works well enough for some subjects, but for a more subtle look, there are some things you can do to modify and soften the flash.

On-camera flash can be very convenient, but its light is flat and harsh when aimed directly at the subject. For more three-dimensional light, use your flash **off-camera** and aim it at an angle to your subject.

The trick is to sync the flash with the camera's shutter without the flash attached directly to the hot shoe. There are two ways to do this: with a **sync cord**, a cable that connects the flash and camera, or with a **wireless remote** accessory. When you press the shutter button, either the sync cord or remote signals the flash to fire only when the shutter is open.

If you use a sync cord, you'll have to plug it into the camera. Some cameras have a built-in **PC terminal**, an outlet that allows you to plug in a sync cord that attaches to the off-camera flash. If your camera doesn't

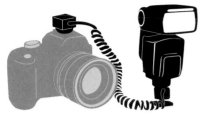

For off-camera flash, you can use an adapter that slides into the hotshoe to attach your portable flash.

have a PC terminal, you'll have to use an adapter that incorporates a PC terminal and slides into the hot shoe.

You can also fire your flash remotely. When you press the shutter button a transmitter built into the camera, or attached via the hot shoe, sends a signal to fire an off-camera flash. Some wireless systems are totally dedicated, with camera and flash designed to work together seamlessly; others use add-on units to make the connection.

Bouncing and diffusing flash are good ways to broaden the flash output and make the light look softer. One reason that flash looks the way it does is because it usually emits light directly at the subject. This produces a harsh, contrasty feel, and can even cause slight image vignetting—with the light brighter in the middle than on the edges of the frame. For a softer, broader, more diffuse look, you can use a portable flash unit that can be bounced, such as models that tilt up and down at different angles—or you can take it off-camera.

Point the flash unit at the ceiling, so the light bounces down to the subject, or aim it at a wall so it reflects obliquely. This causes the light to bounce off the chosen surface and scatter, adding needed illumination to the scene—with a broader and softer effect. Keep in mind that bouncing flash off colored walls or other surfaces may affect the light and give your

Flash directed right at the subject creates a harsh, flat effect (1). It will create more dimensionality if it's taken off-camera and aimed at an angle to the subject (2). For softer and more pleasing results, bounce the flash off a ceiling or wall (3), or even better, use a diffusing accessory on a flash head and bounce it to scatter and broaden the light and diffuse its effect (4).

1

2

3

4

Direct flash Off-camera flash Bounced flash Diffused and bounced flash

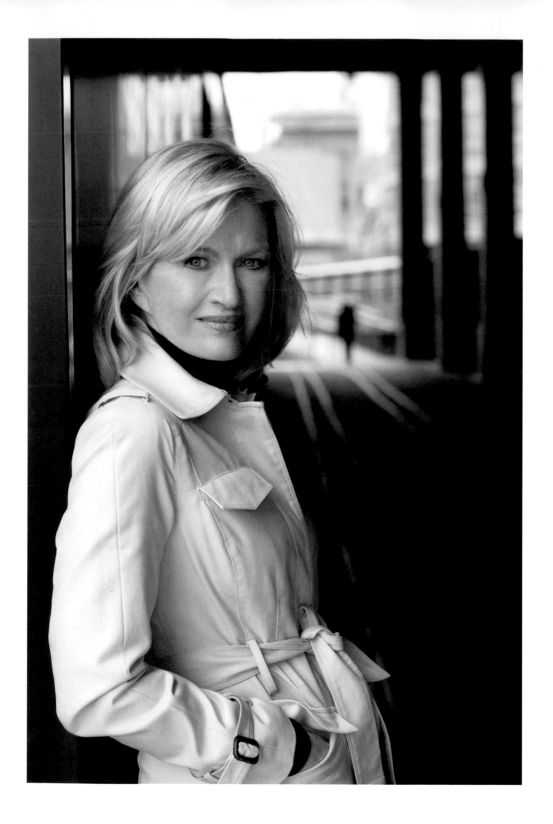

pictures a noticeable color tint. Also, watch out for underexposure, as a dark surface will absorb light.

There also are various accessories that attach to the flash unit and reflect light indirectly toward the subject, or diffuse it somehow. These are especially useful when you don't have a wall or ceiling to bounce light off of, such as in outdoor situations or large indoor spaces. One type built into some flash units consists of a simple reflector or **bounce card** that slides out from the back of the flash head. The burst of flash light hits the card first, and then bounces toward the subject. More efficient types are made of translucent diffusing material that fits around the flash head. The light isn't reflected elsewhere, but the diffusing material softens the flash effect before it reaches the subject.

Diffusion accessories. Reflector or bounce card (1), translucent plastic cap (2), soft cloth or plastic diffuser (3).

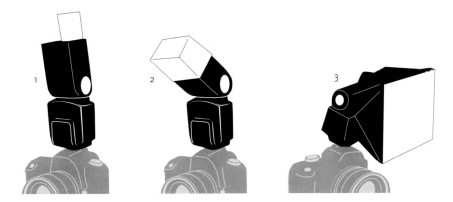

Exposure when bouncing light depends on the distance the light travels—say, from flash to ceiling to subject. This is always significantly further than the direct flash-to-subject distance. It also depends on how much light is lost from bouncing or diffusing. You don't have to worry about any of this with autoflash or TTL, which makes the adjustment for you. But if you're using flash manually, you'll have to take the added distance or diffusion into consideration. Whatever type of flash you use, you will need to use a larger f-stop, higher ISO, or both to compensate for light loss, due to the increased distance or diffusion.

Studio Lighting

Working in a studio is typically less spontaneous than working in natural light. You have to set up the lights, and probably work with equipment, space, and other constraints. As a result, studio photography is usually

George Lange, "Diane Sawyer"
Some subjects come to a studio for their portraits, but sometimes the studio comes to them. Here, Lange takes the famed television newscaster outdoors for a casual look in a natural setting. Placing Sawyer so she would be backlit by the natural light, Lange bounced his portable strobe light into an umbrella and back to "fill in" the shadows to achieve a soft and gentle effect. *www.langestudio.com*

best suited for working with fairly static subjects, such as portraits and still lifes, than for candid shooting.

Nevertheless, working in a studio offers great advantages. It allows you total control over the lighting, so you can set it up as you wish. It also eliminates concerns about bad weather or other conditions that could prevent you from working outside. Keep in mind that not all "studio work" takes place in a dedicated studio. You can use studio lighting and techniques almost anywhere, for subjects ranging from portraiture to architecture.

Good studio pictures generally require specialized equipment and a strong understanding of how to use it. You also can combine natural and artificial light if you know some simple rules about lighting and have a basic grasp of the available tools. This can allow you a measure of control over the final look of your pictures that you can't easily achieve with natural light alone.

A photoflood (1) looks like an oversized household bulb, as does a simple clamp light (2). Both consist of a reflector that holds the lightbulb and uses either a light stand or a clamp to hold it in place.

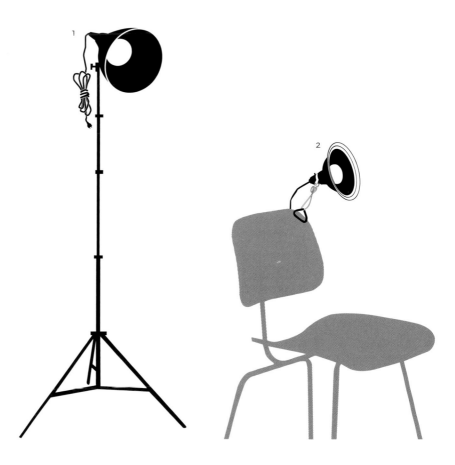

TIP: SUBJECTS WEARING GLASSES

When making a portrait using flash or other supplementary light, watch out for reflection in your subject's glasses if he/she is wearing any. One easy way to avoid reflection is to have your subject turn in three-quarter profile away from the light source—which means away from you if your flash is on-camera. You can also have your subject turn in full profile—or, of course, take off their glasses. However you do it, the idea is to make sure the glasses don't "see" the light, so there will be no reflection.

→ *white balance, pages 37, 39–40*

Continuous lights

There are two types of lights used in studios: **continuous lights** and **strobes**. Continuous lights stay on until they are switched off, much like ordinary household lightbulbs. In fact, the least expensive type, a **photoflood**, looks just like an oversized lightbulb. But rated at 250–1000 watts, it has far more power. **Quartz halogen** continuous lights also are available. These are generally longer lasting, and can be significantly more powerful than floodlights. But they also are more expensive and may require a more elaborate housing. The most common type of continuous lights are called **hot lights** (for the heat they generate). But there are also continuous lights that are not hot, such as fluorescent-type bulbs and LED panels.

Continuous lights are useful, in large part, because they are always illuminating the subject. As you move them around to fine-tune the angles and distances to your subject, you'll be able to see the results pretty much as your camera will see them. However, hot lights can be dangerous to the touch, and possibly uncomfortable for the photographer and the subject who's sitting under them.

The light produced by hot lights is warm in color temperature, rated at 3200K, more or less, much like the warm light you'll find around sunrise or sunset. This means photographs taken under a typical continuous light will have an orange/yellow cast. There are several ways to neutralize the cast, if you like. Perhaps the best method is to adjust white balance in the camera menu, because you'll have less adjusting to do in postproduction. But you can usually make white-balance adjustments in post, especially if you shoot in RAW.

On the other hand, there's often no need to neutralize the color, as some subjects look best with a mild, warm cast. Consider leaving the warmth as is, or simply adjust it minimally in postproduction.

You can make a simple, inexpensive continuous light set-up with a **clamp light**, a bulb inside a reflective housing that directs the light forward. The housing attaches to the back of a chair, a countertop, or some other surface, with a clamp. More sophisticated clamp lights attach to a **light stand**, a tripod made for this purpose, that adjusts to position the light at the height and angle you choose.

You can do a lot with a simple clamp light, especially with small subjects and those that don't need very bright light. These affordable and simple units can even be bought at hardware stores and outlets selling household goods. For safety's sake, make sure your bulb is not too powerful. Most simple clamp lights take 60- to 75-watt bulbs at most. Clamp lights from camera stores and Internet sites may take photofloods, which are a lot brighter.

Barn door

Reflector

Seamless

Softbox

Umbrella

ACCESSORIES: MISCELLANEOUS LIGHTING EQUIPMENT

Barn door. Adjustable flaps, hinged to the sides of a lighting unit and used to block light from reaching certain subject areas.

Battery or power pack. An electrical supply designed to provide the large amount of power needed for studio strobes.

Flash meter. Handheld light meter usually used with studio strobes, but useful with portable flash as well. Flash meters are designed to measure the short burst of light emitted by a flash.

LED Panels. A continuous light source usually used for video, but also available for still photography. LEDs generate little heat, offer variable color temperatures, and are relatively expensive.

Light head. Component of a studio flash, incorporating the flash tube, modeling light, and possibly a cooling fan.

Light stand. Three-legged folding metal structure designed to support light heads. A light stand looks much like a tripod, but with shorter legs and a much longer center post.

PC cord. Cord used to connect a camera to a strobe.

Reflector. Panel used to bounce light—whether natural, continuous lights, or flash. Can be either a commercial reflector made of white or reflective cloth or simply a large piece of white cardboard or foam core.

Seamless. Wide roll of matte surface paper that comes in different colors and patterns. Seamless unrolls to provide a backdrop for photographing in a studio.

Softbox. Boxlike enclosure for studio lighting with opaque side panels and a translucent front panel. Designed to produce even, soft lighting.

Umbrella. Folding reflector or diffuser that looks and opens like a conventional umbrella. It's usually cheaper than a softbox and sometimes comes packaged with lighting kits. Umbrellas are used to soften a light source—either by bouncing light off of it or directing light through it.

Wireless remote. A cordless flash trigger that can be used instead of a sync cord to fire a studio strobe when you press the wireless button.

Studio strobes

Studio strobes are widely used in studios and on location, and are a good alternative to continuous lights. Like your in-camera or portable electronic flash, they provide light in a quick burst—at tiny fractions of a second. Strobes provide much brighter light than in-camera or portable electronic flash units or continuous lights. They are also **daylight-balanced**, with a neutral color temperature of about 5000–6000K (similar to midday sunlight).

A studio strobe is a dedicated flash unit, powered either by a separate **battery pack**, **power pack**, or an internal battery. It's linked to the camera by a cable or by wireless remote, so that it will fire when you press the camera's shutter button. There are simple, affordable studio strobes available, as well as very expensive professional models.

It can be difficult to set up the light with a strobe, because it's not on all the time, which means you can't see its effect until it fires and you check your LCD display. However, most studio strobes have a built-in **modeling light**, a relatively low-powered continuous lamp that can be turned on and off for previewing the lighting effect. This can give you a good idea of where the light will fall, though it doesn't exactly mimic the effect of the much more powerful strobe light.

→ *color temperature, pages 129–130*

Most studio strobes consist of a battery pack (1) and a strobe head (2). With some models, the battery is built into the head.

Basic Lighting Setups

The position of the lights in relation to the subject is a critical factor in your final results, regardless of whether you are using a portable on-camera flash, a 60-watt clamp light, or a powerful studio strobe—or even if you're working with natural light. In fact, a good rule to keep in mind is that artificial light should almost always closely simulate natural light. It shouldn't look phony.

Whatever you do, it's usually best to light minimally—don't use more light than necessary. If you do, the results may look unnatural. The photographs on the following pages show how much you can accomplish with a single lighting setup, used in a variety of ways. These are simple but common studio lighting setups, and they can apply whether you're making a portrait or photographing a still life, interior, or other subject.

Key light

The **key light**, also called the **key** or the **main light**, is the dominant light source, providing the primary illumination in a lighting setup. The key can be positioned anywhere and, as long as it's brighter than any other light source in the picture, it will be dominant in establishing the lighting effect.

A normal position for the key light is pointing down a little at the main subject at approximately a three-quarter angle—from either side of the camera. Don't aim the key head-on at your subject, or you will get a flat, two-dimensional effect (similar to the way direct on-camera flash looks). By placing the key at an angle, you'll brighten one side and place the other in shade. This creates shadows for a three-dimensional effect, generally considered more pleasing and natural—much the way shading works in a drawing.

If you move the key so it illuminates the subject from the side, you'll get a dramatic high-contrast effect where the unlit side darkens. Called **side lighting**, this position can best emphasize the textural qualities of the subject. You also may choose to position the key light behind the subject, called backlighting, to create a silhouetted effect.

→ *backlight, pages 117–119*

The key light establishes the lighting effect (1). Fill light brightens the shadows the key light creates (2).

Opposite page:
The position of the light source has a critical effect on the way the subject looks. Direct light from the front (1) creates a flat, even effect. Light from a 45° angle (2) will illuminate much more of the subject and create a three-dimensional look because of the shadows it produces. Sidelight (3) emphasizes texture, and throws half the subject into shadow while lighting the rest. Light from a 45° angle with a reflector opposite it (4) also creates texture and three-dimensionality, but brightens up the other side of the subject as well. Backlight (5) puts the subject in shadow and creates a silhouette. Light bounced off a reflector placed over the camera (6) is soft and diffuse, but still may cast some shadow because of the angle. Light from above (7) casts deep shadows downward from the subject's eyes, chin, or in this case, beak. Bottom-up light (8) creates a menacing effect.

1

2

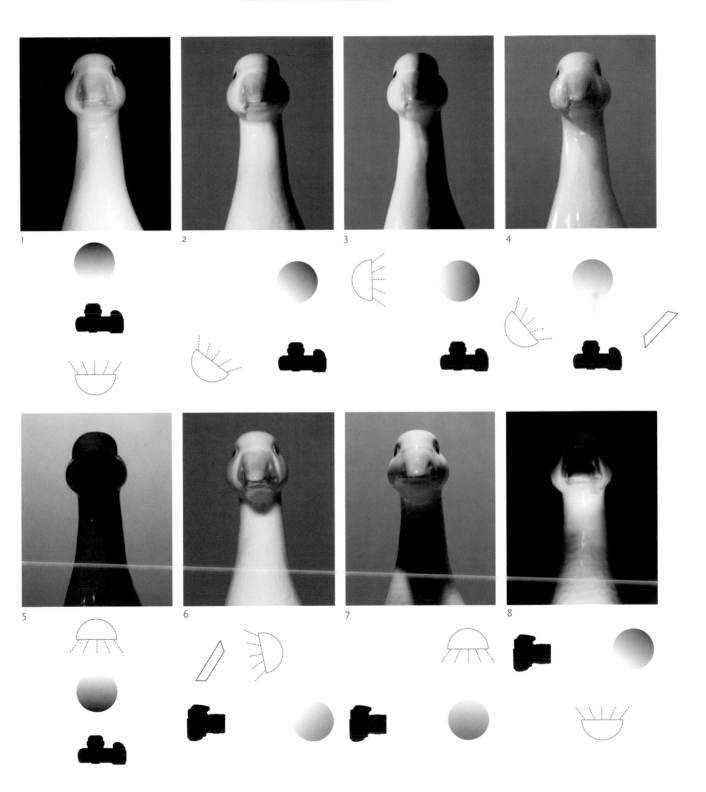

Experiment with your key light by placing it at different degrees of high and low, front-and-back, and side-to-side positions to see how it changes the appearance of your subject. If necessary, you can add other lights or reflecting surfaces to produce the desired effect.

Fill light

Sometimes a single key light is all you need, especially with small subjects that don't require much lighting. But often the shadows produced by the key light appear too dark, in which case you can brighten them up with fill light, often just called fill—as in "fill in the shadows." Usually, the fill is one (or more) separate light source positioned somewhere opposite the key, but weaker in power. The goal is to add enough light to reveal detail in the shadows, but not so much light that the scene will be evenly lit and flat.

You don't need an actual additional light to create fill. Sometimes you can use a simple reflector to bounce light back from the key to brighten up shadows. You can use a commercially made **reflector** for this purpose, but one or more sheets of white poster board or foam core will often do the job. Place the reflector opposite the key light, with the reflector leaned against a chair, wall, or other surface—or with someone holding it for you. Watch the light carefully; you should see the shadows get lighter. The closer the reflector is to the subject, the brighter the shadows.

Other positions

The key and fill are the most important lights in your setup, but there are times when you might want to add additional lights. For example, if an area behind the subject is too dark, you can brighten it with a separate **background light**. You also can use a separate **accent light** or two to brighten small, specific areas of your subject.

Gail Albert Halaban, "Astoria, Night Bridges"
Halaban photographs urban life, from
professional mothers to tableaus of city
dwellers in their private spaces, which she
calls *Out My Window*. Her subjects are
collaborators who help play out a drama
she constructs. She says, "In this work, I
explore the intersections of voyeurism and
community, and private and public space."

Halaban placed a strobe inside the
room to produce enough light to provide
a close balance with the natural light in
the background. The subject is still a
little darker than window view, and the
overall color is warm, making the viewer
experience a little of the longing the subject
might be feeling. *www.gailalberthalaban.com*

Chapter 6
Scanning

Suggested Workflow: Scanning

1. Clean the surface of the original print, negative, or slide to be scanned.

2. Clean the scanner bed (if you're using a flatbed scanner).

3. Position the original in the scanner.

4. Open the scanning software on the computer—either using your image-editing program (if it supports scanners) or a stand-alone program.

5. Preview your scan.

6. Select or crop an area of the image to be scanned.

7. Adjust your scan settings—especially color mode, type of original, and target size.

8. Scan your image.

9. Save the scanned image file.

10. Back up the saved image file.

A digital camera creates an image file when you take a picture, allowing you to download the file to your computer and work with it in an **image-editing program**—adjusting brightness, color, contrast, and so forth. But if you want to work with an image that wasn't captured digitally—maybe an old snapshot or any other picture made on film—you'll first have to scan it.

Thomas Gearty "Jumping Bridge, State Beach," Martha's Vineyard
Gearty took this picture with Polaroid film, a predigital technology, in part because he liked the vintage look—slightly soft, off-color, and square. Polaroid pictures are one-of-a-kind, which means you must find a way to copy them if you want to reproduce them. Scanning provides a simple solution for converting original analog pictures into digital image files, which can then be edited and output—as prints, web images, or whatever form you choose. *www.thomasgearty.com*

A **scanner** is a stand-alone accessory that takes a print or film image (negative or slide) and converts it into an image file. This file will be similar to one captured by a digital camera. However, if your scanner is low quality, or if you don't use it properly, scanning can result in diminished image quality.

There are many kinds of scanners, and most work in a similar fashion. You place the original print or film in the scanner and then use scanning software to read the image and convert it to a digital file. The scanner accomplishes this using a sensor that captures light either reflected off the original print, or transmitted through the negative or slide.

Parts of a flatbed scanner include: a cover, a shield for reflective art, glass for transparent art (film), a glass bed, and positioning guide marks. Note that not all flatbed scanners can scan film.

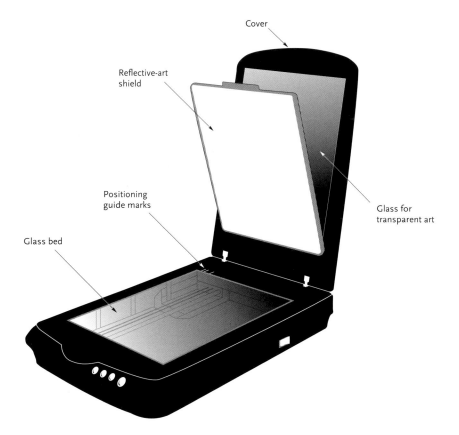

Cover

Reflective-art shield

Positioning guide marks

Glass bed

Glass for transparent art

Naturally, some scanners produce better results than others. Newer models generally have more features and create better scans. Price is another indicator of a scanner's quality. Higher-priced scanners almost always produce better results than lower-priced models.

One of the most important characteristics of a good scanner is its ability to produce large image files, measured by resolution. This allows you to make good quality prints, even at large sizes. Good flatbed scanners can have a resolution of 4800–9600 ppi. The higher the ppi rating, the larger the image file you can create.

→ *ppi, page 218*

Another characteristic of a good scanner is the ability to produce sharpness throughout the image—from edge to edge. This is difficult to judge, but generally, better scanners produce superior edge-to-edge results. Note that a scanner can get out of alignment, leading to less-sharp areas of the scanned image. If there is an alignment problem, you'll probably have to get the scanner repaired.

While the scanner is important, so is the scanning software. Good scanning software provides the ability to adjust tonality and resolution, and offers other features, such as automatic dust removal and retouching. The software that comes packaged with a scanner may do a good job, but independent scanning programs often work even better.

Types of Scanners

Your scanning results will depend on factors other than the scanner and software. Regardless of the scanner, it's best to start with an original print, negative, or slide that is sharp, well exposed, and clean. Still, the scanner is important. There are three types available: **flatbed**, **film**, and **drum**.

Flatbed scanners

Flatbeds are the most common scanner type, made primarily for prints and text documents—originals that are **reflective**, not transparent. You put the original on the scanner's glass bed, close the cover, and you're good to go.

Flatbed scanners are usually the cheapest, especially the models used primarily to scan text documents. But there are many more expensive flatbeds—higher-quality models optimized for scanning photographs. Many can also scan film (negatives or slides). Additionally, flatbed scanners can scan almost anything that fits on their glass beds, including three-dimensional objects, such as flowers or hands.

If you use a flatbed to scan film, make sure you position the negative or slide correctly, so the scanner can read it. Some flatbeds have a strip down the middle for film scans, so placement is critical, otherwise the scanner won't see the entire film image. Many flatbeds have a larger film scanning area, however, and these allow more latitude in positioning your negatives and slides.

Film scanners

A dedicated **film scanner** is usually better for scanning negatives and slides at higher resolutions than flatbed scanners. Its inner workings function pretty much the same way as those of a flatbed, except you put the film in a holder and place the holder in a slot. The scanner then moves the film over a light source, or the light source over the film, to make the scan.

Many film scanners offer batch handling for scanning a group of negatives or slides at once. Some models include other useful accessories, such as a glass holder, which keeps the film extra flat to maximize edge-to-edge sharpness.

Most film scanners handle 35 mm film only. There are much more expensive models available for larger-format film, but many photographers use good flatbed models instead, as they are more affordable and can get the job done.

→ *negatives, slides, page 158*

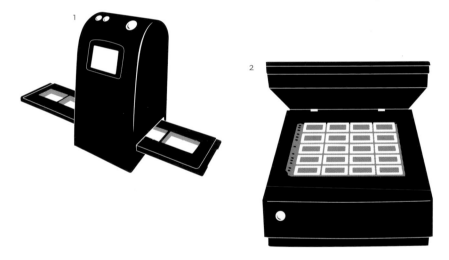

The dedicated film scanner (1) is for negatives and slides only. Many flatbeds (2) handle both film and prints.

Drum scanners

A drum scanner can scan film, prints, or anything that can wrap around its glass cylinder drum. The original is dipped in a fast-drying liquid solution so it mounts evenly on the drum, which then spins around at a high speed while a sensor makes the scan.

Drum scanners are industrial quality and very expensive, so they are usually only found in specialized labs and at commercial printers. Note that some manufacturers of high-end flatbed and film scanners claim they can match drum-scanning quality—and some come close.

Maggie Taylor, "Two Men in a Boat"
Digital technology allows you to make simple pictures easily, but it also allows you to create fanciful images that don't exist in real life. Taylor scans existing pictures and then edits them into her own vision. Here, in postproduction, she combined a scanned nineteenth-century image of two men in a fake boat with a scanned image of a fish, and then added her own digital photographs of water texture and clouds. *www.maggietaylor.com*

1

2

3

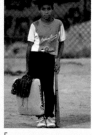

4 5

ABOUT FILM

If you are taking pictures with a digital camera, you automatically have image files as soon as you take your pictures. However, if you want to shoot film, you'll need to scan it (or a print from it) to create digital files. Even if you are shooting digital now, you may have images on film shot in past years—and these will need to be scanned to create image files for such purposes as printing, e-mailing, or posting them on the Internet.

Film comes in various forms and **formats** (sizes). Here are examples of a **black-and-white negative** (1), a **color negative** (2), a color **transparency** (3)— a positive, also called a **slide** when mounted in a plastic or cardboard frame. Prints generally come in **black-and-white** (4) or **color** (5).

You can scan any type of film or print image, but you'll have to set your scanner software accordingly. Set your program for transparent or reflective, color or **grayscale** (black and white with continuous tones in between), and negative or positive. If you're scanning film, you will need a scanner that can take the film format you're using. All film scanners accept 35 mm film, the most common format. However, **medium-format** and **large-format** films are larger than 35 mm and will require a larger film scanner, a flatbed model optimized for this purpose, or a drum scanner.

Some photographers still use film, partly because they prefer working with it, and also when they want excellent image quality but don't have access to a high-end digital camera. Photographing on film and then scanning with a high-quality scanner can sometimes produce better-quality results (and larger image files and prints) than many digital cameras can offer. This is especially true if your pictures were shot with medium- or large-format film. While medium- or large-format digital cameras produce large image files, they are too expensive for most photographers.

Making a Scan

The workflow for scanning film or prints is similar, though the logistics may be a little different. The following step-by-step instructions are a good starting point, but you may want to modify them to accommodate your type of scanner and software— and also your way of working. Note that the two main steps in scanning are previewing the image to be scanned and making the scan itself. However, there are several other steps and options along the way.

To make the best scans, you'll need a high-quality scanner and good scanning software. If you have access to this equipment through school or work, you're in luck, and you can make the scans yourself. Of course, you'll still need to learn good scanning technique—and scanning does take time.

If you don't have equipment available to you, you can always have your scans made at a lab. This will help guarantee high-quality scans and save you time. And though lab scans can be expensive, they are probably cheaper in the long run than buying a high-end scanner and software and doing it yourself, particularly if you make only the occasional scan.

I. Install the software needed to run the scanner. Some computers automatically recognize a scanner once it's hooked up. If you're using a scanner at a school or other lab, the software should already be installed. Otherwise, you'll probably have to install **scanning software**, which will allow you to control the size, resolution, and other attributes of the scan. Scanning software usually includes a **driver**, which is specific to the scanner model and allows it to communicate with the computer. Scanners come packaged with the manufacturer's scanning software, but independent programs are available and sometimes preferable. Make sure you have the most up-to-date version available of the software you're using.

2. Clean the film or print to be scanned. Dust, grime, and scratches tend to build up on prints and film, especially if they have been lying around for a while. This means that scanned image files often need a fair amount of retouching in image editing. You can minimize retouching time by cleaning the original print or film before you scan it. Many scanning programs can do a pretty good job of cleaning up dirty originals during the scan, but this sometimes results in softer (less sharp) looking image files, and will make scanning times a little longer. Starting with the cleanest originals possible will give you the best results.

To clean your film or print, use canned air to blow off loose dust and dirt. Make sure to hold the can upright, and don't shake it, or you may leave a mist of propellant on your original. You can also use a soft brush or static-free cloth to gently wipe prints and film clean. In some cases, you may need a liquid photographic emulsion cleaner to tackle stains or embedded dirt, but use it sparingly or you may do physical damage to the original.

3. Clean the scanner.

a. If using a flatbed scanner, clean the scanner bed. Lift the cover of the scanner to expose the glass bed and spray glass-cleaning liquid on a nonabrasive cleaning cloth and wipe the bed. Spray the cloth rather than the bed so the liquid won't seep into the scanner by accident. Allow the bed to dry completely before making your scan.

b. If using a dedicated film scanner, clean the film carrier if necessary. There is no glass to clean on the scanners themselves, but some film carriers use glass to hold the film flat, in which case use an approved cleaning liquid to clean this glass.

4. Position the original for scanning.

a. If using a flatbed scanner, place prints facedown on the scanner bed. There are usually guide marks showing where to place them so that the

image will appear squared up when you see it on the computer screen. For film, remove the plastic shield (if your scanner has one) on the underside of the scanner cover to reveal a light source. Place the negative or slide in the film carrier and position it on top of the scanner glass. Close the cover and you're ready to begin scanning. The light from the top of the scanner will travel through the film and expose it to the scanner's sensor below.

 b. If using a dedicated film scanner, load the negative or slide into the film carrier, then insert the carrier into the scanner in the designated direction. The scanner will "grab" the carrier and pull it into position for scanning.

5. Open the scanning software, either your stand-alone program or through your image editor, if it allows it.

6. Preview your scan. When you open the scanning software, you'll see a number of options, usually in a window on the screen called a **dialog box**. One of the options will be a **preview button**. Click on the button to see a preliminary view of what you've placed in the scanner.

7. Select an area to be scanned. In preview, select what you want scanned by clicking and dragging your mouse to create a dotted box outlining the desired area. You can outline the entire picture, or you can crop so you'll only scan a section of the image.

 Note that if the print or film isn't squarely positioned in the scanner, your crop will be skewed. When editing the image, you may be able to square it up, but don't depend on it. Instead, reposition the original, and do another preview—then reselect or recrop to get it right.

 When you make the selection, always be sure to select only the image. If you select an area outside the border, for instance, the scanner will include that data when it calculates exposure, and the resulting scan may be too light or too dark.

8. Choose your settings. Now you must give the software more information about the kind of scan you want to make. You may be given a choice of automatic (simple) or manual (advanced) modes. If you choose automatic, the scanner will use its default settings, which may give you perfectly good results. However, for best control over your scans, you should set your software manually. Your main choices are color mode, type of original, and target size (dimensions and resolution). Your scanning software probably offers additional choices, but these are the most important ones.

In the preview window of your scanning software, you can decide to scan the entire image or to crop it. Click and drag to draw a box around the area you want to scan—in this case, to get a tighter view of the woman with a less distracting background.

Color mode indicates the kind of color information you want the scanned image file to include. You can choose to scan in **color** or grayscale (black and white with **continuous tone**, a range of grays in between), but you'll capture the most information by scanning in color, then converting to black and white in image editing later, if you choose.

› bit depth, page 39

When setting color, you'll have a choice of bit depth (or color depth), which is a measure of how much color information will be in the image file. For instance, a 48-bit scan should reproduce more of the original's colors than a 24-bit scan.

Choosing a higher bit depth means the computer will have more information to work with in terms of providing precise control and fine-tuning of color. In theory, you'll want as much color information as possible. But more information also means larger image files, which can be bulky and slow. They also take up more storage space. Still, to help guarantee the highest-quality results, make your scan at the highest bit depth possible.

One scanning software will look different from another but they all will offer many of the same options so that you can scan to make the kind of image file you want. Here the scanning software is set to make a 16" x 20" scan from an 8" x 10" print. The resolution is set at 300 ppi, which should provide a scan large enough to make a good-quality print at the target size.

→ *resolution, pages 15, 33*

Type of original refers to the characteristics of the original to be scanned. Your choices will probably be **reflective** (print) or **transparent** (film). You will also have a choice of positive or negative and color or black and white.

Target size sets how large the final image file will be. This is a combination of **dimensions** and resolution. Dimensions refer to the physical size of the desired scan, and resolution is the number of pixels per inch in the scan.

You can choose to scan for a specific size, or you can choose to make the largest scan possible. For example, you can make an 8" x 10" original into a 16" x 20" scan by choosing 16" instead of 8". The program will

automatically adjust the other dimension to maintain the aspect ratio, so the original 10" dimension will go to 20". Once you've established the dimensions, set your desired resolution. For best results when planning to make prints, choose at least 240–300 ppi. (Some printers require slightly more or less.) For viewing images on a monitor only, you'll only need 72 ppi, but if you make a 300 ppi scan, you can always lower the resolution later in image editing.

Scanning for a specific size allows you to save on storage space, but it may mean that you'll have to rescan if you need a larger file in the future. Alternatively, you can make the largest, highest-quality image files your scanner allows, the first time you scan. This way you can adjust the dimensions and resolution of your pictures to any smaller size you like later in your image editor.

MAKE YOUR SCANS LARGE

When making a high-resolution scan, there are a couple of factors to consider. The larger the original, the larger the maximum scan you can make. And generally the better the scanner, the bigger the maximum scan size. Here are a couple of suggestions for making the largest image file your original and scanner are capable of.

Make sure the target dimensions are set to the same size as the original. So, if you're scanning a 35 mm slide, the target should be set to 1" x 1 1/2"—the same size as the slide image. Your software should describe this in percentages, as 100% (of the original).

Set the ppi to the maximum your scanner allows in order to capture as much raw information as possible from the original print or negative. A high-quality scanner may allow a maximum resolution of 4000 to 9600 ppi—or more. However, your scanner software may allow you to set an even higher resolution than your scanner is actually capable of. But don't do it. Any setting higher than the scanner's maximum resolution is produced by **interpolation** (artificially adding pixels), which can reduce the quality of the scan.

9. **Make your scan.** Once you've chosen your settings, you're ready to make the scan. Click the scan button. The process may take anywhere from a few seconds to several minutes, depending on the scanner and your settings.

→ *lossless, pages 36, 197*

10. **Save your scan.** Use a lossless file format for saving the scanned image file in order to preserve as much information as possible. TIFF is a good choice, and can be used pretty much by any image-editing program. Some scanning programs have their own proprietary formats, but these are not recommended because they may not be cross compatible.

Save your scanned image file in an uncompressed format, such as TIFF. Note that the saved file to the right is named for the subject (Chrissie running) and original negative file number (09–05), and that the file will be stored in a folder named *Scanned Images*.

Lawson Little, "Shelton 'Hank III' Williams," Nashville, Tennessee
Traditional portrait photography usually concentrates on a subject's face and features. But good portraiture can be broader than a facial study. Environmental portraits show a subject in context. Here, we see musician Hank III, barely fitting in a small dressing room. Clothes, hangers, and even a friend's foot show a certain randomness that suggests much about the life of a traveling musician.
web.me.com/lawsonlcorbettlittle

You now have an image file ready for editing. In many ways, this file is similar to the image files produced by digital capture. It's good practice to set up a dedicated folder on your computer, perhaps named *Scanned Image Files* or something similar. This way you can put all your scans in one place for easy retrieval.

Name each saved file and place it in that folder. You can choose any name you want, but make it consistent with the rest of your scanned images, and set up a naming system that makes scans easy to find. For

Tina Barney, "Two Students #354"
Well known for her photographs of American aristocracy, Barney was one of the first photographers to seriously consider scale—the size of a print. This was partly because photography has only recently (1970s) become accepted into the wider art world, where scale in painting and other media have long been important. Also, digital technology has made large-format printing much more practical.

Barney's detailed prints measure 48" x 60" and even larger. She makes the scans from large-format film (usually 4" x 5"), which generally provides better results than scanned prints. *www.janetbordeninc.com*

→ *back up, page 203*

TIP: SCAN FILM

In general, you're better off starting with film than with a print, as film contains more information for your scanner to capture. However, it's possible to make a good scan from either a print or film. If you don't have the original film, scan the print, but make sure it's as clean and undamaged as possible, or you may have to spend a lot of time retouching it.

example, let's say you're scanning a slide of a pig in mud. Ideally, you should have a reference number for the original slide—perhaps 09–33 (indicating the thirty-third roll of film made in 2009). Try naming the scan of this slide as follows: pig_09-33_scan.tif. "Pig" is the subject, "09–33" is the slide number (so you can find the original later, if needed), and "scan" indicates the original was scanned from a print or film, rather than captured digitally. The file format is TIFF.

As you make more and more scans, you may want to set up subfolders for different projects, time periods, or whatever categories you choose. So, within the *Scanned Image Files* folder, you might have folders named *Trip to Prague, Pictures of Jenny,* or *2011.*

The goal is to have a system that is orderly, consistent, and sensible. Over time, you'll likely create hundreds or thousands of files. Starting with a good plan for naming and storing your files makes it easier to search for them later.

11. Back up your image files. Once you've saved a scan, back it up immediately, as you would with digital capture files. You should make two or more backups, preferably to a hard drive. In case of theft, fire, or other physical threats, put the original and backups in different locations.

Histogram before adjustment

Histogram after adjustment to increase the scan's tonal range.

SCAN FOR A WIDE TONAL RANGE

You can make various adjustments to your image using scanning software, but you're almost always better off making your adjustments later on when image editing. In the long run, overadjusting when scanning may limit your options.

However, there is at least one case in which making adjustments when scanning can pay off. You can set the scanning software to produce an image file with an especially wide tonal range—relatively flat and low in contrast. This will allow you to retain as much information from your original as possible, which in turn will give you plenty of options later in image editing.

With scanning software, you can see a histogram of the image during preview, similar to the one that your camera displays when playing back a captured picture. It may show up automatically, or you may have to select an adjustment, probably called "levels" or "histogram." There will be three arrows under the histogram—one on the left, one in the middle, and one on the right. Slide the left and right arrows to just outside the very edges of the image's histogram, leaving the middle arrow alone. This will tell the scanning software to capture the broadest range of tones your original has to offer.

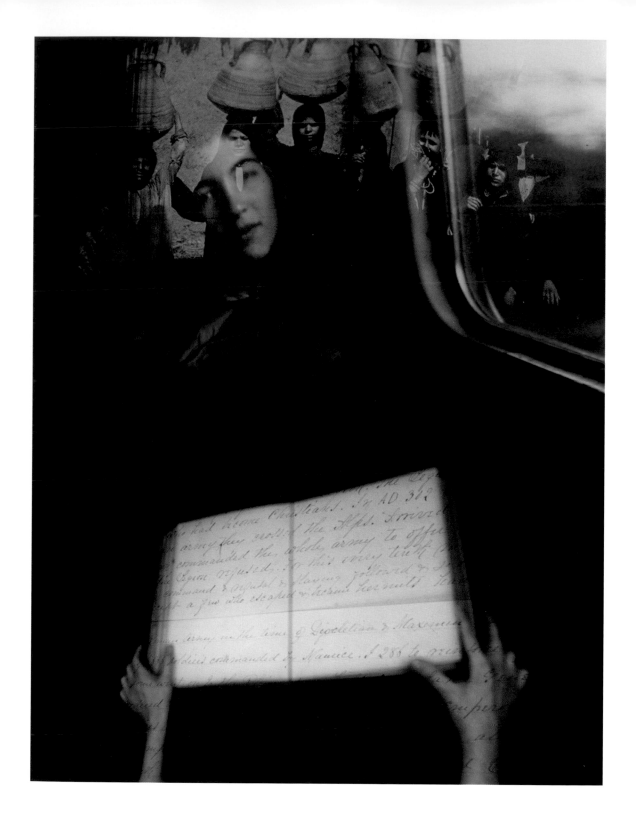

Chapter 7
Image Editing

Suggested Workflow: Image Editing

Image editing workflows vary widely depending on the particular editing program you use. For specific instructions, make liberal use of the program's help menu and website.

1. Calibrate your monitor so what you see on the screen will match your prints and other output.

2. Open your image file in an image-editing program. If you are working with a RAW image file, you will have to convert it first, so your image editor can open it. Some editors have a RAW file converter built in and will open RAW files automatically, but in some cases you may need to open the file in a dedicated RAW converter first.

3. Apply noise reduction. If working in RAW, apply it within the RAW conversion software.

4. Use the cropping tool to tighten or reframe the composition by trimming off unwanted edges, if desired.

5. Adjust overall image brightness and contrast. You can do this automatically, but for more control, do it manually, using sliders, levels, or curves.

6. Adjust overall color, either automatically or better yet, manually. Note that changes to the overall brightness, contrast, or color often affect one another, so you may have to go back and forth while making these edits.

7. Use a retouching tool to eliminate unwanted image blemishes.

8. Fine-tune local areas by burning, dodging, and/or adjusting the brightness, contrast, and color of specific parts of the image.

9. Apply other filters as desired.

Lorie Novak, "Voyages (per)formed #5"
Novak's work often combines her own stories with broader cultural references. She says, "I question how photographs affect how we know what we know, how personal remembrances and cultural memory intersect, and how photographs influence storytelling and history."

Here, the top half of the image is made by projecting two overlapping film images, and rephotographing the projection—a nineteenth-century Moroccan woman combined with a self-portrait. The lower half uses a similar technique to combine two different images—a fragment from the same nineteenth-century period with hands holding an open book. Novak then combined the two projected images in image editing to help "place the past in the present and the present in the past." *www.lorienovak.com*

→ *lossless, pages 36, 197*
→ *PSD, page 197*

10. **Save as a master file** using a lossless file format such as TIFF or **PSD**. You now have an edited image file with all its information intact, from which copies can be created for different purposes.

11. **Resize for your specific use**, such as for printing or posting on a website. Create a new copy of your master file, if your image editor doesn't do this automatically, so you won't overwrite it accidentally.

→ *sharpening, pages 200–201*

12. **Apply sharpening** as needed to your resized image file.

13. **Save the resized and sharpened file** if your program doesn't do this automatically.

→ *back up, page 203*

14. **Create at least one backup copy** of your images as soon as you save them, so you don't forget and risk losing the pictures.

One of the major advantages of digital photography is the ability to adjust a picture after it has been taken. This allows for great control over how your pictures look. In addition, a digital workflow allows you to move your pictures from one place to another, search for them, store them, and in general develop a well-organized and easily managed archive of your work.

Image editing and **image management** are key elements of postproduction (post)—the work you do after image capture or scanning. Image-editing programs allow you to prepare an image file for printing or other forms of output, such as posting on the Internet. Most often, you'll want subtle edits—perhaps cropping a little to tighten the composition, or tweaking brightness to make colors pop. But you can also make more extreme adjustments, such as putting a human head on a donkey or making a green house red. Note that the terms edit and adjustment are used interchangeably—adjusting an image is essentially the same as editing it.

Most pictures need some degree of adjustment in post. However, editing time can be minimized by doing all you can to make things right when you take the picture. It helps a lot if the subject is well lit and correctly exposed, and if your camera's image sensor is free of dust and dirt.

Note that the term Photoshop is often used to mean image editing—as in "I'll have to Photoshop this." This is because Adobe Photoshop, the industry-leading image-editing program, is so ubiquitous. However, there are all kinds of image-editing programs available. In fact, many programs, including some word processors, have at least rudimentary image-editing capabilities.

Image management (or **archiving**) programs allow you to import, organize, and store your pictures. Image management allows you to do many useful things to your image files, including naming them, adding

descriptive **keywords**, and placing them in folders for future reference and retrieval.

Image editing is the more complex part of postproduction, and this chapter will concentrate on it. But in terms of software, the distinction between image editing and image management is hazy, as many programs do both. Some programs are very simple to use and allow basic adjustments only, while others are complex and boast many features. Some come bundled with related programs, while others are dedicated either to editing or management, but not both. However, all have the same goals: to allow you to make your pictures look the way you want them to, and to help you organize and archive them.

Hardware Matters

You can work in postproduction on any computer, either a Mac or a PC. Post often involves large image files and complex operations, so the newer and more powerful the computer, the better—otherwise, you may find editing slow going, and you may be limited in the software you can use.

For fast and efficient postproduction, use a computer with a lot of **RAM** (internal memory available to run software and data) and a fast **processor** (best for handling large amounts of data). It also helps if your computer has a hard drive with plenty of available space. You will need one or more external hard drives to back up your image files once they've been edited and saved. Closing applications that aren't in use and keeping your computer's desktop neat may also speed things up.

It's very important that you use a good monitor, preferably one made specifically for displaying images. High-quality monitors can be as pricey as computers, or even more so, but without one it will be difficult to accurately evaluate the brightness, contrast, color, sharpness, and other characteristics of your pictures. Note that a good monitor isn't enough for optimal image editing—it must also be **calibrated** for accuracy.

→ *monitor calibration, pages 172–173*

Furthermore, your monitor's placement is important. You will see better if you work in a dimly lit room, away from indoor lights, windows, skylights, and any other ambient light that can interfere with the displayed image.

Also, take care where you place yourself when working on the computer. Use a comfortable chair and sit upright. Position the monitor so you're looking slightly down at it. It's easy to relax your posture while working, but this can lead to back and neck problems and even more serious medical conditions, so be sure to maintain your posture. It also helps if you take a break every thirty minutes or so and walk away from the computer for a few minutes.

A hood over the monitor can make the image on the screen easier to see.

MONITOR HOOD

Accurately viewing an image on a monitor can be difficult unless you are able to block out all extraneous light, which could cause your colors to appear to be less accurate. Any ambient light may affect the way the picture looks on the monitor. It's best to keep the lights dimmed with the screen positioned away from windows or skylights.

A monitor hood can help block light from the screen, keeping reflection to a minimum. It might even reduce eyestrain from working on a monitor that's too bright. Some high-quality monitors come with built-in hoods, but usually you'll have to add your own. Make sure it fits around your monitor snugly. Hoods can be fancy or simple, custom fit or adjustable. You can even make your own by fitting pieces of cardboard around the monitor.

Calibrating your monitor

Monitor calibration involves setting up your computer and monitor so your monitor matches industry standards of color display. The idea is that color from every calibrated monitor should look the same. This helps guarantee that what you see on the monitor is what you'll get—for instance, when you make a print or upload an image to a lab or photo-sharing site.

Calibrating a monitor may sound daunting, but it's actually fairly simple if you have the right tools. For one thing, your monitor may already be calibrated if you're working in a school or other digital-imaging lab. If you aren't, you'll have to calibrate your own monitor, but the process is practically automated.

To start, you'll usually need calibration software and an instrument that measures color, called a **colorimeter**. If at all possible, use a high-quality monitor optimized for viewing images, not text. You should calibrate your monitor in conditions similar to those you'll be working in. Ideally, a good working environment has white or light gray walls and is dimly and neutrally lit—with no fluorescents, tungstens, or strong window light.

There are various ways to calibrate a monitor, and a variety of products available to do the job. Here is a typical workflow, though yours may differ somewhat.

A colorimeter lies over the computer monitor to read and calibrate the displayed color.

1. Load the calibration software onto your computer.

2. Plug the colorimeter into your computer.

3. Position the colorimeter so it hangs over the top of the monitor.

4. Tilt the monitor back slightly so the colorimeter lies flat against the display.

5. Run the calibration software. It will display a series of standardized color swatches for the colorimeter to read. The software will most likely automatically adjust brightness, contrast, and color on your monitor, but it may ask you to do it manually.

6. Make sure the colorimeter is positioned over the first swatch of color. After a few minutes, the software will automatically adjust your monitor so it displays colors consistent with industry standards.

Note that monitor calibration isn't enough to ensure accuracy throughout the output process: there has to be **color management** every step of the way. This means that all your devices must conform to the same color standards. If you are sending your images to someone else's computer, that computer's monitor must also be calibrated if you want them to look the same. And when making prints, your printer must be set up with the correct **paper profile** (sometimes referred to as a **printer** or **print** profile) so each print will match the displayed image.

→ *paper profile, page 221*

COLOR SPACE

The term color space is used to describe the way color is represented. The two most common color spaces are: **RGB** (red, green, and blue) and **CMYK** (cyan, magenta, yellow, and "key" or black). RGB is the preferred color space for working on a computer monitor, as well as for digital capture and scanning. It offers the widest range of colors, mixing red, green, and blue at different intensities to produce these and all other colors you see.

CMYK is used in commercial and inkjet printing and contains a more limited range of colors. It describes inks that are applied to paper and reflect light—as opposed to RGB, which describes projected light. CMYK color is good enough for printing pictures, but inadequate for capturing them or viewing them on a monitor.

Grayscale is a third color space, used for creating continuous-tone black-and-white images—pictures with only black, white, and a range of grays in between. Grayscale contains no color information.

In addition to these three color spaces, there are also sub-spaces. For example, Adobe RGB is one company's version of RGB, and sRGB is a form of RGB that presents a more limited palette of colors, which is often used for making snapshot-size prints and for posting photographs on the web.

A related consideration is **bit depth** (or **color depth**), which describes the amount of color information in your image file. Maximum bit depth is determined by your camera—for example, some cameras produce 8-bit files, while others can produce 14-bit files. In theory, more information means more accurate color. In practice, you may see the difference, but often times you won't see any difference at all.

↳ *bit depth, page 39*

Getting Started

The first step of postproduction is to organize your image files on the computer. Create a new folder, and download pictures from your camera to it. Or, if you already have captured or scanned image files, make sure they are in an accessible folder. There are many methods of organizing your image archive, some of which will be covered later in this chapter.

→ *downloading pictures,*
pages 42–43

Various ways to download pictures from your camera were discussed earlier. You can use the cable that came with your camera to plug it directly into the computer. Or, you can use a memory card reader, either built into your computer or independent of it. With some cameras and memory cards, you can even download your images though a wireless network.

Once your pictures are on the computer, you must decide which ones to edit. You can view your pictures one by one by double clicking the image-file icon, or you can view several pictures at one time in an image-management program. These programs primarily organize and display pictures to facilitate browsing through large numbers of files, but most also have some basic image-editing capabilities.

WORKING IN RAW

When taking pictures, you set the camera to save your images as either JPEG or RAW (or both). If you opted for JPEG, simply open it in your image editor and go to work. Some image editors open RAW files directly, but because they are often camera or manufacturer specific, you may have to take additional steps to convert their data into a format your image editing software can read. First, open them in a separate **RAW file converter** and then open the converted files with your image editor. This gives you the added capability to perform some adjustments using the RAW converter, such as noise reduction, and exposure, which may make image editing easier later on.

JPEG files are compressed in-camera, causing some of the image data to be lost. Less data means less flexibility in your image-editing adjustments. In contrast, RAW image files are compressed in a lossless manner, so they retain all the information the camera captures. RAW files give you more information to work with when image editing, thus allowing more control of the process and better results.

Every camera has a different name for its RAW format. There is, however, a universal option for RAW called DNG. This is a file format that was created to be universally compatible and stable—so that in the future these kinds of files will remain viable. You can convert your camera's RAW files into DNG using RAW converter software. The idea is that these converted files should be readable by all image-editing software now and in the future.

Simple image-editing programs allow you to make basic adjustments, oftentimes only automatically. More powerful programs allow you to make dozens of adjustments, and give you a choice of manual or automatic control. Most programs offer many of the same basic adjustments, but there are significant differences in the way they work and in the degree of control they allow. More powerful programs usually produce superior image files, but simple programs cost less and take less time to learn.

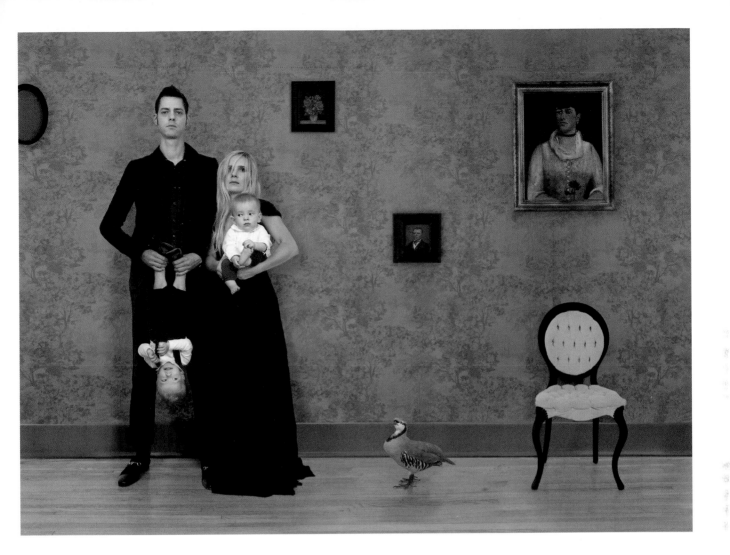

Julie Blackmon, "American Gothic"
Blackmon's somewhat autobiographical
world often depicts the ideal suburban
family on the verge of disaster. She
uses rich color and digital editing and
manipulation, as well as references from
art history, to describe elements of family
life in a frenzied world. Blackmon says, "As
an artist and as a mother, I believe life's
most poignant moments come from the
ability to fuse fantasy and reality: to see the
mythic amidst the chaos."
www.julieblackmon.com

One adjustment you should make early on in your workflow, regardless of your image editor or whether you're working in RAW or with JPEGs, is **noise reduction**. Not all pictures require it, but when you're photographing in low light or with a high ISO—or if you've underexposed your pictures—there's a good chance you will need some noise reduction. You may have noise-reduction capability built into your image editor, or you may want to use separate noise-reduction software. More on this later in this chapter.

→ *noise reduction, pages 195, 197*

Image editors offer a number of ways to make changes to your pictures. They use **adjustment tools** to make specific edits. There are many different adjustment tools, depending on the image editor you use. However, any good image editor will allow you to crop and zoom, as well as adjust image brightness, contrast, and color, and also retouch spots and other blemishes. Note that your image editor may offer more than one tool to produce similar results.

Cropping

Cropping refers to trimming an image for tighter composition. You can crop minimally by slicing off a distracting element at the edge of the frame. Or, you can crop more drastically by making a rectangular image square or by cutting out all but the eyes of a portrait subject.

Mild cropping makes subtle improvements on the final results. But you have a finite number of pixels in your image file, so if you crop an image too much, you may end up with a file that has a resolution too low to print. You could then enlarge the file when image editing by **up-rezzing**, asking your image editor to invent pixels to make the image larger, but this will probably sacrifice image quality. You'll get the best results by taking the picture the way you want it initially, rather than cropping later. Not only will the image quality be better, but it's likely your composition will be tighter and more natural.

→ *up-rez, page 37*

Step-by-Step: Cropping

1. Select the crop tool in your image editor.

2. Click on the image, then drag your cursor to make a box indicating where you would like to crop.

3. If necessary, resize this new frame by grabbing a corner or an edge and dragging it to where you want it—or move the entire box by clicking and dragging from the middle.

4. Apply the crop. Various ways to do this include double clicking inside the new frame, by clicking a button, or by pressing *enter* on your keyboard.

1 2 3

This picture in a zoo (1) is slightly off-center. Cropping (2) allows you to eliminate part of the image, and focus attention on the lion's face (3). ©Jesse Stansfield

→ *retouching, pages 188–189*

Zooming

Zooming allows you to magnify the image, making it easier to view specific areas or details while making small changes, such as retouching. You can zoom in close so you can work on a very small area of your picture, perhaps to retouch a blemish, or zoom in just a little, maybe to darken a larger area selectively. Once you've made your edits, zoom out to view the image at its original size and make sure it looks right overall.

Zooming is widely used and extremely helpful. But it doesn't alter your picture on its own. Rather, it works in conjunction with one or more other editing options, making them easier to use.

Various image-editing programs handle zooming in different ways. Some use a zoom tool, which you select and apply to the area of the image you want enlarged. Other image editors use sliders to enlarge the whole photo. Either way, you should be able to control how far in you want to zoom.

Overall Image Adjustments

Image editing allows you to make broad adjustments to the whole image, as well as specific adjustments to select areas. Typically, you'll want to make the overall changes first, before tackling the select areas. Make the adjustments you need, but generally keep it subtle.

Brightness, contrast, and color

These adjustments are the most common, and are fundamental in establishing the tone and look of your pictures. Note that with some image-editing programs, brightness and contrast are adjusted at the same time using the same tool.

TIP: LOOK AT THE HIGHLIGHTS
A good way to judge brightness is to look for detail in the highlight areas. You'll want your highlights to look bright but still retain some detail—you don't want them to be muddy or dim, but don't brighten them so much that they become blank white.

Brightness is the overall lightness and darkness of an image—whether it's too light, too dark, or just right. An image with good overall brightness displays a range of tones from light to dark, with good detail throughout. Brightness is sometimes referred to as **exposure** or **density**, and is usually a product of how a picture was exposed in the camera. An image that is too dark overall was underexposed; an image that is too light was overexposed.

Contrast is the relative difference between the highlight areas and the shadows in an image. A picture with average contrast has a wide range of tones from lights to darks. Low-contrast pictures are flat, often with highlights that aren't too bright and/or shadows that aren't too deep. High-contrast pictures tend to be harsher, as they have bright highlights and dark shadows, with fewer tones in between.

Contrast can be affected by a number of factors, such as inherent subject characteristics and subject lighting. Most often, you'll want your image to have a good range of contrast—not too much or too little. However, you could always decide that a harsh or flat look better suits certain pictures.

Color is a somewhat more complicated matter than either brightness or contrast and it may take you some time to figure it out. There are more aspects to it, and more ways to control it. For example, you can adjust the overall white balance (color temperature) or the overall **colorcast** (tint) of an image.

→ *white balance, pages 37, 39–40*

A good way to judge color is to look at areas of the image that should be white or light gray, such as ice or sidewalks. Darker areas tend to mask colorcasts so that subtle tints are less likely to show up here than they are in lighter areas.

White balance refers to how warm or cool the image looks—generally a function of subject lighting. A warm picture might have been shot inside in tungsten light, whereas a cool picture might have been shot outside on a drizzly day. Generally, you want neutral color balance—more or less. But at times, you might go for a warmer or cooler look, depending on the mood you want the picture to express.

Colorcast refers to the overall color bias of a picture. There may be a variety of reasons you get a cast. It can happen when strong colored lights in a scene spill over to nearby areas—say, light from a red neon sign reflecting onto a white wall or a portrait subject.

TIP: DON'T GO OVERBOARD
Image editing offers so many options that it's tempting to use as many of them as you can. But it's best to resist the temptation. Overworking image files can make them look artificial—for example, textured skin that looks too smooth due to excessive retouching or colors that look artificially bright due to oversaturation. Such extreme editing draws attention to your manipulation and away from the image itself. Also, constant readjusting and resaving image files can introduce digital artifacts. This is especially likely when working with JPEGs, which are highly compressed to begin with.

A colorcast may even be an inherent quality of the way your camera or scanner processes the image. One camera (or scanner) might produce a slightly cooler or warmer colorcast—though any such difference would probably be subtle.

The intensity or richness of color is its **saturation**. A highly saturated image will be vivid; imagine your pictures on a bright day at sunset. An unsaturated image will have flat color—dull and possibly almost **monochromatic** (one color)—such as on a gray, cloudy day, or at dusk. Your image editor may have a separate saturation adjustment option—usually as a slider.

Saturated color is intense and rich, as on a sunny day with the light shining on a colorful subject (1). Unsaturated color is flat and dull, as in this graffiti on a shaded wall (2).

The primary colors of light are red, green, and blue, which mix to produce any other color. Cyan, magenta, and yellow are the secondary colors—complements to the primaries.

COLORS OF LIGHT

Having a basic understanding of color theory is helpful when image editing, but it is not necessarily required because many of the adjustments are automated or intuitive. In brief, you adjust color by mixing the primary colors of light, which are red, green, and blue (RGB). Two **primary colors** of equal intensity, when added together, form **secondary colors**—cyan (bluish green), magenta (purplish red), and yellow. Green and blue mixed together form cyan; red and blue form magenta; and red and green form yellow. If you're a painter, you may know primary and secondary colors as they refer to pigments; here, they refer to light, which is a different matter.

Each secondary color is the **complement** (opposite) of a primary. Thus, cyan is the complement of red; magenta is the complement of green; and yellow is the complement of blue.

In theory, you can create any color at all by mixing RGB colors in various strengths. When you adjust the color in image editing, you will often see a second color represented. For example, when you go to a red slider to make adjustments, you will see red at one end of the slider, and its complement, cyan, at the other end.

Editing methods

Image-editing programs update and evolve constantly, so it's impossible to accurately describe each and every one in detail here. Consequently, the descriptions in this section are general. Also, there are many ways to make your overall image adjustments. What follows is an explanation of these adjustment methods with some suggested ways to use them. The goal is to give you a fundamental understanding of your options so you can develop your own image-editing workflow over time. Refer to your image editor's help menu or website for specifics.

| Enhance | Select | Filter | View |

Auto Smart Fix
Auto Levels
Auto Contrast
Auto Color Correction
Auto Sharpen
Auto Red Eye Fix

Adjust Smart Fix…
Adjust Lighting ▶
Adjust Color ▶
Convert to Black and White…

Adjust Sharpness…

Your image editor can automatically adjust the overall image. You may also make automatic adjustments to specific characteristics such as brightness, contrast, and color.

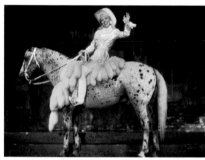

Original image Image after the automatic adjustment

Automatic (auto) adjustments are simple, quick, and easy. They are built into every image-editing program. Sometimes these adjustments are fully automatic, and occasionally they allow for some degree of manual control as well.

If you select the fully automatic option, your image editor will adjust brightness, contrast, and/or color simultaneously, according to its preset parameters. You can also, in some programs, select automatic brightness, contrast, and color separately.

Automatic editing has its advantages. It is easy to understand and quick to use, thus handy for e-mail and other simple applications, such as social networking. It works well enough if you're not fussy about the results. But most of the time it pays to be picky. Take control of your pictures by using these more hands-on and sophisticated editing options: sliders, levels, and curves.

Sliders are horizontal scales with a marker that you can move left or right to control image adjustments. Using sliders is intuitive. Simply drag the marker in either direction. As you do, you'll see how the adjustment affects the displayed image. Note that one adjustment usually affects another. For instance, if you adjust brightness until it looks right, adjusting contrast next may throw off the brightness a bit. You may have to work back and forth between tools until you get it right.

Step-by-step: Using sliders to adjust the overall image
See examples on pages 182–184.

1. Locate the brightness slider in your image editor. Your program may call it exposure instead.

2. Move the marker to the left (-) to darken the image overall, or to the right (+) to lighten it. Note that the appearance and direction of the sliders may vary according to your image-editing program.

3. When you are satisfied with the overall image brightness, locate the contrast slider. Move the marker to the left (-) to reduce overall image contrast, or to the right (+) to increase it.

4. Examine the image to make sure you're satisfied. Sometimes changing contrast throws off the brightness—and changing brightness throws off contrast.

5. When you are satisfied with both brightness and contrast, locate the color sliders. Image editors offer different choices, but the following steps are most commonly found.

6. Adjust the overall white balance, if your image editor allows it. Slide the marker towards one end for a cooler effect or toward the other for more warmth.

7. Now, adjust the overall colorcast. Slide the marker to the left or right, adjusting the colors and their complements—making the image more red/cyan, green/magenta, or blue/yellow.

8. Increase or decrease color saturation. Locate the saturation slider and move the marker for less color intensity (-) or for more (+).

9. Adjust, examine, and readjust your edits as needed.

Levels and **curves** are graphs that create a visual representation of the information in your image file, allowing you to edit it. These adjustments are similar to the ones you can make automatically or with sliders—namely brightness, contrast, and color. However, with levels and curves you'll be better able to make subtle adjustments and fine-tune the results.

While levels and curves are often linked, each has a different appearance and is applied in a different way. Sometimes levels and curves are used independently, and sometimes they are used together. Your image-editing program may offer levels and curves separately or combine them. And some programs may not offer them at all.

1

2

The first overall adjustment you'll want to make is probably image brightness. The original picture (1) is too dark. The adjusted picture (2) has been brightened.

1

2

Brightness sliders before (1) and after (2) the adjustment

1

2

Brightness levels before (1) and after (2) the adjustment

1

2

Brightness curves before (1) and after (2) the adjustment

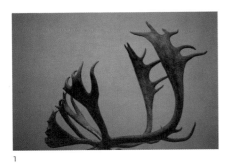

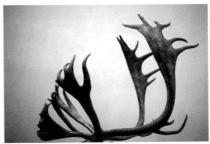

Often the second overall adjustment you'll want to make is image contrast. The original picture is flat (1), with low contrast. The adjusted picture (2) has more pop.

1

2

Contrast sliders before (1) and after (2) the adjustment

1

2

Contrast levels before (1) and after (2) the adjustment

1

2

Contrast curves before (1) and after (2) the adjustment

1

2

1

2

Usually, the last overall adjustment is color, after you've established brightness and contrast. The original picture (1) has a strong magenta cast. The adjusted picture (2) is more neutral in color, with the magenta toned down.

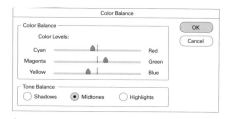

1

2

Color sliders before (1) and after (2) the adjustment

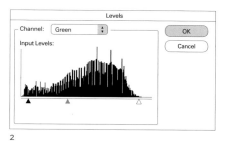

1

2

Color levels before (1) and after (2) the adjustment

1

2

Color curves before (1) and after (2) the adjustment

Levels uses a histogram to visually describe the data in your picture. Like the histogram in your camera (or scanning software), it maps out a range of image brightness levels from shadows on the left to highlights on the right. Middle areas represent midtones. As with sliders, one adjustment usually affects another, so don't be surprised if you have to readjust after examining each change you make.

Step-by-step: Using levels to adjust the overall image

1. Locate and open the levels adjustment tool in your image editor. A histogram representing the picture will appear. Below it, you'll see a horizontal slider with three markers: black (for shadows), gray (midtones), and white (highlights).

2. Slide the midtone marker to control overall image brightness. Sliding it to one side lightens the image, while sliding it to the other darkens it.

3. Now, slide the shadow and highlight markers to adjust contrast. To increase overall contrast, slide the black marker to the right, darkening the shadows. Be careful, though. Slide it only to the point where the histogram information begins. If you slide it too far, you'll eliminate shadow information. This is called clipping, and you'll usually want to avoid it. Now, slide the white marker to the left— again only to the point where the histogram information begins, to avoid clipping highlight detail.

→ clipping, page 113

You don't have to slide both markers. You can choose to darken the shadows and leave the highlights alone—or brighten the highlights only.

4. Now, examine the image to make sure you are satisfied with both brightness and contrast.

5. Once you've established the overall image brightness and contrast, adjust the color. Some image-editing programs don't allow you to do this with levels, in which case you'll have to use sliders or curves.

If you can adjust color with levels in your image editor, the program will offer three separate color channels, representing complementary colors—red/cyan, green/magenta, and blue/yellow.

Select the red channel to adjust for red and cyan. Slide the center marker one way to add red overall and the other way to add cyan. Select the green channel and move the middle marker to adjust the balance of green and magenta. And select the blue channel to adjust blue and yellow.

6. Adjust and readjust your edits as needed.

Curves, like levels, visually describes the data in your image, mapping out a range of densities along a line graph, from shadows (bottom left) to midtones to highlights (top right). It also may show a histogram, to be used either as a reference or for making adjustments to levels and curves in tandem.

You change the shape of the curve to make your adjustments. Keep in mind that changing one part of the curve will almost certainly affect other parts—so again, adjust, examine, and readjust as needed.

Step-by-step: Using curves to adjust the overall image

1. Locate and open the curves adjustment in your image editor. A graph appears with a straight diagonal line.

2. To adjust the overall brightness, click on the middle of the line to create a point. Drag this point above or below the straight diagonal to lighten or darken the image overall. You should see the image change as you drag the point. Note that how the graph appears may vary depending on the image editing program.

3. When you are satisfied with the overall brightness, adjust for overall contrast by changing the relationship between the shadows and highlights. Place a point along a shadow area (lower left) of the line, and drag that point down to darken the shadows, or up to lighten them. Then, place a point along a highlight area (upper right). Drag the point down to darken the highlights or up to lighten them. You can also choose to darken the shadows only, and leave the highlights alone—or brighten the highlights only.

 Adjusting the curves in this way provides enough overall contrast control for most purposes. However, with some image editors, you can place multiple points along the curve and drag the line up or down for even more precision.

4. Examine the picture to make sure you are satisfied with both brightness and contrast.

5. Now, adjust the color. As in levels, use the individual red/cyan, green/magenta, and blue/yellow channels. With image editors that don't allow color adjustments with curves, use sliders.

 Select the red/cyan channel. Place a point in the middle of the curve and drag it up to add red overall, or down for cyan. Select the green/magenta channel, and drag the curve up to add green and down for magenta. In the blue/yellow channel, drag the curve up to add blue and down for yellow.

6. Adjust, examine, and readjust as needed.

Andrew Pinkham, "Maya"
To make his dog portraits, Pinkham takes several pictures of different details and combines them in a sophisticated image editor, blending the elements into one piece. They are really more like paintings than photographs, highly reminiscent of seventeenth-century portraiture with their muted colors and ambiguous backgrounds. Printed on canvas to further mimic a painting, Pinkham's work is both beautiful and tongue-in-cheek. He says he has "always strived to have my animal portraits show the subject in a heroic light." *www.andrewpinkham.com*

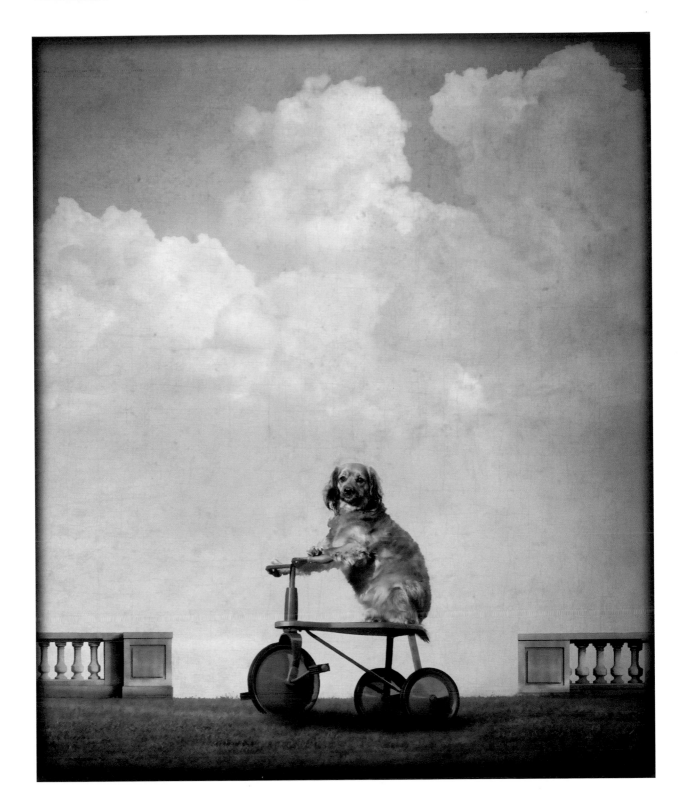

→ *cleaning the image sensor,*
page 32

Retouching

Retouching refers to getting rid of unwanted marks and other blemishes in a picture. You typically get these marks from dust or dirt on your camera's image sensor or on your scanner, but you can also choose to retouch distracting parts of a scene, such as a crack in a wall or an out-of-place hair.

Some image-editing programs offer a single tool for retouching, while others offer several, with each functioning a little differently. There are various tools for retouching, such as a **cloning tool**, **spot removal tool**, **spot healing brush**, and **patching tool**. Some of these tools have multiple applications. For example, a cloning tool can be used for retouching, but it can also be used to copy a tree from one part of a scene to another.

Whatever the retouching tool is called, the basic idea is the same. Choose the blemish, speck, or mark you want to fix, then find and copy an area in the picture that looks like the area around the blemish. Finally, paste it over the mark you want to retouch. Some retouching tools do all of these steps automatically in a single operation, while others work more manually and require multiple steps.

Extensive retouching can be time consuming. You can make things easier by keeping your camera's image sensor clean, as a dirty sensor is often the culprit. The same guideline applies to scanning. Make sure the film or print to be scanned, as well as the scanner glass, are free of dust and other debris or marks. These precautions should produce clean image files that require little, if any, retouching.

There are other ways you can clean up during image capture to minimize retouching later. With portraits, make extra sure your subject is arranged the way you want her/him—hair in place, shirt collar clean, and so forth. The same goes for still subjects, such as plants and flowers. Use canned air, a soft cloth, or a brush to remove all visible distractions, such as dust or pollen on leaves.

Even if you do all you can to minimize blemishes ahead of time, you may still have to retouch. You can do this anytime during image editing, but it's best to do it early on. That way you'll have a cleaned-up image file to work on before applying other adjustments.

Step-by-step: Retouching
Some retouching tools are highly automated, while others blend manual and automated control. Here are examples of both.

Auto retouching tool
1. Zoom in on the area that needs retouching.

1

Dust on the image sensor leaves small dark specks on the image (1). To retouch the specks, zoom in on the problem area (2) and use a retouching tool to eliminate them (3). Note that the white spots were actually on the candy, not from the image sensor, but you can retouch them as well. When you're finished, zoom out to see the entire picture.

2

3

2. Select the auto retouching tool by clicking on it.

3. Move the cursor to the area that you want to retouch and click.

4. The program will analyze the area broadly and automatically cover the blemish to match surrounding tones and colors.

5. Zoom out, zoom in, and retouch as needed.

Manual retouching tool

1. Zoom in on the area that needs retouching.

2. Select a retouching tool by clicking on it.

3. Visually identify your target—a mark, speck, or blemish you want to fix.

4. Click to take a sample from part of the image comparable to the area around the blemish. Although this sample is often adjacent to the blemish, it doesn't have to be. It could be any part of the image that has matching colors or tones.

5. Move your cursor to the target and spot or paint over it until the mark, speck, or blemish disappears.

6. Zoom out, zoom in, and retouch as needed.

Local Image Adjustments

Now you've got an image with good overall brightness, contrast, and color. Look at it critically to identify specific areas that need improvement. Perhaps one corner of the picture should be a little lighter or an area in the middle a little warmer.

The best image-editing programs allow you to go into local areas and selectively make changes like these—and many more. Simple editing programs may allow few, if any, local adjustments. But more sophisticated programs offer a variety of local options. Following are some of the most commonly used.

Burning and dodging

Probably the most fundamental local adjustments are burning and dodging, which allow you to darken (burn) or lighten (dodge) specific image areas without affecting the rest of the image. If the sky is too bright, you can burn it in; if the shadow on a face is too dark, you can dodge it.

Be careful to apply only the minimum amount of burning and dodging. If you burn too much, whites may go gray and look phony. And too much dodging can turn black shadows muddy or make them look washed out.

Step-by-step: Burning and dodging

There are different methods available for burning and dodging, depending on the image editor you use. What follows is the simplest method, requiring only one step. However, to have even more control you can also burn and dodge by selecting an area and darkening or lightening it using sliders, levels, or curves, as described previously.

The initial image (1) looks fine in general, except for the right side, which is a little bright. Burning that side (2) will darken it and leave the rest of the picture unchanged, to focus the viewer's attention toward the sign, which is the most important part of the composition.

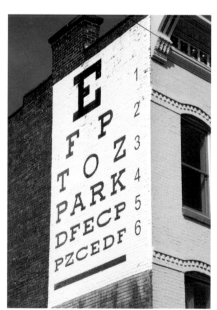

1

2

To burn

1. Select the burning tool.

2. Click and hold down the mouse button to paint over the area you want to darken. The longer you do so, the greater the effect. You'll see the area darken as you paint.

3. If it's still too light after a few seconds of burning, click again to burn in more. You can continue clicking for increased darkening effect.

Don't worry about being too precise. You may burn in a bit in adjacent areas you don't want to darken, but chances are they will blend seamlessly into the darkening areas anyway. If the burn doesn't look right, don't save the image you're working on. Simply start over, or select *undo* to go back and try again.

The initial image (1) looks fine in general, except for the bottom right corner, which is too dark. Dodging that corner (2) will lighten it while leaving the rest of the picture unchanged. This helps to balance the tones overall and also reveals more detail in the shadow areas.

1

2

To dodge

1. Select the dodging tool.

2. Click and hold down the mouse button to paint over the area you want to lighten. The longer you do so, the greater the effect. You'll see the area lighten as you paint.

3. If it's still too dark after a few seconds of dodging, click again to dodge more. You can continue clicking for increased lightening effect.

As with burning, you may dodge a little in adjacent areas you don't want to lighten, but chances are they will blend seamlessly into the lightening areas. If the dodge doesn't look right, just start over.

Selecting and adjusting

Simple burning and dodging are one-step processes. But many local adjustments require two or more steps, depending on your image-editing program. Note that some image editors don't offer selection tools.

The first step is selecting an area or areas you want to adjust with a **selection tool**. This allows you to isolate a local area of the picture that you can then edit. Selection tools don't affect the image on their own, however. You'll need one or more additional tools to make the edits you want in the selected areas.

The second step is to apply an edit to the selected area. You can apply it using sliders, levels, or curves—or any one of several other adjustment tools offered by your program. For instance, you can select a pale blue sky and make it look deep blue.

Some adjustment tools were mentioned earlier, such as the cropping, zooming, and retouching tools. However, image editors may offer many others. Different programs offer different tools, but many of these tools are similar, and some image editors even offer two or more tools that can produce comparable results. As you get to know your image editor, you'll get a sense of the method you prefer.

Step-by-step: selections and adjustments

What follows are a couple of simple examples of making adjustments within your selections. Keep in mind that there are a wide variety of other kinds of adjustments as well.

To darken or lighten an area

1. Choose a selection tool.

2. Select the area you want to adjust by outlining it with the selection tool.

3. Apply sliders, levels, or curves to darken or lighten the selected area only.

To change color balance in an area

1. Choose a selection tool.

2. Select the area you want to adjust by outlining it with the selection tool.

3. Apply sliders, levels, or curves to adjust the color balance in the selected area only.

IMAGE-EDITING TOOLS

Here are some common image-editing tools and a brief description of what they do. As noted earlier, not all programs offer all these tools—and in some programs, similar tools go by different names and may also function slightly differently.

 Adjustment brush tool. Selects an area where you want to make an adjustment. Click and paint (move the brush around) on the area, then choose from a series of listed options to make adjustments such as brightness, contrast, color, sharpness, and so forth.

 Autoadjust tool. Enhances the picture automatically. Click the button and overall exposure, contrast, and color are automatically adjusted.

 Burning tool. Darkens a local area selectively. Click and move the cursor around so the targeted area becomes darker. The more you click, the darker it becomes.

 Cloning tool. Copies an area of the picture to paste it elsewhere. Click on the part of the picture you want to copy, and then move the cursor to the targeted area. Click and paint to make the clone.

 Cropping tool. Trims off the edges of an image to your specifications. Click and drag to make a box indicating the crop. Double click to complete the crop.

 Dodging tool. Lightens a local area selectively. Click and drag the cursor around so the area becomes lighter. The more you click, the lighter it becomes.

 Hand tool. Grabs an image to move it around. This tool is especially useful when you are zoomed in—when the entire image doesn't fit on the screen. Click to grab a part of the image and drag it around to reveal out-of-sight areas.

 Lasso tool. Selection tool for drawing a free-form selection. Click and use the cursor to draw an outline around an area of any shape.

 Magic wand tool. Selection tool that automatically guesses areas you want to isolate. You click on an area, and the magic wand finds and selects similar tones in the selected area.

 Quick selection tool. Works much like the magic wand, guessing an area that you want to select as you guide it. You click and drag to paint over this area, and the tool selects it—and also surrounding areas with similar tones.

 Rectangular marquee tool. Selection tool that allows you to easily choose a rectangular (or square) part of the image. Click and drag to create a rectangular (or square) selection within the image.

 Red-eye correction tool. Automatically fixes red-eye caused by a camera flash. Click on the eye you want to fix, or drag the cursor and make a box around the red-eye, and the program automatically removes the red.

 Retouching/spotting tool. Automatically fixes marks, specks, or blemishes on an image that you select. Click on a spot or mark that you want to get rid of, and the tool paints over it, making it look like the area around it.

 Rotate tool. Rotates the image whichever way you specify. Simply select rotate left or rotate right and then click on the image to turn it.

 Zoom tool. Zooms into a part of the image. Click on an area and the screen zooms in, allowing you to see a blown-up detail of the picture.

You can change the size and density of many adjustment tools by using sliders or whatever means your image editor provides.

CUSTOMIZING THE TOOLS

You can customize most image-editing tools for greater control of your adjustments. Two common examples are **brush size** and **opacity** (density), but some tools have other options unique to them.

With many tools, your cursor acts as a brush. You can alter its size according to the size of the target area. For instance, to retouch a tiny mark on a nose, you'll need a very small brush. To darken a bright sky, you'll need a much larger brush.

You can also alter the brush's opacity, which determines the intensity of the adjustment. Select a high opacity for strong adjustments, and a low opacity for milder ones. Make a strong adjustment to retouch an unwanted mark on a black sweater or a mild adjustment for a light burn to an ocean scene.

When you select a tool, its brush size and opacity level will appear on the screen. You set these separately, depending on the program. Chances are you will see the size of the brush cursor change as you adjust it, but you may or may not actually see the opacity results until you've made your edits.

Plug-ins and Filters

A **plug-in** is accessory software that adds functionality to existing programs. Some integrate fully with the program and others work in tandem. In some ways, plug-ins work a little like apps for cell phones and tablets (except they usually work within sophisticated image-editing programs). They are available for countless purposes, such as customizing editing features, creating new adjustment tools, or allowing newly introduced software or hardware to work smoothly with the program. There are plug-ins that can smooth out imperfect skin tones or make your digital pictures look like they've been shot on photographic film.

Plug-ins are often available from the same companies that make image-editing software, but many come from independent developers. Regardless of the source, your plug-in must be compatible with your editing program.

Filters are a category of plug-ins. Some don't actually need to be "plugged in," as they come preinstalled in your program. Image-editing filters can provide effects similar to what camera filters produce, but they also offer many more options.

Some filters are commonly used and simply enhance the image—for example, sharpening or noise-reduction filters. Others add a more extreme visual effect, such as making a subject look warped. It's generally best to use filters in moderation—to make mild image changes—but you can choose a more radical approach if you like.

→ *camera filters, pages 78–79*

Two of the most widely used filters are noise-reduction filters and sharpening filters. Both types are integrated into many image editors, but are also available from independent developers as plug-ins—and these often offer more options and better results than integrated filters. You can apply noise reduction at almost any time in your image-editing workflow. It's usually best to sharpen as the final editing step, if needed.

→ *sharpening, pages 200–201*

FILTERS

You can apply filters to an image overall, or you can apply them locally. Here are some commonly used image-editing filters:

Artistic. Creates painterly and other "creative" effects.

Blurring. Makes an image look softer, more diffuse.

Distortion. Warps or otherwise purposely deforms an image.

Gradation. Creates a transitional color or tonal effect.

Noise reduction. Minimizes the effects of noise and sometimes other digital artifacts.

Sepia. Makes the image look old fashioned, turning it yellowish-brown and white.

Sharpening. Makes an image look crisper, but can't fix an image that is out of focus.

Special effects. Adds unusual visual elements, such as lens flare.

Texture. Adds textural qualities to an image.

→ *image noise, page 34*

Noise-reduction filters

These filters can minimize or even eliminate unwanted image noise and other digital artifacts. If you shoot RAW, use the noise-reduction filter in your RAW converter before editing. As with most image adjustments, you should use noise-reduction filters sparingly. Better yet, take steps to minimize image noise when taking pictures, so you won't have to worry about reducing noise in post. Using a good camera, setting a low ISO, and avoiding underexposure are a few ways to do this.

A noise reduction filter can help minimize the appearance of noise and other digital artifacts. This image detail shows a lot of noise in the original (1), but much less after a filter has been applied (2).

1 2

Tim Garrett, "Arch," Saint Louis, Missouri
Garrett developed an app for smart phones
that takes four pictures in succession, just
like an old-school photo booth. "Everyone
is familiar with the booth's iconic output:
a vertical strip of four head shots," says
Garrett. "I am interested in using this
familiar format to create images that are
unfamiliar." Here, using photos from his
smart phone, he takes four strips of four
pictures each and collages them in post for
a very unfamiliar view of the famous Saint
Louis arch. *www.photobooth.net*

Step-by-step: noise reduction

1. Select a noise-reduction filter. Use the one that comes with your image editor or a plug-in from an independent developer.

2. Apply the noise-reduction filter, and your image editor will automatically minimize noise. Depending on the program, you may be able to adjust the amount of noise reduction, usually with sliders.

Saving Your Image Files

Once you've finished editing your image, it's time to save it. There are various ways to do this. For example, you can save it as a JPEG, which compresses the information, making a small image file that is easy and fast to handle and takes up a minimal amount of storage on your hard drive. However, it's highly recommended that you use a lossless format instead—one that retains all the file information when saved.

→ *lossless, page 36*

→ *TIFF, page 36*

The two most popular lossless options are TIFF and PSD. TIFF is a universal standard and is compatible across all image editors. PSD is an Adobe Photoshop file format, and may or may not be as compatible, depending on your program.

When you save this lossless image file, you create a **master image file**. This information-rich file should be the basis for any and all other future versions that you make of the file—whether you resize it, convert it to black and white, change the file format, make new adjustments, and on and on. Whatever you choose to do, make sure that you keep the master file intact, and save the alternate versions as separate image files.

Some image-editing programs automatically save different versions as new files for you. This way there's little chance of losing the master by saving over it inadvertently. With other image-editing programs, you may need to make a copy of the master file, edit the copy, and save that version as a new image file. Use a different but related name when saving so you can more easily find it later. For example, if your master file is named *sadie_master.tif*, you can save a small JPEG for e-mailing as *sadie_email.jpg*.

It's good practice to set up dedicated folders on your computer to house your picture archive. There are different ways to do this. For instance, under your main image archive folder, you might create subfolders with project names—such as "horses," "football," or "birthdays." Or, you could set them up chronologically, with all pictures taken in a particular year grouped together and pictures in the next year placed in a separate folder. All of these subfolders can reside in the main image archive folder.

TIP: KEEP THE ORIGINAL INTACT
For maximum protection against loss of your image files, always keep the original RAW capture file intact. Always work off a copy of the original when you are image-editing. Save the original safely away and edit the copy to make a master image file. This way, you will always have an information-rich file to fall back on if something were to go wrong with the master file, or if you want to edit the original differently in the future.

Resizing

The image you see on your screen will print, or otherwise output, at the size set when you originally took the picture (or made your scan). However, you'll usually need a different size for printing or other output, which means you'll have to resize your image file. Note that changing your image size shouldn't affect any of your other edits—cropping, brightness, contrast, color balance, and so forth.

There are two settings to consider when resizing an image: the image size (in inches or centimeters) and resolution (ppi—pixels per inch). Set your size according to the height or width you want—whichever you consider most important—and the program will automatically set the other dimension, keeping the aspect ratio of the image intact.

The second setting is resolution, which refers to the amount of pixels per inch (ppi) in your image file. You must set resolution according to how the image will be printed, or otherwise output. For viewing on a monitor only, you'll usually need 72 ppi. But there are exceptions—for example, high-definition monitors may require files with higher resolution. For printing you'll usually need even more resolution for best quality results—about 240-300 ppi.

Keep in mind that you can't just set any resolution you want and still expect good results. Your original capture or scanned image file has a finite amount of pixels, and to a large degree these pixels determine the maximum size and resolution of your output. The measurement of these pixels is called the **pixel dimensions** and is a count of exactly how many pixels tall and wide an image is. So if you have an image that is 4" x 6" at 300 ppi, your pixel dimensions will be 1200 px x 1800 px (4" x 300 pixels = 1200 and 6" x 300 pixels = 1800). The measurement of these pixels is especially useful when uploading images to a website, for example when submitting pictures for a grant or contest.

Your image editor may have an option to **resample** the image—change the actual amount of pixels in your image file. If you select resampling, adjusting either the image size or resolution will not affect the other. In this way, the image editor allows you to set the size of the file you want by altering the amount of pixels in the image file. For example, say you have an image file that is 8" x 12" at 150 ppi. If resampling is selected, and you change the dimensions to 4" x 6", the file will simply be resized to 4" x 6" at 150 ppi, effectively getting rid of the extra pixels that made up the bigger file.

If you don't select resampling, adjusting one setting (size or resolution) will cause the other to change, and will preserve the amount of pixels in the image file. For example when resampling is not selected,

→ *image size, page 37*
→ *resolution, pages 15, 33, 162–163*

TIP: OK TO BREAK THE RULES

While you're editing your pictures, keep in mind that you don't always have to follow the rules of balanced color, exposure, and other elements, to make a good picture. Consider using a strong colorcast to create warmth or drama, or dense shadows and minimal highlights to make an image feel brooding and edgy. A bright photo with strong highlights, dark shadows and heavily saturated color could have a striking graphic or surreal quality.

Try not to go overboard, though. Relying too much on color or saturation can sometimes make an image feel contrived, and it is not a good substitute for a great subject or composition. But don't be afraid to experiment.

downsizing an 8" x 12" file at 150 ppi to 4" x 6" causes the resolution to automatically adjust to 300 ppi. Adjusting to 4" x 6" doubles the ppi and keeps the number of pixels intact.

Making your image files larger than the original capture or scan is more problematic than making them smaller. Increasing the size of an image file requires up-rezzing it. In some cases, up-rezzing a small amount will look just fine, but it's best to not have to up-rez at all.

Many image editors have built-in up-rezzing capabilities, but plug-ins from independent developers, made specifically for this purpose, can produce better results for dramatic enlargements. Still, it's best to keep up-rezzing to a minimum—or to avoid it altogether.

As discussed, if you resize an image file, you should first copy the master file and work on that copy. (Some programs do this for you automatically.) That way you don't alter the master, and you can print or otherwise output again to that size whenever you like. Over time, you may well accumulate multiple resized versions of the same image.

Note that you could choose to resize a picture when printing or otherwise outputting it, but you're much better off doing the resizing in your image editor. This is because resizing requires **interpolation**, a complex

Image size box before resizing (1). Resizing without resampling keeps pixel dimensions intact (2). Resizing with resampling changes pixel dimensions and keeps resolution intact (3).

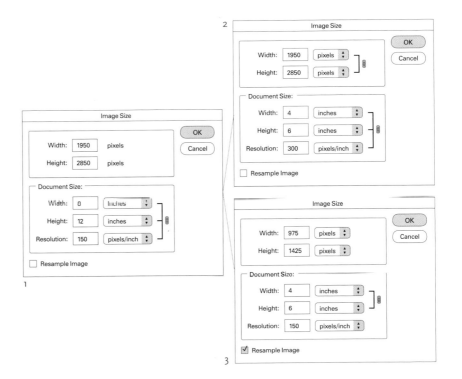

process that uses algorithms (mathematical formulas) to create new pixels and enlarge the image file. Image-editing software is designed to interpolate in a more sophisticated way than printing or uploading software.

Step-by-step: resizing

1. Make a copy of your master file if your program doesn't do this for you automatically.

2. Select the image-size option in your image editor. Your image dimensions and resolution (ppi) will be displayed.

3. With the resampling option not selected, reset the image dimensions to your desired size. This should adjust the resolution according to the number of pixels in the original image file.

4. Now, select the option to resample and set your desired resolution. Set 72 ppi for viewing on a monitor only or 240–300 ppi for making prints. If your ppi is over 300 though, don't worry about changing it—you can still print at a higher resolution.

5. Save the resized file as an additional copy with these settings, using the new version for printing or other output.

Sharpening filters

The final step after resizing is to apply the sharpening filter, if needed. You probably won't need it if you are working with JPEGs, because they get sharpened when they are compressed in-camera. But you may have to sharpen your RAW files since lossless compression does not involve sharpening.

Sharpening can make an image appear crisper by heightening the contrast between pixels. Depending on the image-editing program, you can choose to sharpen an entire image or just a selected area—and you also can control the degree of sharpening.

The effects of a sharpening filter can be subtle but still worthwhile, as the detail from the picture to the right shows. Before sharpening (1), the eyes and eyebrows are a little soft. Sharpening (2) helps correct that.

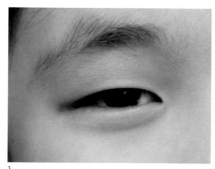

1

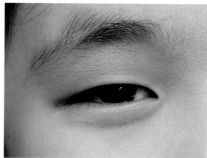

2

Oversharpening can add digital artifacts, such as jagged edges as shown in this image detail. When that happens, it may be time to scale back the degree of sharpening. © Jack Schow

Sharpening can enhance a picture, but it won't make unfocused pictures sharp, so don't depend on it to save poorly captured pictures. Also, be careful not to overdo it. It's possible to make a picture look too sharp, even surreal. And over-sharpening can produce unwanted digital artifacts, such as jagged edges and increased image noise. When sharpness is applied selectively, this can be even more apparent, as the selected area may look conspicuously different than the rest of the image.

Step-by-step: sharpening filter

Overall sharpening

1. Select a sharpening filter.

2. Zoom into your image so that you can see details when applying the sharpening.

3. With simple filters, the program will automatically sharpen the entire image when applied. With more advanced filters, you can adjust the amount of sharpening yourself, usually with sliders.

4. Save the sharpened image as an additional version of the master file.

Selective sharpening

1. Use the lasso or equivalent selection tool to isolate the area of the image you want to sharpen.

2. Select a sharpening filter.

3. Zoom into your image so that you can see details when applying the sharpening.

4. The program will automatically sharpen the selected area of the image. With more advanced filters, you can adjust the amount of selective sharpening yourself, usually by using sliders.

5. Save the sharpened image as an additional version of the master file.

Image Management and Archiving

When you have only a few pictures, you can find and work with them easily. But as you accumulate pictures over time, it becomes more difficult and time consuming to organize them. Working digitally gives you the opportunity to manage your image files easily, and with great flexibility.

There are many image-management programs available to help you do the job. They can also help you search for pictures and keep track of them—for example, if you have more than one edited version of a single image file. Often, these programs have both editing and management functions, though some are better at one or the other. And some link up directly to a separate image editor.

You have to import your image files into some management programs to work with them. With other programs, you can directly access and work with all files stored on your computer's hard drive or any storage media plugged into your computer.

With image management software, you can organize, search, and archive your pictures with relative ease and great flexibility. Many programs have image-editing features—or link seamlessly to an image editor.

metadata, pages 31, 33

MANAGING PICTURES

There are several ways to manage your image archive. One is by using **keywords**, descriptions of your pictures that you add to the metadata. Typically you do this in the image editor under "file info" or some such. You can then search by keyword to find related images.

A keyword usually consists of a word or a short phrase. For example, for a picture of a drummer, you might apply these keywords: *musician*, *beat*, *passion*, *noise*, *frantic*, *energy*, *fun*, or *rhythm*. In many programs you can apply as many keywords as you like. You also may want to apply the photographer's name as a keyword, and some programs have a separate field in the metadata for this.

You can also caption or title your images in the metadata, so you can identify your subject and where you took the picture. And image management programs often allow you to rank and label your image files as another means of organizing them. All of these methods are helpful in searching through your pictures.

Some type of external hard drive is needed for backing up and storing your photographic archive.

Backing Up and Storing Your Pictures

As your image archive grows, it will take up more and more space on your computer's hard drive. This can be a problem, as you can fill up the hard drive after a while—and slow down your computer. When your hard drive fills up, consider moving your pictures off the computer onto an external hard drive so you'll have all of them stored in one place—where they will be easier to organize and manage. You may be doing this already, for instance if you're using a hard drive to bring your pictures to school or to a lab to work on them.

The external hard drive capacity you'll need depends on the number of pictures you have and the size of the image files. But it also depends on how many pictures you'll be taking in the future—and that's hard to predict. If you're serious about photography, get a large-capacity hard drive, at least 1–2 TB (1000–2000 GB), and expect that you'll start filling it up over time.

Having your own image archive is one thing. You also have to protect it. You could easily lose all your pictures if your hard drive becomes corrupted, damaged, or lost—and external hard drives are subject to failing after only a few years.

Your best protection against such disaster is to **back up** (copy) your images as you go. Get a second external hard drive and make an exact copy of your image archive. You can use a dedicated backup program to do this. Many such programs will automatically detect and back up any new information as it appears on your computer, after its initial backup. Alternatively, you can save the extra expense by leaving your images on the computer's hard drive, if it has enough room on it, get one external hard drive, and back up your archive on that.

Other options are more expensive and/or more complex. You can use a **RAID**, which is an array of connected hard drives that are designed to store information more reliably. There also are a number of online back up or "cloud" services that provide virtual storage options. This allows you to access your images from any computer via the Internet at any time, but it's relatively expensive and uploading can take a while, so it may be best used for only your most prized images.

Regardless of the method you choose, do not underestimate the importance of backing up. It's not unusual for some photographers to use three or four backup hard drives, storing each in different locations—in case of fire, flood, or other misfortune. Unfortunately, many photographers employ this strategy only after losing significant amounts of their work because it wasn't backed up to begin with.

Jeff Jacobson, "Iowa Clouds," Iowa City, Iowa

The idiosyncratic Jacobson fell in love with photography after a brief career as a lawyer for the American Civil Liberties Union. One of the top photojournalists and documentary photographers of his generation, Jacobson's work has always had a personal perspective. "Many photojournalists think that they are documenting some sort of objective reality that exists in front of the camera," he says. "Any good photojournalist or documentary photographer acknowledges that what they are documenting is their perception of that reality."

In recent years, Jacobson has turned his camera more and more inward. He took this picture while traveling in Iowa, where he was born, while visiting childhood friends and "shooting a landscape lodged in my memory."
www.jeffjacobsonphotography.com

Chapter 8
Printing and Other Output

Suggested Workflow: Printing

1. Make sure your printer is set up and ready to go—with the correct print driver installed, ink cartridges in place, and paper loaded. When using the printer for the first time, or after a period of disuse, do a **nozzle check** to make sure the print head is unclogged and aligned.

→ *nozzle check, page 214*

2. Open your prepared master image file.

3. Size the image file to the dimensions and resolution you want. The dimensions should be set in inches and the resolution in ppi—usually 240–300 ppi for high-quality prints.

→ *ppi, page 218*

4. Select *print* in your image editor and a print dialog box will appear. Then:

> **a.** Select the printer you are using.
>
> **b.** Set the paper size and type.
>
> **c.** Set the image to print at 100%.
>
> **d.** Create the borders you want for your image, including both the size of the borders and where you want the image to sit on the page.
>
> **e.** If your software allows it, make sure color management is set so that the image editor, not the printer, controls the color.
>
> **f.** Choose the paper profile for your paper type—or download a profile—so the printer is matched to the paper and inks you are using.

5. Select *print* to exit the image editor and send the image file to the printer. In some programs, a second print dialog box will appear—the printer's print dialog box. (Make sure all of your intended settings are maintained in this box.) In other programs, all of your print options are integrated into one dialog box, described above.

6. Examine the print and reprint if necessary.

7. If you plan to display the print, overmat and/or frame it. Store unframed prints safely away in a storage box made for photographs.

→ *overmat, pages 231–233*
→ *storage and display, page 228*

Once you have edited your image file, you're ready to put it to use—to **output** it. You have several choices. You can print it yourself or send it to a lab for printing. You also can e-mail it or put it on your website or a photosharing site—or even send it for reproduction in print form, such as in a book or magazine. This chapter concentrates mainly on printing, with references to other types of output.

The most important thing to keep in mind about printing is that a good print starts with a good image file, prepared in your image editor. If you get the image file the way you want in image editing, you should be able to repeat that look consistently every time you make a print—and at any size you choose. Moreover, you have far more control in image editing over such matters as image resolution, brightness, color, and contrast. Even when you can make adjustments when printing, you probably don't want to, because you won't have the same level of control—and it will be difficult to repeat the results at a later date.

→ *monitor calibration, pages 172–173*

The goal is to make a print that looks as much as possible like the image on your monitor. Assuming your monitor is of decent quality and has been accurately calibrated, you should be able to accomplish this. Still, there's a lot to consider when you're actually printing to ensure your prints look the way you want. For example, your computer must have the correct **print driver** installed. A print driver is software that converts your image files to a form that can be recognized by your specific printer. The driver may already be on your computer, but if it isn't you'll have to install it, either with an installation disk or by downloading it from the printer manufacturer's website, to ensure that you get the most recent version.

Once you have the correct print driver installed, you can then tell the printer the other things it needs to know, such as the type of printing paper you're using, the size of the paper, and your desired image borders. In this chapter you'll read about some of the technical and creative choices you'll have to make when printing, but be sure to read your printer's manual with care, as every printer works a little differently.

If everything is set up correctly, making a print can be almost as easy as printing a term paper or a résumé—in theory. Simply open a well-edited image file on your computer, then choose print and click *OK*. However, much can go wrong along the way, including the

mechanics of printing, such as paper jamming and ink clogging—not to mention user error.

Inkjet Prints

There are a few different digital print options available to you, but the most popular by far is **inkjet**. Other types include **digital C** and **dye-sublimation** prints, both of which are covered briefly later in this chapter.

→ *digital C-prints, page 216*
→ *dye-sublimation, page 216*

Inkjet Printers

Inkjet printers spray miniscule ink droplets onto paper to form an image. Some printers can also print onto other media, such as CDs, DVDs, and film. You load paper (or other media) into a tray or some other feeding device, and a series of rollers transports the paper as the printer deposits the inks.

Inkjet printers are widely used for their compact size, ease of use, and relatively low price. There are many types of inkjet printers available. Some are basic and cheap, made mostly for printing letters, term papers, and other text. If you are printing photographs, photo-quality inkjet printers deliver the best results. These models, however, are typically more costly—although many high-quality models are affordable—and take six, eight, and even more different colored inks to produce rich, saturated results.

Perhaps the greatest advantage of an inkjet printer is that individual photographers can own or use one without having to send their work to a lab to be printed (although you can have a lab make inkjet prints, if you like). Printing for yourself is not only more affordable, it also allows

Inkjet printers are relatively compact and affordable, and can be used almost anywhere. This model sits on a desktop, and takes sheets or rolls of paper up to 13" wide. Models that make larger prints are pricier and take up more space.

you finer control over your work. If a print is not good enough, you can remake your image file and print again on the spot—and over and over, if need be, until you get it just right.

You'll get best results from newer printers with inks made by the printer's manufacturer. Some older models and incompatible inks can cause problems, such as creases, jams, roller marks, or smudging. Keep in mind that the cost of inks can be high, even though the printers themselves are generally affordable. Some models are more economical than others in terms of ink cost and the amount of ink they use to make a print.

Inkjet printers come in all sizes—from small-format models to very large ones. Models are often categorized according to how wide they can print. For example, you can make a 17" x 22" print on a 17"-wide printer or a 44" x 66" print on a 44" printer. Keep in mind that you can always make smaller prints than your printer's maximum width—and you can also make prints of virtually any length if your printer takes roll paper.

Small-format printers take up very little space on a desktop and are economical. So are the paper and inks they use. They are relatively easy to clean and maintain, as well. However, many small-format printers are multiuse. Make sure you use a model that is optimized for photographic quality.

Large-format printers take up a lot of space and are expensive, as are the large papers and high-capacity inks they use. They also work best with consistent and regular use. Because of this, these printers are most practical in a school or other lab. If you will only make large-format prints occasionally, consider using a more modest-sized printer in your own digital darkroom and using a lab printer for large prints when you need to make them. If you don't have access to a lab with a large-format printer, you can always send your image file to a professional lab for printing.

For good inkjet prints, you'll need printing paper optimized for photographic quality. There are many choices available from printer manufacturers and independent suppliers. They range widely in surface, color, and quality. More on papers below.

Inkjet prints are sometimes identified as **archival inkjet prints**, **pigment prints**, or a similar name to indicate premium papers and inks were used. Occasionally you'll see the designation **Epson print**, referring to a manufacturer widely associated with inkjets. Or, you may see the term **Giclee**, a fancy word for inkjets. You may also see reference to **Iris** prints, an early proprietary inkjet process.

→ *troubleshooting inkjet printing, pages 221–225*

Graham Nash, "The Man Jan Sees"
Nash is a musician by trade (with Crosby, Stills, Nash, and Young) but is also a photographer and digital printing pioneer. This photograph of musician David Crosby was taken on film in 1969 and printed twenty years later on an Iris printer, an early inkjet proofing system made for the printing industry.

In 1991 Nash and studio partner R. Mac Holbert established Nash Editions as the first studio specializing in digital prints for fine-art photography. At the time, hardly anyone knew what a digital print was. But within a few years, affordable desktop printers became widely popular, in large part because of the efforts of Nash and Holbert.
www.nasheditions.com

Inkjet papers

Inkjet papers come from different manufacturers in a wide variety of sizes, weights, surfaces, and tones. Most printers take all types of papers. You don't have to buy paper from your printer's manufacturer to make a good print—papers from independent manufacturers can be excellent, but some may require a little bit more effort in order to make a print that matches what you see on your monitor.

There are affordable photo-quality papers, as well as a wide range of premium choices. Some are commonplace and others more obscure. There are even inkjet papers that mimic the look of photographs made in a traditional darkroom. Some papers have a textured or toothy surface, including watercolor, fabric, handmade, and many other specialty types. Images on these kinds of papers offer unique visual effects, but may also produce less sharpness and/or more muted colors.

Sizes of inkjet papers vary widely, and come in both sheet and roll form. As a rule, rolls are more cost-effective than sheets, but sheets are generally easier to handle. Rolls are often used for large-format prints and sheets for small format, but small-size rolls and large sheets are available.

Some typical sheet sizes include the following: 8 1/2" x 11", 11" x 17", 13" x 19", and 17" x 22". Rolls come according to width: 17", 24," 34," and 44" are common sizes. This allows you to print with one image dimension equal to the width of the paper (or a little smaller, if you want a border), and the other dimension proportionally longer—perhaps 44" x 66" or 42" x 64" (with borders), for example, on a 44" roll.

Most photo-quality inkjet papers are heavyweight—more bulky than normal papers. This makes them relatively easy to handle and less susceptible to physical damage. Occasionally, paper that is too heavy, for example watercolor papers, may jam or not even work with certain printers.

Inkjet papers are available with different surfaces—microscopically thin coatings that help the inks adhere to the paper and to optimize their performance. The most common surfaces are **gloss, semigloss,** and **matte**, although sometimes different descriptions are used. For example, one manufacturer's luster may be another's semigloss.

In addition, some paper surfaces are completely smooth, whereas others have some texture or "tooth." This may or may not be related to whether it's glossy or matte. For example, glossy papers are usually considered smooth surfaced, but many actually have a bit of texture.

TIP: THOUGHTS ON PAPER SURFACES
It's difficult to imagine how one paper surface differs from another without actually seeing sample prints. One manufacturer's "glossy" may look quite different from another's. Try to view real prints made on a paper that you're interested in using. Any photography store should have paper samples for you to compare, and many manufacturers and online suppliers will send samples on request. Also, if you see a print you especially like, ask the photographer what kind of paper he or she used.

Note that framing a print with glass or Plexiglass can change its look dramatically. An image on matte paper will appear more glossy and saturated with standard glass in front of it and any print will seem more muted when covered by a non-reflective glass.

Also, note that some paper surfaces are more delicate than others. Take care when removing them from their packaging to avoid scratching and other physical damage. Most paper types are coated for printing on one side, though some are designed to be printed on both sides.

Your choice of surface can significantly affect the way a print looks. You should try to match the surface with the look you feel best suits your image. Here are some general guidelines, but, as always, make your own judgments.

Glossy papers enhance an image's sharpness and contrast. They also yield superior saturation, producing deeper and richer colors, which can give a print more presence and impact. On the other hand, a glossy surface may be too reflective and shiny for your taste. It also may emphasize any surface scratches or other abrasions on the paper.

Matte-surface papers may make images feel quieter and "gentler"—partly because they appear to have less contrast and are not reflective. Colors may appear to have somewhat less saturation and punch when compared to glossy surfaces. Matte papers also are particularly subject to scuffing, something that can be minimized with a sealant sprayed on after inks dry. See the box on the next page for details.

Tonally, inkjet papers are white, but not every paper is the same tone of white. A **warm-tone** paper has a slightly off-white or cream-toned base, whereas a **cold-tone** paper has a purer, "cooler" white base. The difference can be subtle or distinct. Usually papers specifically advertised as warm-tone are the most noticeably warm.

Keep tone in mind when looking at papers. By comparing the white margins of different papers, you can easily see how they differ. In general, warm tones make the overall image feel softer and more yellow-brown, with less contrast. Cold tones produce sharper, more saturated results with greater contrast.

There are premium papers available that claim superior results. Manufacturers often designate these papers as "fine art" or "archival." They also may be identified by their higher cost.

There is no strict industry standard for premium papers. Some have special coatings for an enhanced surface or better ink absorption. Others might be a little heavier for safer handling. Still others claim greater longevity because they are made from acid-free or rag (100% cotton) materials and/or lack **optical brightening agents (OBAs)**—chemicals added to many inkjet papers to achieve bright whites, often at the expense of long-term image permanence.

To protect the surface of your inkjet prints, use spray sealant made for the purpose. Holding the spray can upright, apply an even coat of sealant in a back-and-forth motion.

SEALING AN INKJET PRINT

The surface of an inkjet print is subject to smudging, scuffing, and scratching. Also, paper is inherently porous, so it can absorb moisture and airborne pollutants that could lead to warping, image fading, staining, and other problems. Inks may even bleed (spread out) slightly over time, making an image appear less sharp than when originally made.

Some paper surfaces and inks are more or less resistant to these problems, depending on the type. For example, many matte papers are particularly subject to scuffing. Whether matte or glossy, you can help preserve your inkjet prints, protect them from physical damage, and help repel moisture by using a **sealant**.

Wait for the inks to dry, and then spray the print's surface, moving the can of sealant back and forth, gently and evenly. Wait for this coat to dry, and respray at least two or three more times; large-scale prints may require additional treatments. Follow the sealant's package instructions, as one manufacturer may recommend a different method than another. And always spray in a ventilated area, preferably while wearing a protective mask.

Some sealants will leave the surface of your paper unchanged. Others are available in glossy, semigloss, and matte versions. The most common approach is to match the spray to your paper. Use a glossy spray with glossy paper. Alternatively you can use the spray to change the look of the image surface. Use a matte spray on a glossy print to make it look more matte, or a glossy spray on a matte print to give it gloss.

Inkjet inks

The inks used when inkjet printing are a critical factor in how your prints look and how long they will last. Higher-quality inks can often produce better color and are more permanent. They may also represent a considerable expense. It's possible that you'll spend more on inks over time than you will on the printer or even printing paper. Unfortunately, this is difficult to gauge since ink costs vary widely, and each print uses different amounts. Fortunately, many newer printers are more efficient with inks than older models. Note that inks get used up in other ways, as well—such as when cleaning the **print heads**, which are the parts of the printer that actually spray ink onto the paper.

There are many considerations when discussing inks—and also many opinions and claims made, not all of which are proven. In practice, you may not have many options available, as inks are so dependent on the printer model—either at the lab you use or even if you have your own printer. Still, consider the following whether you use a high-end, large-format inkjet printer or an inexpensive desktop model.

Color is formed when different inks are mixed together as they are sprayed onto the paper. Good photo-quality printers use sets of six or more different colored inks—for instance, such colors as cyan, light cyan, magenta, light magenta, yellow, black, and light black. Premium-quality printers may use eight, ten, or even more inks. In general, more inks lead to better quality results—images with greater depth and richer color.

Different printer models use different color sets. Some use dark and light inks of the same color for added richness; some use a gray in addition to a black for the same reason. Sometimes there are separate matte and glossy black inks available for matte and glossy papers.

Ink is generally packaged in a cartridge, which is inserted into the printer. Photo-quality printers use separate ink cartridges for each color, allowing you to replace individual inks as they run out. The amount of ink used is affected by several factors—for example, paper surface. Glossy papers use less ink than matte papers, which are more absorbent. Also, different color inks get used up at different rates, depending on the image. For example, printing a lot of seascapes, with blue skies and water, will deplete the cyan inks more rapidly than the magenta inks.

Ink quantity can vary, but generally cartridges come in different sizes. The larger the size, the lower the per-print cost. However, only high-end printers offer you a choice; most printers take one-size cartridges only.

Ink cartridges are available for specific printers from that printer's manufacturer. One manufacturer's printer will not accept a cartridge from another manufacturer. In fact, even different printers from the same manufacturer often require completely different cartridges.

Some inks, particularly those in less expensive printers, use dyes to help form color. These provide excellent results, but may not be as long lasting as pigment-based inks, though pigments may be a little less rich in color.

Setting Up the Printer

Using an inkjet printer is fairly easy, especially if you're working in a school or other lab where the printer is already set up for you. If you have your own printer, or even if you're working in a lab, there are some basic things you should know to make a printer work properly and efficiently.

1. Make sure the printer is plugged into a safe power source, preferably a surge protector, which is a device that shields your printer and other electrical equipment from blackouts and voltage spikes.

2. Connect the printer to your computer using the correct cable.

3. Make sure the necessary print driver is installed on your computer.

4. Install the ink cartridges. First, gently shake each cartridge in a back and forth motion for a few seconds. Then, plug the cartridges into their labeled slots. Never force a cartridge into place. It should click in without much pressure.

5. Turn on the printer. It will go through an automated set-up routine, which might take about a minute or so.

6. Load your printing paper, making sure the coated side is oriented in the right direction for your printer. If you're using sheet paper, load as many sheets as you need, but probably no more than fifteen at a time, depending on the printer. Make sure the sheet-paper guides in the paper-loading tray are set to a width that fits your paper, so the sheet will be properly aligned when it feeds into the printer. Some heavier papers must be loaded one sheet at a time, or fed using a special tray.

If you're using roll paper, position the paper in place on the spindle. In most cases, you'll manually feed the end of the roll into the printer up to an indicated starting mark. (Make sure the coated side of the paper faces in the right direction—up or down.) Most models will then automatically adjust the paper after you've loaded it to bring it to the correct starting position.

7. If you're using the printer for the first time, or if it hasn't been used in a while, do a nozzle check to make sure the print heads are properly aligned and inks are flowing freely and evenly. A nozzle check is an automated function that unclogs the nozzles and realigns the print heads to factory standards. With some printers you press a button to start the nozzle check. With others, you initiate it through the printer software. Either way, the printer will print out a series of color patterns. If the patterns are broken up and irregular, you'll have to clean and/or align the print heads. If the patterns are unbroken, with no gaps, the print heads are okay.

8. Now, you are ready to print.

Gaps in the test pattern indicate misalignment or clogging (1). A test pattern with no gaps indicates that your print nozzles are in alignment and unclogged (2).

1

2

LARGE-FORMAT PRINTS

Any print bigger than 17" x 22" or so could be considered a large-format print. However, it's increasingly popular to make even larger prints—say, 44" x 66" or even larger. Today in schools, art galleries, and museums, large-format photographic prints are commonplace, but it wasn't always so. While always possible, it was difficult to make big prints until digital printing came along.

Large-format prints are impressive. They have great impact and draw attention to a photograph, even when viewed at a distance. But they aren't always easy to make. You'll need a good image file that's sharp and well exposed, with a resolution that's high enough for good print quality. Otherwise your image may look pixelated or soft when printed. You also will need a large-format printer and the know-how to use it. Alternately, you could have a lab make your largest prints—not a bad idea if you print large infrequently, as printers perform best when used on a regular basis.

Keep in mind that many digital cameras can't produce a file with enough resolution to make really large prints, aside from professional-level DSLRs (and medium- or large-format models). And while your scanner may be capable of making a very high-resolution scan, it is limited based on the size and quality of the original film or print image.

You can artificially create more pixels and increase your file size by up-rezzing. This can allow you to print larger than your original image file's dimensions, but it is a workaround and it has its limits.

Large-format prints can be costly and time-consuming to make, so be sure to handle them with care once they are made. This is not always easy to do when dealing with a big print. You will also need the space to store a large-format print safely.

Making an Inkjet Print

As discussed, good printing technique is mostly a matter of getting your printer to accurately reproduce the edited image file. If your monitor is calibrated correctly, your print should closely match what you see on the screen. Following are steps and considerations for making good inkjet prints.

Prepare the image file for printing

Open the master image file in your image editor and set your desired print size by specifying the dimensions and the resolution. Resolution in an image file is measured in ppi (pixels per inch). For printing you should usually set the resolution at 240–300 ppi for best-quality results. Check your printer's manual for recommended file resolution for printing, as some require a bit higher or lower, depending on the model. If you can't set a ppi as high as 240–300 for your desired print size, you may need to up-rez the file. You can do this in most image editors or by using plug-in software made for the purpose.

→ *plug-in, page 194*

In most cases, you can also set the print quality, which adjusts the dpi (dots per inch). Dpi refers to the resolution of the print—how many dots of ink per inch the printer sprays onto the paper.

DIGITAL PRINTING ALTERNATIVES

Inkjets are the most common form of digital printing. But there are two alternatives worth mentioning: **digital C-prints** and **dye-sublimation prints**.

A digital C-print (sometimes called a digital C) is a hybrid that uses digital technology to print an image onto traditional photographic paper. The "C" in digital C-prints stands for **chromogenic**, the name of the process by which traditional photographic papers form color. You may also see this process referred to as **Lambda** or **Lightjet** prints, in reference to manufacturers of digital-C equipment.

As with inkjets, making a digital C-print starts with an image file, either from a digital camera or a scan. But you cannot make digital C-prints from this file yourself, because they require very expensive and sophisticated equipment. You'll have to use a professional lab. At the lab, the image file is projected onto traditional photographic paper with equipment that uses a series of lasers. The exposed paper is then developed and processed in a sequence of chemical baths—in the same way that traditional color prints have been made for decades.

As with inkjets, you must edit the file before printing, then send the file to the lab. Alternatively, you can ask the lab to do the editing. However, for best results, adjust the image yourself, since the lab can't know exactly how you'll want the print to look. You'll also have to make sure you're meeting the lab's requirements in terms of file size, color space, and so forth. This information will be on the lab's website, as will be instructions for sending the edited file (usually by uploading it but possibly by delivering it on a disc or other media).

Much of the time, there's no easy way to tell a digital C from an inkjet print. Nonetheless, there are differences—for instance, the paper. There are far fewer digital C-print papers available than inkjet papers. And many professional labs offer one brand of paper only, usually with a choice of glossy and semimatte surfaces. Inkjet papers are available from many manufacturers in a wide variety of surfaces, sizes, tones, and quality.

Digital C-prints can appear sharper, with more contrast and more color saturation, than inkjets. This is partly because the image is made by exposure to a series of lasers, and partly because glossy C-print papers may have a shinier surface than many glossy inkjet papers. In addition, the inks laid down by an inkjet printer can sometimes spread subtly over time, causing image edges to become slightly less distinct.

Digital C-prints may be an affordable option, even though you have to pay a professional lab to make them. Inkjet prints can often be costly, especially if you're using premium papers and inks. And if a lab makes inkjets for you, they will almost certainly be more expensive than digital Cs. Like inkjets, you can make very large-format digital C-prints—with professional labs capable of printing at sizes up to 4' x 6' and even larger.

Most digital Cs are color images, but the same process can be used to make black-and-white, brown-and-white, or other monochromatic prints. A similar hybrid process is available from a few labs to make monochromatic prints onto traditional **silver-gelatin** paper—the same type of paper that has been used to make traditional black-and-white prints for decades. The process is more rare than digital C printing, and requires a lab that uses different equipment, papers, and chemical baths. But the basic idea is the same. A digital file is exposed with lasers onto photographic paper and then chemically processed.

Dye-sublimation, or **dye-sub** prints, are another method of making digital prints, though generally a less popular and less satisfactory one than either inkjet or digital C-prints. In a dye-sub printer, the image is formed using heat-transfer technology to move dyes onto the paper. Dye-sub prints have a thin laminate coating, which helps protect them from fading and makes them somewhat water resistant.

Dye-subs look something like digital Cs. The output quality can be very good, but individual prints can be fairly expensive. Size also is an issue. Dye-sub prints are generally no bigger than 8" x 10," and usually smaller. For instance, snapshot-sized prints made by compact printers and on-the-spot labs are often dye-subs.

Alex MacLean, "Tehachapi Windmills"
MacLean's main subject is land use—
in particular the relationship between
natural and artificial environments. He is
interested in the history of land, how it has
evolved, and how human interaction has
changed it.

The Tehachapi Windmills are a unique
landscape built in response to the natural
environment. The heat of the Mohave
Desert causes the air to rise and, in turn,
sucks replacement air through a pass from
the Central Valley, creating a strong airflow
to spin the wind turbines. "For me, the
challenge was to take the picture in the
turbulent air along these ridges and hold
the camera still enough to get a sharp
picture." *www.alexmaclean.com*

DPI VS. PPI

The terms ppi (pixels per inch) and dpi (dots per inch) are often confused and even wrongly used interchangeably. Ppi refers to the resolution of an image file—literally how many pixels are in the file. The ppi is mainly determined by the quality of the captured image (regardless of whether it's from a digital camera or a scan). The higher the resolution of the capture, the greater the ppi. For instance, a camera with a full-frame image sensor will give you more ppi than a point-and-shoot, and a 24-MP camera will produce more ppi than a 10-MP camera.

Dpi refers to the resolution of the printed image—how many dots of ink per inch the printer sprays onto the paper. Two main factors affect dpi. The first is the type of printer you use. Better quality models are capable of printing at a higher dpi, which in turn usually produces higher quality results. The second factor is the level of print quality you choose in the print dialog box. For instance, you may be able to choose options that range from *fine* to *document* (text only) and incremental steps in between. When you choose *fine*, the printer will spray more ink to achieve a higher dpi.

Print dialog box

Once your image is the size you want, select *print* in your image editor. A **dialog box** will appear, displaying a number of printing options for you. Note that image editors use different methods of displaying print options. Some have two print dialog boxes—one that is part of the image editor and one that comes with the print driver. Most of the time, however, your choices will be displayed in a single dialog box, combining all the options. Regardless, the print dialog box (or boxes) will have several options to choose from—some more widely used than others. The following are most important:

Select your printer from the list in the dialog box's drop-down menu. The list will include all printers installed on the computer. Some computers recognize printers automatically, but with others you may have to install the printer the first time you use it.

Set the type of paper you are using and the paper size in the drop-down menu. You may have to go into page setup, a separate dialog box, to find this menu. If you are using sheet paper, simply select your paper size from the list. You also can create a custom size for a sheet that's not listed or for roll paper.

Scale the image to 100% to match the dimensions and resolution you set in your image editor.

Create borders to position the image on the page. To center the image, select the *center image* option. To place it off-center or to customize the

The print dialog box is where you make many important settings, including paper type and size, border sizes, color management, and paper profile. The box will look something like this (right). Note that some programs divide these settings into two separate dialog boxes—one for the image editor and one for the printer.

borders, deselect *center image* and set the borders to your desired size. For example if you want more of a margin on the bottom of the image than on the top, increase the bottom margin width and/or decrease the top.

You can choose to **bleed** an image, which means printing it to the edge of the paper, without borders (borderless). To do so, specify *bleed image* in the print dialog box, if your software allows it. The image size and paper size must match exactly. However, this can be complicated, because you'll have to adjust your image to fit existing paper sizes. You can also make the image size a little bigger than the paper, so it will bleed, but you'll end up with a cropped image. Perhaps a better solution if you want a bleed is to make the borders as small as possible and trim them off later on.

→ *color management, page 173*

Set color management so that the image editor, and not the printer, controls the color. This way the printer should faithfully reproduce the information in your edited image file. You may also have to turn color management off in the printer's dialog box, to signal to the printer that the image editor is in control.

Alec Soth, "Members of the Bemidji Lumberjacks High School Varsity Girls Basketball Team"
Soth says "I fell in love with the process of taking pictures, with wandering around finding things. To me it feels like a kind of performance. The picture is a document of that performance."

This picture is from *Fashion Magazine, Paris/Minnesota*—a kind of hybrid of magazine and book. "I'm not really comfortable saying I know anything about Paris or its fashion world," Soth says, "and I suspect that most fashionable Parisians know just as little about Minnesota. What is interesting is the space between us." *www.alecsoth.com*

Because of the many variables involved, your initial print may not be just right. Consider making a small version, a **test print**, to ensure the image looks the way you want it to before making a full-size print. This may seem like an annoying extra step, but it can ultimately save a significant amount of expense and time, particularly when making large prints that use a lot of paper and ink and take several minutes or more to print out.

For the test, choose a small image size in your print settings. Say you plan to make a 12" x 18" print. Set the print size to 4" x 6" for the test, and then make your print. If a print looks right small, it should look the same when you reset it to full image size.

Use smaller size paper—making sure it's the same type as you'll use in the final version—when you make the test. If you set up the borders so the image falls on one corner of the paper, you can often reuse the sheet for future test prints to cut costs.

Choose the paper profile that matches your printer to the specific paper and ink you're using. The print driver may have your specific paper profile built-in. If not, you can download it from your paper manufacturer's website. You must download a profile that is specific to your printer. If you use the same paper on a different printer, you will have to download a new profile for that printer.

Click on *print* to send your image file to the printer. Printing can take a few seconds for a small print or several minutes or more for a large-format print—depending on the size of the image file, your computer, your printer, and the paper and inks. Inks may not be fully dry when the paper exits the printer, so handle prints with care.

Examine the print to make sure you are getting the brightness, contrast, and color you want. Prints can take several minutes to dry fully after they come off the printer. So give them time before judging them. If you don't like the results, go back to the image file and re-edit it and reprint. If the print looks good, you should be able to reprint at any time later on, using the same settings, and get the same results.

Troubleshooting Inkjet Printing

Inkjet printing can be a little finicky. If you're at a work or school lab, you can usually ask a technician or fellow student for help. But troubleshooting when printing on your own can be a challenge.

Probably the most common problem when inkjet printing is a clogged or misaligned print head. Since this problem can show up in many ways, it's usually the first thing to check when you're not getting your desired results.

When the print head is clogged, the ink is not flowing smoothly and can cause a print to have uneven color, or show spotted lines across it where the ink didn't flow evenly.
© Jack Schow

Here are some of the most common problems you might encounter when making inkjet prints, with suggestions on how to solve them. Many of the problems could have a variety of causes and solutions. It's always a good idea to refer to your printer manual or manufacturer's website when troubleshooting. Internet searches also may be fruitful.

Pixelation

Problem
Print too light; white spots/lines; streaking

Cause
Clogged print head, especially if printer hasn't been used recently

Solution
Clean the print head and then do a nozzle check. Repeat as needed.

Problem
Pixelated image, rather than smooth look

Cause
Image quality (ppi) too low in image file

Solution
1. Up-rez the file in your image editor.
2. Print at a smaller size.

Problem
Overall color cast with black-and-white prints

Cause
Color is selected instead of black-and-white in the print dialog box.

BLACK-AND-WHITE PRINTING

Some photographers choose to make black-and-white pictures to make their images stand out from others, to make them look older or more neutral, or even to give them a high-contrast, graphic effect. Whatever your reasons, when making black-and-white prints there are several options to consider.

If you have prepared a black-and-white image, either from digital capture or an edited image file, it's possible to simply print it using the same settings you would use for a color image, as discussed in this chapter. This method, however, may introduce a subtle or not-so-subtle colorcast in your final print.

An alternative is to use your printer's black-and-white mode, which is built into the print driver of most photo-quality printers. By choosing black and white, you are allowing the printer to take over color control, so make sure you have set in your print dialog box "printer manages colors" (or some such) instead of "image editor manages colors," as suggested earlier.

Most black-and-white printing modes also offer some additional monochrome options, such as printing in sepia tone or with a different color tint. You also may be able to make some changes to the brightness and contrast, but in most cases these changes are best made in your image editor.

TIP: VIEWING LIGHT

The light under which you view a print can have a subtle but still noticeable effect on the way a print looks. Certainly, a print will appear very different when seen in bright light than in dim light. But the color of the viewing light is also an important factor.

There are special color-balanced (neutral) lights made for viewing and evaluating prints. These are ideal for establishing a standard to judge color balance from one print to another. But in the real world, light is rarely neutral. A print will look warm if you view it with common household bulbs, green under fluorescents, and bluish in natural light on a cloudy day.

Ideally, you should view and evaluate a print under the same light in which you expect the print will be seen. In practice, this is virtually impossible, unless you are making prints for a specific location. Therefore it's often best to view and evaluate prints under tungsten light, as most prints are displayed indoors. An even better option is to view prints with a mix of tungsten and daylight (or daylight-balanced bulbs) to blend the color of the viewing light.

Solution

Select the black-and-white printing setting in the print dialog box, which will direct the printer to manage the color.

Problem

Print blurry overall

Cause

1. Paper loaded into printer upside down
2. Printer using too much ink, possibly due to incorrect paper setting in the print dialog box

Solution

1. Reprint, using the correct side of the paper. (Most papers only have one side for printing.)
2. Make sure your paper selection in the print dialog matches the paper you are using.

Problem

Inconsistent or missing colors

Cause

1. Print head clogged
2. One or more inks low or depleted

Solution

1. Clean the print head, and then do a nozzle check. Repeat as needed.
2. Replace individual cartridges as needed.

Problem

Jammed paper

Cause

1. Paper loaded into the printer crooked
2. Wrong paper type selected in the print dialog box
3. Printer can't use the type of paper loaded.
4. Wrong paper feed setting selected
5. Paper loaded in the wrong paper-feed tray

Solution

1. Load new paper, being careful that it is straight and flat in the tray.
2. Go back to the image editor's print dialog box and the printer's print dialog box and make sure the right paper is selected.
3. Use a paper that your printer can handle—or use a different printer.
4. Select the correct paper feed setting.
5. Load paper in the correct paper-feed tray.

Posterization

Puddling © Jack Schow

Problem

Posterization, also called **banding**, when a smooth tone or color renders as distinct steps or bands rather than a continuous gradation

Cause

1. Print head clogged or out of alignment
2. Ppi set too low

Solution

1. Clean the print head and then do a nozzle check. Repeat as needed.
2. Set the ppi to 240–300.

Problem

Shadow areas low in contrast or lack a deep black

Cause

1. Print head clogged
2. Black ink(s) low or depleted
3. Matte paper in use

Solution

1. Clean the print head, and then do a nozzle check. Repeat as needed.
2. Replace black ink cartridges as needed.
3. Use glossy or semimatte paper.

Problem

Uneven, rough vertical lines

Cause

Misaligned print head

Solution

Align the print head.

Problem

Puddling (image showing random patches of ink density)

Cause

1. Printer spraying the wrong amount of ink, possibly due to incorrect paper setting or dpi setting in the print dialog box
2. Print head clogged
3. Print made on wrong side of paper

Solution

1. Make sure your paper selection and/or dpi setting in the print dialog box matches the paper you are using.
2. Clean the print head and do a nozzle check.
3. Reprint on correct side of paper.

TIP: COLORCAST
When a color print comes out of the printer showing an unnaturally magenta cast, it's a good sign that you've forgotten to turn off the printer's color management in the print dialog box. When making color prints, always control color through the image editor, not your printer.

Bronzing © Jack Schow

Problem
Prints too dark or light overall

Cause
1. Poorly calibrated monitor
2. Incorrect paper setting in the print dialog box
3. Print head clogged

Solution
1. Calibrate the monitor.
2. Make sure your paper selection in the print dialog box matches the paper you are using.
3. Clean the print head, and then do a nozzle check. Repeat as needed.

Problem
Bronzing, random metallic effect, especially in shadow areas, most evident on glossy/semigloss paper

Cause
1. Printer using too much ink, possibly due to incorrect paper or dpi setting in the print dialog box
2. Low-quality paper, ink, or printer

Solution
1. Make sure your paper selection and/or dpi setting in the print dialog box matches the paper you are using.
2. Use better quality materials.

Handling and Storing Prints
Prints can get damaged easily, so don't ruin your efforts with sloppy handling. Some types of prints are more susceptible to damage than others. Inkjet papers are usually heavyweight, and that can help prevent denting and creasing. But some inkjet papers have a delicate surface that scratches and scuffs easily. Digital C-prints are generally not as heavyweight as inkjets, thus are more susceptible to denting and creasing.

Some suggestions for careful handling and storing of your prints:

1. With an inkjet print, wait several minutes after it comes out of the printer to make sure the inks are dry. In high humidity, drying may take even longer.

2. When handling prints, use lintless cotton or nylon gloves to avoid leaving behind fingerprints, smudges, or other marks. Gloves are readily available at photography suppliers and other sources, such as art-supply stores.

Use lintless cotton gloves whenever possible to minimize damage when handling prints.

3. Handle prints with both hands and hold them so the paper has a little give and dips slightly in the middle. You can hold a smaller print by the short sides—for example, by the 13" sides on a 13" x 19" print. Large-format prints are particularly difficult to handle and susceptible to damage. Hold them by opposing corners and take care not to move or work against the way the paper naturally falls.

4. For maximum surface protection, consider sealing inkjet prints with a protective spray, especially when using matte-surface papers.

→ *sealing a print, page 212*

5. You can scratch or otherwise damage the sensitive surface of prints when stacking or storing them. To avoid this, center each one on top of the stack, so that you don't have to shuffle them to get them to fit into a box. Use archival interleaving sheets or plastic print sleeves for additional protection.

6. After you are finished with a print, store it away in a box, preferably one made to store photographic prints. This will help protect it from many hazards—spilled coffee, a playful cat, or dust and grit that might accumulate and damage its surface. Make sure the box is sturdy enough so it won't collapse over time.

Putting prints away as soon as you're finished with them helps protect them from damage.

Use a box the same size as the prints so they won't shift around inside. This will reduce the chances of scratching and other damage when the box is moved.

7. Store print boxes safely away from excess heat or humidity—and away from windows, skylights, or other places that might expose the box to the elements.

Archival Matters

Over time, prints are subject to deterioration, such as fading, staining, or physical damage. The term **archival**, as in suitable for an archive, is broadly used to describe long-term print stability. A print made to last a long time is said to be archival, as are interleaving sheets and boxes made of materials that won't harm the stored prints.

The color of prints is subject to fading over time.

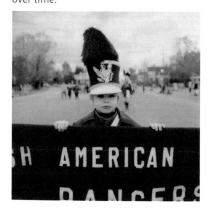

However, it's not only prints that you have to worry about. There are archival concerns about your image files and how they are stored—whether on hard drives, CDs, or DVDs. Whatever the form, the basic question is the same: how long will an image survive? If you understand the factors that affect the stability of your pictures, you can take steps to maximize their long-term survival. This takes a little extra work, but it's usually worth it—especially when you consider the time, effort, and expense you've already invested in creating your photographs.

These are the archival factors you should keep in mind: printing papers, inks and/or dyes, light, heat and humidity, storage and display, and environment.

Printing papers

The inherent characteristics of printing papers are an important archival factor. Some materials last a long time; others are prone to discoloration or deterioration. Ideally, the paper content should be as neutral or as benign as possible, meaning it should not contain components that break down over time to form acids or other harmful substances. Acid-free and rag (100% cotton) papers are less likely to deteriorate with time, and so are considered most archival. But it's not only the paper content that affects longevity. Coatings applied by the manufacturer also may have long-term impact. For example, the plastic used in **resin-coated (RC)** papers may eventually crack. Also, many inkjet papers use optical brightener agents (OBAs) to produce brighter whites, but these whites may fade as they age.

→ *OBAs, page 211*

It can be difficult to figure out which papers are more archival than others. Websites that rate the longevity of various papers are a good start, but in general your prints are probably safest if you use fresh, premium papers without plastic coatings or optical brighteners.

As for digital C-prints, you generally can't choose the paper. The lab does that for you. Digital C and dye-sublimation papers are resin coated, but these papers are still generally thought to offer very good long-term stability, in large part because of the dyes they use to form their color.

Inks and/or dyes

The inks or dyes that form a photographic image are subject to fading and general deterioration, regardless of the paper used. Most photo-quality printers use inks that are very stable, but some are more stable than others. For example, inks that are pigment-based rather than dye-based are considered more archival. Fresh inks may be longer lasting than inks that have been sitting around for years. And bargain-priced inks may be no bargain at all.

Light

Exposing a print to strong light can cause image fading and other stability issues. This is a particular concern with sunlight and any other light containing UV (ultraviolet) rays. If you display framed prints on your walls, hang them away from the direct light of windows or skylights. When possible, frame prints using UV-protecting Plexiglass or glass to

filter out harmful rays. These options are more expensive than standard Plexi or glass, but promote image stability. Otherwise, keep unframed prints stashed away safely in the dark in an archival storage box.

Heat and humidity

High heat and humidity are also enemies of long-term print stability. In fact, many museums and other archives keep their valuable images stored in fully controlled environments—at low temperature and low humidity. While not a practical solution for individuals, you can take some simple steps to mitigate these factors.

Keep storage temperature and humidity as consistent as possible. Store prints at room temperature or preferably cooler—especially if you live in a warm climate—and in conditions of fairly low humidity. Keep prints away from attics (heat), basements (humidity), and rooms in which temperature and humidity fluctuates, such as bathrooms and laundry rooms.

Storage and display

There are many enclosures available for print storage and display, from paper and plastic envelopes and sleeves to mat boards and boxes. But make sure that whatever you use is safe. Look for the word archival on the product package, and also check to see that materials used are made of rag or acid-free paper or board—or made of inert plastics, such as polyester, polypropylene, and polyethylene. Avoid storage products made with such materials as glassine, PVC, cardboard, Styrofoam, wood, and rubber cement—all substances that could possibly harm your pictures over time.

ARCHIVAL MEDIA

Various media used for storing image files, such as CDs, DVDs, flash drives, and hard drives, also have long-term stability issues. For example, they can become corrupted and lose their stored data. They also can suffer damage from high heat or humidity. In addition, many storage disks have a metallic layer, which is subject to magnetic charges, oxidation, and physical damage, such as scratching.

All digital media has a limited lifespan, usually significantly shorter than inkjet and digital C-prints. There are safe enclosures available to protect CDs and DVDs, such as archival sleeves and boxes. And there also are premium gold-layered disks, which are more protective.

If you are marking on a CD, use an archival marker, available from select photographic suppliers and art-supply stores. It is also a good idea to write on the plastic inner ring of the CD rather than on the disc itself, as the ink can eventually cause disk deterioration.

Be sure to make multiple back-ups of all your image files. Use external hard drives, DVDs, or virtual storage—web-based ("cloud") services that are professionally maintained, monitored, and backed up.

Environment

Though rare, a variety of environmental conditions also can affect a print's longevity. In the tropics, for example, fungus and mold can collect on a print and destroy it. Certain chemicals and other airborne pollutants can also damage prints.

These factors are often hard to quantify and control, but good sense in handling, displaying, and storing prints will go a long way toward preserving them. Keep your photographs and other media in safe boxes, away from poor air quality, bright light, high heat, and high humidity, as described above.

Working with Labs

You don't have to make your own prints; labs can make them for you. There are basically two kinds of labs: consumer and professional. Professional labs provide better overall quality, as well as high-end scanning and image-editing services, such as color correction and retouching.

There are labs that specialize in inkjets, while others focus on digital Cs and even dye-subs. Some labs offer more than one choice. The suggestions below apply to all labs, regardless of print type.

By sending your work to a lab for printing rather than printing it yourself, you are giving up some control over the final result—but not as much as you might imagine. If you prepare the image file correctly and to the lab's specifications, you should get good, consistent, and repeatable results. Most labs will provide a **soft proof**—an on-screen version of what your print will look like. The soft proof should be fairly accurate, but only if your monitor is properly calibrated.

One clear advantage to making a print yourself is convenience. If you are unhappy with a print you make in your school lab or at home, you can return to the computer, make changes to the image file, and reprint. With a professional lab, you'll have to wait to see the print and reedit the image file if you don't like the results. Then you'll have to resend the file and wait for the reprint.

There are many ways to deliver your image files to a lab for printing. If they have a retail location, you can deliver them in person on a CD, DVD, hard drive, or other media, but online delivery is probably the most convenient. **FTP (file transfer protocol)** is a commonly used method to exchange image files over the Internet. Custom labs usually offer FTP services through their websites for delivery of image files that are too large to e-mail. You'll need a user name and password to access a lab's FTP site, and the lab will provide that information on their website.

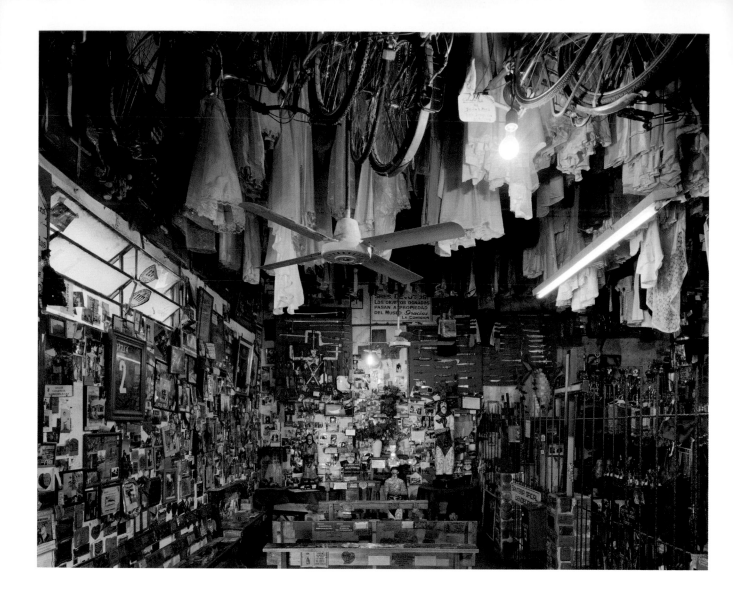

Guillermo Srodek-Hart, "Gauchito Gil Museum"
Srodek-Hart documents the shrines of his native Argentina. This one is dedicated to Gil, a legendary nineteenth-century hero. Natural light from two windows lit the shrine. The light was strongest from the right, so Srodek-Hart used a portable flash to even out the light. He bounced the flash off the ceiling to avoid reflections from the shrine, but the dark ceiling absorbed light. So, with his camera on a tripod, he fired the flash six times to produce enough light for a good exposure. *www.srodekhart.com*

A lab is your partner in making prints. When you find one you like, stick with them. You will each get to know what to expect from the other, and hopefully build a good working relationship over time. The lab will be able to advise you on best methods of image-file preparation and other matters, and also keep you up to date with important changes in software, printing materials, and so forth.

One major advantage of using a professional lab is that they will probably keep a copy (archive) of the image files they print for you. This is mainly for convenience, as reprinting is quicker when they can access an already edited image file right away. Furthermore, that copy also acts as a backup, providing a measure of safety for your files. The lab also may keep a proof from the file that you've already approved, which helps them make a match when reprinting.

Digital projector

PRESENTING YOUR WORK

Once you've made your pictures, you'll want to display them somehow—as actual prints or in digital form. Following are a few of your many options.

If you make prints, the most common presentation method is **framing** and hanging them on a wall. You can send prints to a framer or frame them yourself. Good frames are available at retail stores and website suppliers. The choice of treatment and color is up to you and your budget, but it's usually best to choose a simple frame—one that will complement the image and not distract from it.

You can show your photographs on your computer, of course, but you can also project them, using a **digital projector** that mirrors what's on your monitor's screen. Most digital projectors connect to your computer with a cable, but there are also models that project from other sources, such as a music player, camera, or smart phone. For best results, project on a bright white wall in a room with dim lights and blocked-out windows. Fresh projector bulbs provide the best color, but unfortunately replacing older bulbs is an expensive proposition.

For portability, a **tablet** or even **smart phone** is an excellent choice for displaying photographs. The relatively small size is a drawback, for sure. But a big plus is that photographs are illuminated on the screen, which can make them look better than when printed on paper, where the light is reflecting off the image rather than shining through it.

Matting Prints

One good way to display and protect a print is to mat it between two pieces of board. Use the bottom board to support the print, attached loosely with tape or mounting corners. The top board is an overmat, the same size as the support board, with a window cut out to frame the

picture. Make sure you use archival mat board to help keep the print safe from contamination over time.

Matting helps flatten a print, provides a clean, neutral environment for viewing it, and offers a measure of protection. The surface of the print sits just below the overmat, shielding it from physical damage, while the mat helps protect the paper from nicks and creases. And if the overmat becomes dirty, you can easily replace it without damaging the print.

You can mat prints yourself at relatively little expense, although matting takes care and time. You can also buy precut mats from art-supply stores and online suppliers, or you can have a frame shop mat your prints for you. Consider the following factors when choosing mat board: color, weight, surface, quality, and size.

Color

Mat boards come in black, gray, and other colors, but most photographers prefer white. Many shades of white are available, from cool to warm toned. The board color should generally be neutral or complementary—and not a focus of attention.

Weight

Mat board is usually rated according to thickness, designated as "ply." Two-ply board is lightweight, flexible, and economical; four-ply board is medium to heavyweight, sturdy, and more expensive. Some photographers use heavier eight-ply board for even more strength and protection.

Surface

Mat board comes in a variety of surfaces, from smooth to rough. You will probably want a surface somewhere in-between—flat and matte, but not too rough or textured—to provide a neutral and attractive frame for your prints.

Quality

High-quality board looks good and ages well, while cheaper boards may discolor and deteriorate with time—or even cause matted prints to eventually stain. Archival rag board (made from 100% cotton fibers) or acid-free board is considered safest for long-term display and storage.

Size

Mat board comes in various sizes and may have to be cut down for use. Pick a board with dimensions that are compatible with the size of the

print you are matting. Most of the time the overmat provides a border of at least three inches on all sides, so the total board size should be the size of the image plus at least six inches in each dimension. That means for a 12" x 18" image, you'll need a support and an overmat cut to at least 18" x 24".

An overmat can help display and protect a print. Most overmats provide a border of approximately three inches around the window displaying the picture, though the size of the border is up to you.

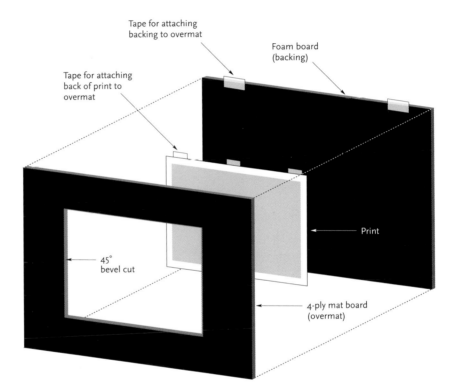

Tape for attaching
backing to overmat

Foam board
(backing)

Tape for attaching
back of print to
overmat

45°
bevel cut

Print

4-ply mat board
(overmat)

Elinor Carucci, "Hand in Shower"
Carucci is well known for her very personal photographs of her family, including this one from her book *Closer*. "The camera was...both a way to get close, and to break free, "she writes, "It was a testimony to independence as well as a new way to relate."

Many photographers take pictures to help document their life and also to make sense of it. Their subjects are people and places, but also obsession and boundary, vulnerability and strength, and a wide range of other feelings and emotions.
www.elinorcarucci.com

Index

Acknowledgments

It takes a "village" to complete a book like this, and I truly got by with a lot of help from my friends. Debbie Grossman of *Popular Photography* was the book's lead technical editor, aided by huge efforts from Tom Gearty, CJ Heyliger, Angela Mittiga, and Jesse Stansfield. Chris Dailey, Bruce Myren, Jack Schow, Jonathan Singer, and Steve Smith also contributed key editorial guidance. Amanda Collins, Jason Potts, Chrissie Robinson, and Lewis Wheeler were handsome and willing models. And, of course, thanks to all the gifted photographers who contributed their beautiful portfolio images.

On the production side, Kiki Bauer was amazing—creative, patient, precise, and incredibly hard working. The same can be said of Mine Suda. Together they made a plodding manuscript look amazing—fun and readable. Thanks also to copy editor Anne McPeak, who crossed every *t* and dotted every *i*, and to indexer Nancy Wolff.

Warmest regards to editor Michael Sand and his sidekick Melissa Caminneci, who not only named the book, but helped shape it. Many thanks for everything, including your endless patience. Also, a thankful nod here to my unforgettable former editors at Little, Brown, Mary Tondorf-Dick and Dick McDonough.

Finally, Allison Carroll was involved every step of the way—from the research to the writing and the picture program. She even modeled for a couple of the example pictures! Allison gets top credit in a very talented field.

About the Authors

Henry Horenstein has been a professional photographer, teacher, and writer since the 1970s. He studied history at the University of Chicago before turning to photography, earning his BFA and MFA from the Rhode Island School of Design (RISD) while studying under the legendary photographers Harry Callahan and Aaron Siskind. Horenstein's photographs are collected and exhibited internationally, and he has published over thirty books, including *Black & White Photography: A Basic Manual,* used by hundreds of thousands of college, high school, and art school students as their introduction to photography. He has also published several monographs of his own work, including *Show, Honky Tonk, Animalia, Close Relations, Humans,* and many others. Horenstein lives in Boston and is professor of photography at RISD. His photographs can be seen at *www.horenstein.com.*

Allison Carroll is a teacher, photographer, and writer. She earned her BFA in photography from the Art Institute of Boston at Lesley University, where she also taught for several years. Carroll lives just outside of Boston, and currently teaches photography at St. Sebastian's School in Needham, Massachusetts. Her photographs can be found at *www.allisonmcarroll.com.*